THE ROSE ART MUSEUM AT BRANDEIS

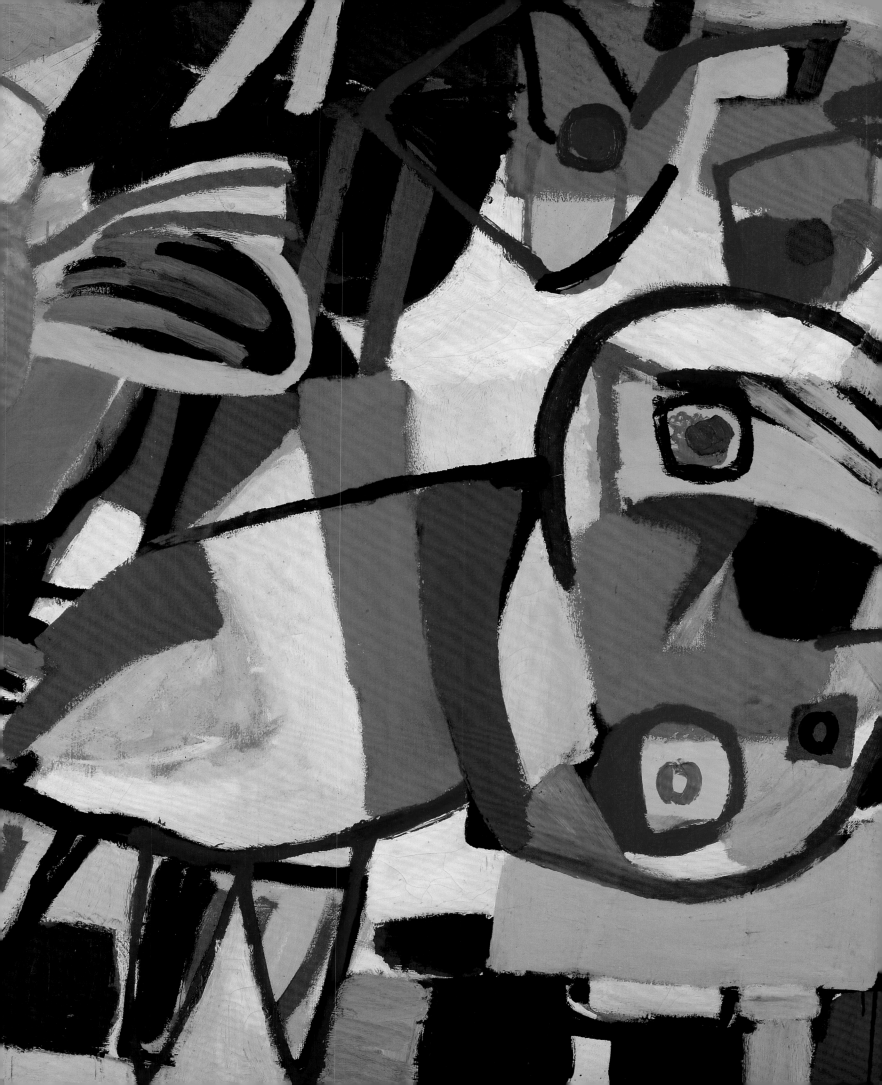

THE ROSE ART MUSEUM AT BRANDEIS

by MICHAEL RUSH *and others*

ABRAMS NEW YORK

FRONTISPIECE | **KAREL APPEL,**
Dutch, 1921–2006
Untitled (detail), 1951
See page 26

EDITOR: *Margaret L. Kaplan*
ASSISTANT EDITOR: *Aiah R. Wieder*
DESIGNER: *Judy Stagnitto Abbate / Abbate Design*
PRODUCTION MANAGER: *Jules Thomson*

Library of Congress Cataloging-in-Publication Data

The Rose Art Museum at Brandeis / by Michael Rush et. al.
 p. cm.
 ISBN 978-0-8109-5574-5 (hardcover)
 1. Art, Modern—20th century—Catalogs. 2. Art, Modern—21st
century—Catalogs. 3. Art—Massachusetts—Waltham—Catalogs. 4.
Rose Art
Museum—Catalogs. I. Rush, Michael. II. Rose Art Museum.

 N6487.W27R67 2009
 709.04'00747444—dc22

 2008055020

Published in 2009 by Abrams, an imprint of ABRAMS

Printed and bound in China
10 9 8 7 6 5 4 3 2 1

Abrams books are available at special discounts when purchased in
quantity for premiums and promotions as well as fundraising or
educational use. Special editions can also be created to specification. For
details, contact specialmarkets@abramsbooks.com or the address below.

115 West 18th Street
New York, NY 10011
www.hnabooks.com

The Rose Art Museum

PRESIDENT'S NOTE

I am grateful to principal donors Michael P. Schulhof, Jonathan Novak, and Diego Gradowczyk, alumni of Brandeis University, whose vision and generosity inspired this project; former Assistant Curator Adelina Jedrzejczak, alumna Ann Tanenbaum, and project coordinator Kelly Powell for their tireless efforts in assembling this handsome and historic volume.

JEHUDA REINHARZ, PRESIDENT
BRANDEIS UNIVERSITY

INTRODUCTION

The year 2011 marks the fiftieth anniversary of the Rose Art Museum at Brandeis University. Born from the dream of Brandeis President Abram Sachar and two generous supporters, Edward and Bertha Rose, the Rose has in its relatively brief life, assumed a place of prominence as the leading collecting museum of modern and contemporary art in the region. Every new institution aspires to greatness in its early statements and hopes for the future, but the Rose, through an almost magical combination of shrewd collecting and remarkable generosity of donors, has actually surpassed the optimism of its earliest days.

The Rose collection, comprised now of more than 7,000 works of art in all media, began well before the founding of the museum. Brandeis, as is well known, grew from the determination of a forceful band of leaders committed to liberal education in both the arts and sciences. President Sachar, by all accounts a genius at persuading others to join his dream for a Jewish-sponsored museum in the best tradition of Jewish scholarship and discipline, believed deeply in the role of the arts in a liberal education.[1] Well before the Rose Museum grew on the slight rise up the road and to the left of the entrance to Brandeis, the university received numerous gifts of art and sponsored many exhibitions in various places around the campus. Sachar proudly noted in his memoir that before the first class graduated from Brandeis in 1951, the university had already received more than 300 paintings,

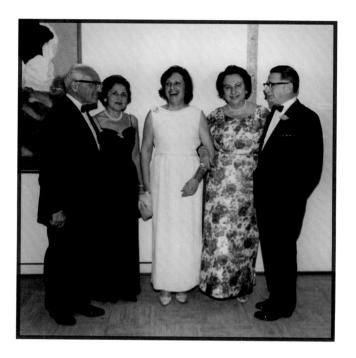

many of them outstanding works by artists such as Stuart Davis, Fernand Legér, Milton Avery, and George Grosz. Several came from the "Modern Art Collection," as it was called, of Boston collector Louis Schapiro. The contagious enthusiasm among early donors to Brandeis embraced art in equal measure to other disciplines. The Slosberg Music Center, dedicated in 1957, housed an art gallery in the lobby of its recital hall, but years before that, classes and studios (and no doubt informal "exhibitions") were carved out of spaces in both the Castle[2] and the gymnasium.

The story of the Rose collection is intimately bound up with the faculty of art history and practice at Brandeis.

Left to right: Mr. and Mrs. Abraham Sachar, Mildred S. Lee, Bertha and Edward Rose at the Rose Ball, 1964

Within three years of Brandeis's founding, Mitchell Siporin, an ex-military man and WPA artist, was hired as the first artist-in-residence. To its credit, Brandeis, unlike some leading universities even to this day, supported the practice of art as well as the study of art history (so, too, with music and theater). Siporin, whose own work reflects the struggles of his youth during the Great Depression in Chicago, was appointed the first curator of the Brandeis University Art Collection in 1956. In the same year, the Charna Stone Cowan Rental Collection was established, enabling students to "rent" (for very nominal sums) artwork for their rooms. This policy still exists, having been greatly enhanced by a gift of more than 500 pieces from Boston gallerist and early Rose supporter Mildred Lee in 1971 in honor of her father, Robert W. Schiff.

The story of the Rose proper begins in 1960 with the establishment of the Poses Institute of Fine Arts with funds from Jack I. Poses and his wife, Lillian. Dedicated to presenting major art exhibitions and sponsoring seminars with important contemporary artists, the Poses Institute will be remembered not only for its programs but also for its first director, Sam Hunter, who quickly also became the first Director of the Rose Art Museum. In May of 1960, ground was broken for the Rose building. Hunter, then thirty-seven, had been an art critic for the *New York Times*, an Associate Curator at the Museum of Modern Art, and a teacher of art history at the University of California, Los Angeles, and Barnard College in New

York City. Just prior to his coming to Brandeis, he was Chief Curator and Acting Director at the Minneapolis Institute of Art.[3]

Hunter came of age as a writer and critic in the late 1940s and '50s, just when American artists were causing a seismic shift in the art world. Jackson Pollock, Willem de Kooning, Mark Rothko, Clifford Still, Arshile Gorky, Robert Motherwell, to name a few, collectively ruled the art world with their variants of Abstract Expressionism. Hunter, a prolific and gifted writer, created verbal descriptions of their vigorous paintings in words that remain the gold standard for art writing. Hunter's keen insight into the art of his time, and prescience regarding what was to come just beyond the current moment, formed the storied basis for the Rose's renowned collection.

While Director of the Rose, Hunter was approached by the organizers of the 1962 Seattle World's Fair to curate an exhibition for the Fine Arts Pavilion. His fervent attention to the work of scores of artists, known and unknown, combined with the mandate to create a world-class exhibition, gave Hunter access to a broad swath of artists, eighty-seven of whom (with 114 works in total) he placed into the Seattle exhibition. They included Josef Albers, Alexander Calder, Joseph Cornell, Stuart Davis, Willem de Kooning, Sam Francis, Helen Frankenthaler, Philip Guston, Grace Hartigan, Hans Hofmann, Jasper Johns, Joan Mitchell, Jackson Pollock, Robert Rauschenberg, Frank Stella, and Theodoros Stamos, all of whom are

represented in the Rose collection! This exhibition closed in Seattle on October 21 and opened at the Rose, astonishingly, on November 21. Given what we know about installing, de-installing, and shipping, this was nothing short of a miracle.[4]

A miracle of another kind occurred during a four-month period in 1962–63. As Hunter describes it, "Leon Mnuchin called from New York one day to announce that he and his wife, Harriet Gevirtz-Mnuchin, had inherited a sum of $50,000, with which they wished to fund a contemporary art collection at Brandeis."[5] With what has happened in the art market since, that is like Bill and Melinda Gates calling one day and saying they have $150 million to start a contemporary art collection!

Hunter reports that he and "Leon immediately set out to explore the galleries. We often made gallery rounds with Robert Scull, a friend of Leon's and a prominent New York collector," especially of Pop Art. During their rounds (which included studio visits during which they bought directly from artists), they managed to gather early and important works by Jasper Johns, Robert Rauschenberg, Roy Lichtenstein, Claes Oldenburg, Jim Dine, Tom Wesselmann, James Rosenquist, Adolph Gottlieb, Robert Indiana, Ellsworth Kelly, Morris Louis, among many others. Their limit was $5,000 a painting (which meant several were bought for much less). Warhol had already become a bit expensive, Hunter says, so they went for one of his lesser works from the "paint-by-number series." If the term "miracle" may be evoked for a third time, a couple of years later Hunter's successor at the Rose, William Seitz, exchanged that Warhol (*Do It Yourself Sailboat*, 1962) for *Saturday Disaster*, 1964. Collectively, at this writing, the Gevirtz-Mnuchin col-

lection, along with the Warhol, are worth in excess of $200 million.[6]

It is important to remember that Hunter and Mnuchin went in search of art, not market value. "The guiding principle of the selection was individual quality rather than tendency," Hunter wrote for the brochure accompanying the exhibition of the collection. "As a matter of policy, the collection focused on younger artists with only a token representation of the older generation. . . . Abstract Expressionism is the collection's point of departure, taken at a point of subtle but significant transition."[7]

Abstract Expressionism may have been the point of departure, but, even for Hunter, this movement was only part of the story. Hunter referred to the "decentralized art of linear fragments and excited handling" of artists like Pollock and De Kooning that yielded to a "simpler, unified and pacific image established by nuanced color contrast" in the work of Adolph Gottlieb and James Brooks. The paintings of Ellsworth Kelly and Robert Indiana were "linked to the movement toward a more rigorous formality," while the work of Rivers, Dine, Rauschenberg, and Johns represented a "reaction to the personalized expression of the older generation of abstract artists with the incorporation of popular imagery and the object." Ever mindful of the role of the museum within the larger life of the university, Hunter wrote that "the main purpose of the collection is aesthetic, but in the life of the university

it also has larger meanings and uses as an index to contemporary civilization. . . . In picturing himself, the adventurous artist also shows us the best and worst of our world, and speaks for the human condition."[8] This sensitivity to the role of the artist in addressing the human condition is particularly evident in the ongoing collecting policies of the Rose. Building on a strong base of American Social Realism (Max Weber, George Bellows, Thomas Hart Benton, Reginald Marsh, Hyman Bloom, George Grosz), the Rose regularly admits works of social significance to the collection, as seen in its body of feminist work (Judy Chicago, Ana Mendieta, Marisol, Yayoi Kusama, Cindy Sherman, Hannah Wilke, Francesca Woodman) and numerous examples of socially conscious work in several media by a wide range of artists, including Nan Goldin, Barry McGee, Anri Sala, Christian Boltanski, Mona Hatoum, Zhang Huan, Alfredo Jaar, William Kentridge, Isaac Julien, Tracey Moffatt, Kiki Smith, Dominic McGill, Natalie Frank, to name but a few.

The Rose Art Museum opened its doors on May 3, 1961, almost exactly one year after breaking ground.[9] Donor Bertha Rose had a significant collection of porcelain and ceramics (including French decorative earthenware from the Napoleonic era) that went on permanent display in specially made vitrines placed along the stairwell opening on the first floor of the Rose building. There they remained for almost fifteen years (not exactly "permanent"), while the walls across from

them held the most challenging and daring art of the 1960s and '70s!

Thanks to the enduring generosity of so many donors, the Rose collection has never ceased to grow in quality and depth. William Seitz, who took over from Hunter in 1965,[10] was another distinguished writer and also an artist. While Rose Director, Seitz was asked to organize the American portion of the IX São Paulo Bienal in 1967. Among the twenty-one artists curated by Seitz, eight were represented in the Gevirtz-Mnuchin collection and another five entered the collection during Seitz's tenure. In the introduction to the catalogue of the Bienal, President Sachar wrote: "It is a matter of great satisfaction that the United States exhibition of the IX São Paulo Bienal should carry a Brandeis imprimatur. . . . [In] the arts, where tomorrow is always as important as yesterday, and where the young in aspiration and spirit are ever in the vanguard, perhaps it is appropriate that Brandeis, not yet twenty years old, should help to lead."[11]

What is striking about Hunter and Seitz is that both maintained their commitment to scholarship and connoisseurship while collecting and administering. Like other directors of their time (Lloyd Goodrich, Walter Hopps), they were leaders who placed the study and presentation of art first. Indeed, their shrewd collecting sensibilities were not based on luck and timing, as is often said, but intimately linked with their writing, curating, and constant looking at new work.

Equally important, if a bit less dramatic in the telling, were the gifts of the brothers Joachim Jean and Julian J. Aberbach and publisher Harry N. Abrams. From the former came Willem de Kooning's *Untitled*, 1961, and Robert Motherwell's *Elegy to the Spanish Republic No. 58*, 1957–61; from Abrams, Philip Guston's *Allegory*, painted in 1947.

Guston's extraordinary work was found rolled up in a corner of the auxiliary painting and sculpture storage room in late 2006, apparently never having been exhibited in the museum. A collective gasp was uttered by the staff as the painting was unwrapped and spread out on the floor of the Rose building. Guston, whose place in the pantheon of mid to late twentieth-century American painters is still developing, passed through so many stylistic changes in his career (from the purely figurative to the abstract to the symbolic to the seemingly comic-inspired Pop) that it is not totally surprising that a work of his might have been forgotten. In this magical work, the optimism of Guston's youth is fully represented by the smiling sun. So is his fascination with Surrealism, evident in works from the 1930s (e.g., *Mother and Child*, 1930, and *Bombardment*, 1937–38). *Allegory* is remarkable not only because of its unfortunate extended anonymity, but also because it was one of the last paintings he made before turning to the colorful abstractions for which he has become known.

Guston's remarkable artistic journey put him in

close touch with many other artists in the Rose collection, including Stuart Davis, Willem de Kooning, Franz Kline (during his WPA period), and especially Robert Motherwell, with whom he shared a deep interest in philosophy and the work of Paul Cézanne. The Rose's small Cézanne *Bather* (9 ½ x 5 ½ inches), once owned by artist Pierre Bonnard, is a true gem. It is actually not dissimilar in size to the artist's prized *The Apotheosis of Delacroix*, 1890–94, which measures 10 ¾ x 14 inches. Motherwell was fond of saying he experienced the "shock of recognition" when, as a student, he first saw a Cézanne in Paris.

A major link among the New York painters of the 1960s was Black Mountain College in North Carolina. Students and teachers at this celebrated institution included Franz Kline, Robert Rauschenberg, Cy Twombly, Willem de Kooning, and Josef Albers, all of whom are represented in the Rose collection. Albers, whose daring orange palette suffuses his *Formulation: Articulation* series, 1972, and is reflected in both the De Kooning and the Motherwell, was himself an Expressionist painter early on. Though his canvases can be most easily associated with a minimalist aesthetic, his highly influential pedagogical methods stressed direct experience with what he called "the dynamic properties of materials." Associations such as these reverberate throughout the collection.

Despite the frequent and all too familiar pressures of financial limitations, a compelling synergy between donors and institutional vision has propelled the

Rose toward its enduring prominence among university art museums. In the 1960s, with a gift from Cleveland art collectors Maurice and Shirley Saltzman, an artist-in-residence program was established. Early recipients of this award included Philip Guston, Jacob Lawrence, Frank Stella, Elaine de Kooning, painter and activist Anthony Toney, and sculptor Richard Lippold. The artist-in-residence program was reinvigorated in 2002 with the Nathan and Ruth Ann Perlmutter award, which has enabled the Rose to recognize extraordinary young talent—including Dana Schutz, Clare Rojas, Xavier Veilhan, and Alexis Rockman. Several artists, including Stella, Louise Nevelson, Kiki Smith, and Schutz received

Philip Guston at the *Philip Guston Select Retrospective* exhibition in 1966

their first major or very early museum exhibitions at the Rose.

The adventurous collecting spirit initiated by Sam Hunter has never faltered at the Rose. From the 1970s and beyond, first under the directorship of Michael Wentworth (1970–74) and then Carl Belz (1974–98), the Rose's preeminent collection of modern and contemporary art grew steadily. Extraordinary individual collection gifts continue to enhance the Rose's holdings. The Teresa Jackson Weill bequest of 1975 contained superior works by American artists of the first half of the twentieth century, including Stuart Davis; The Herbert Plimpton Collection, 1993, ushered in forty-five American Realist (including Photorealist) painters; and a contemporary collection from Michael Black and his wife, Melody Douros, advanced our contemporary holdings with more than three dozen works largely from the mid 1990s to the 2000s.

Director Belz and Curator Susan Stoops acquired paintings by Helen Frankenthaler, Robert Mangold, Lawrence Poons, Katherine Porter, and Agnes Martin, among many others, including especially works by Boston artists, who represented an important and growing art scene locally. In 1981, the first acquisition endowment, the Rose Purchase Fund, was established from the estate of Edward and Bertha Rose. The multimillion dollar Sara and Mortimer P. Hayes Acquisition Fund, created in 2001, enabled the Rose actively to purchase significant art on a

yearly basis, though by this time the art market had begun its march toward dramatically higher prices.

In the late 1990s, under Director Joseph Ketner (1998–2004) and Curator Raphaela Platow (2002–7), the Rose adopted a plan to maximize acquisition funds by entering into the arenas of photography and video art. Works by Nam June Paik, Matthew Barney, Bernd and Hilda Becher, Anri Sala, William Kentridge, Robin Rhode, to name but a very few, advanced the collection into the new era of media and digital art. This direction echoed the important 1970 exhibition *Vision and Television*, organized by Rose curator Russell Connor, the

Louise Nevelson at her exhibition in 1967

first exhibition of video art in a U.S. museum. During Director Ketner's tenure, the collection received an essential database updating, as well as a new home for display: the Lois Foster Wing, a 5,000-square-foot contemporary space designed by Graham Gund Associates, Boston. Dr. Henry and Lois Foster have nurtured the Rose for most of its history, with Lois personally writing thank-you notes and words of encouragement to all members for almost thirty-five years! The history of the Rose is the history of the generosity of donors like the Fosters.

I was privileged to assume the directorship of the Rose late in 2005, continuing to work with Raphaela Platow before she left to assume the directorship of the Contemporary Arts Center, Cincinnati. Inheriting the mantle of such esteemed predecessors, I quickly embraced the collection as the prize jewel that it is. It has been an immense pleasure to support several collection-based exhibitions, including the memorable *Rose Geometries*, 2008, by Assistant Curator Adelina Jedrzejczak and the ongoing *Paper Trail* exhibitions organized by invited artists, including Odili Donald Odita and Margaret Evangeline, who have immersed themselves in our works on paper collections, creating exhibitions with their own work in dialogue with ours. In 2008, I was able to place center stage another part of our great collection in *Invisible Rays: The Surrealism Legacy*.

The Collections Committee, under the leadership of Marlene Persky, has seen more than sixty new works come into the collection, including pieces by Jenny Holzer, Jessica Stockholder, Joseph Cornell, and Joel Shapiro (the latter two courtesy of Brandeis alumnus and Rose Board member Jonathan Novak), Natalie Frank (courtesy of Board member Eric Green), Vik Muniz and Marcel Duma (courtesy of Marlene Persky and former Board Chair Gerald Fineberg, respectively). The list goes on. Through a painstaking process of selected deaccessioning of works that do not comply with our mission, which is devoted to modern and contemporary art, we have more than doubled our acquisition endowments.

Fifty years young, the Rose has accomplished in its short life what many institutions can only dream of. The dream of the Rose is to honor its unique and inestimable collection, exhibiting it in ever new and experimental ways and enhancing it with the inexhaustible generosity of donors and the keen, experienced eyes of its caretakers.

MICHAEL RUSH
HENRY AND LOIS FOSTER DIRECTOR
ROSE ART MUSEUM

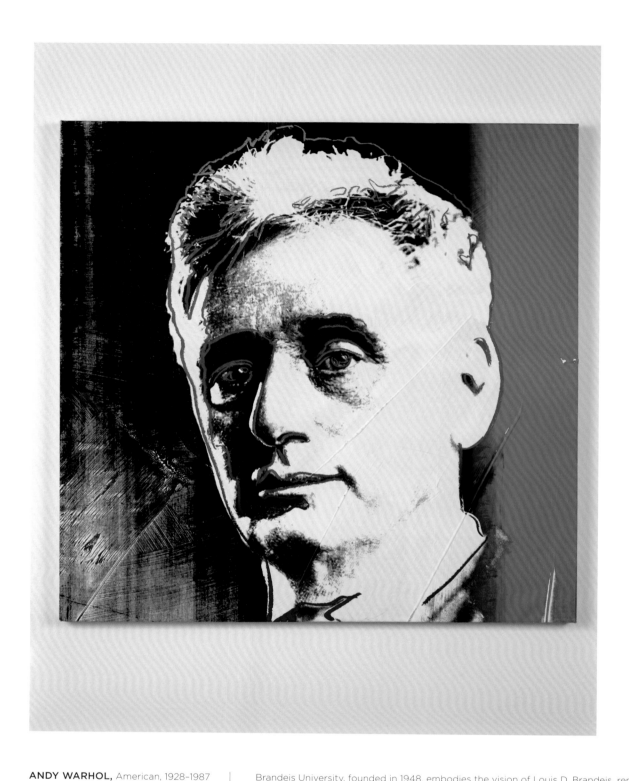

ANDY WARHOL, American, 1928–1987
Louis Brandeis, 1980
Acrylic and silk-screen on canvas,
40 x 40 inches
Gift of Mark, Andy, and Julie Feldman.
Courtesy Ronald Feldman Fine Arts,
New York, 2005

Brandeis University, founded in 1948, embodies the vision of Louis D. Brandeis, renowned attorney, Supreme Court Justice, and prominent member of the Jewish community. His commitment to social justice has served as a pillar of the University's mission since its establishment. To commemorate Justice Brandeis's 150th birthday, gallery owner Ronald Feldman donated this celebrated Andy Warhol portrait of the Justice taken from the series *Ten Portraits of Jews of the Twentieth Century*. Feldman, a friend of Warhol's, encouraged the artist to represent not only the rich and famous, but also figures of social and political significance, which his *Ten Portraits* series successfully achieved. In the portrait, Warhol applies red and black acrylic paint and silk-screen enamel to canvas, simultaneously combining a graphic sensibility with a more painterly quality. The two styles coexist in the center of the picture, where Warhol's hand-drawn marks highlight Brandeis's facial features.

HELENE LOWENFELS '05

ACKNOWLEDGMENTS

The Rose Art Museum has been sustained for almost fifty years by the unflappable generosity of donors and the steady willingness of Rose personnel to work well beyond expectations. The production of this volume resulted from the extraordinary efforts of many people, including especially former Assistant Curator Adelina Jedrzejczak and consultant Kelly Powell. To them we owe a deep debt of gratitude. Special thanks also to Margaret L. Kaplan at Abrams for her steady guidance throughout this process.

The small working quarters of the Rose have been a beehive of catalogue activity for more than a year now. Special thanks to Lindsey Farrell, Dana Harrison, and Caroline Weitzman, who volunteered their time. Registrar Valerie Wright and Preparator and Assistant Director for Operations Roy Dawes were constantly available for all manner of tasks. Photographer Charles Mayer set up a professional studio in one of our storage facilities to complete the huge task of photographing the collection. Emily Mello, Education Director, Stephanie Herold, Assistant Director of Development and Marketing, and Jay Knox, Museum Administrator, all contributed significantly to this effort.

Special thanks also go to the numerous alumni and former curators and directors of the Rose who contributed entries to the catalogue. Their spontaneous eagerness to be part of this project was truly inspiring. Directors Sam Hunter, Carl Belz, and Joe Ketner were very helpful, indeed, regarding the history of the Rose and its collection.

As always, the Rose Board of Overseers has been deeply supportive, most especially Jonathan Novak, and also Diego Gradowczyk and Ann Tanenbaum. Marlene Persky, Gerald Fineberg, Eric Green, and the indomitable Lois Foster have contributed greatly to the Rose's collection. So many others in the history of the Museum have been so influential: Mildred and Herbert Lee, their son Jonathan, our current Board Chair, and Stephen Alpert. Very special thanks also to donor and alumnus Michael Schulhof.

MICHAEL RUSH

HENRY AND LOIS FOSTER DIRECTOR

ROSE ART MUSEUM

EUROPEAN AND AMERICAN MODERNISM: MAPPING COORDINATES

Nancy Scott

The Rose Art Museum collection of modernist works, based on the generosity of individual donors over decades spanning the rapid developments of recent art, possesses cohesive traits that describe a twentieth-century cultural map. In times that were fraught with war and European dislocations yet seeded by transnational cultural exchange, from New York to Paris or Berlin and back, the artists represented here sought to create art anew. Paris was the magnet for both American and European artists, whether they came before 1914 or after 1920, drawn by the lure of School of Paris artists and expatriates. Paul Cézanne, Fernand Léger, Henri Matisse, and Georges Braque are among the important French artists who anchor the Rose Art Museum's early modern works.

Germany was also a locus for the beginnings of an avant-garde art, particularly in the first two decades of the twentieth century. The emergence of the Blaue Reiter group in Munich in 1911–12, with the painter Wassily Kandinsky at its head, provides another key to the development of twentieth-century abstract art. These artists in turn drew Marsden Hartley to Germany in 1913, and others from our collection—such as Marc Chagall and Oskar Kokoschka—notably to exhibit in Berlin at Herwarth Walden's vanguard Der Sturm gallery.

The Rose's Cézanne *Young Bather,* 1875–77, represents a beginning. In its geometric simplification of rectangular brushwork and solid planar attachment of form to landscape, it engages the prior technique of Impressionism's daubs and indistinctness, techniques that are themselves the very seedbed of Cézanne's own stylistic development. The Rose work is an oil study for what would become a years-long series of male bathers in Cézanne's oeuvre. Our *Bather* has been copied in a lithograph by Pierre Bonnard, and links forward to single bathers, a later version of which was once owned by Edgar Degas (now Collection Jasper Johns), and reaches its fullest expression in the *Grand Baigneur* (1885–87, Museum of Modern Art, New York). The figure study at the Rose is anchored between tree and ground, firmly fitted into riverbank and the leafy yellow-green rectangular foliage. The small oil, no larger than a sheet of typing paper, is a fitting progenitor for later painters, just as it anticipates Cézanne's own mature period. Pablo Picasso famously called Cézanne "the father of us all," and stated elsewhere, "it is Cézanne's doubt that forces our interest."

An early experimental masterpiece by Marsden Hartley, *Musical Theme: Oriental Symphony,* 1912–13, demonstrates how Paris and Berlin were the focus points of prevailing aesthetic innovations of the time. Here, from a series started in Paris that Hartley called *Intuitive Abstractions,* is an adventuresome, richly brushed canvas, startling for its early date from an American artist. One

can find Matisse's color richness, yet painted with an eye to the spiritual transcendence sought by Hartley. The whole is presented in a joyous confetti explosion of shapes and symbols. Using the symbol and sign method of early Synthetic Cubism, with color washes evoking his study of Cézanne's watercolors, he introduces musical clefs and pictographs, a statuette of the seated Buddha, and the mudra at center, shaped by a mandorla, all integrated into the mounting scaffolding of colored forms. The color music of synaesthesia meets the cyclic transport of meditation and nirvana.

The date itself is significant, as the *Musical Theme* painting is referenced in two letters written by Hartley from Paris late in 1912, where he frequented the Saturday salons of Leo and Gertrude Stein. In early 1913, he passed through Munich, where he met Kandinsky for the first time. Later, after settling in Berlin in May, he showed part of the new group of works to Franz Marc and Kandinsky. The Russian artist critiqued the work, not altogether favorably given Hartley's reaction, but did recommend Hartley's paintings to Walden when an exhibition at the Galerie Goltz, where the Blaue Reiter group showed, became impossible. Gino Severini, the Italian Futurist, displaced Hartley's work in that critical summer of 1913.

Florine Stettheimer, also a friend of Gertrude Stein's, made stage sets in New York for her 1934 collab-oration with Virgil Thomson, *Four Saints in Three Acts*. In *Music*, c. 1920, she created an airy stage for the many performers who passed through her home and life, a figurative interior counterpoint to Hartley's *Musical Theme*.

Marc Chagall, the Russian painter who arose out of the shtetl culture of his birthplace, Vitebsk, represents a very distinct interpretation of the abstracted body. Chagall's purple-faced, rouged *Woman with Flowers*, 1910, presents a calm profile, just as she suggests the fantastical world explored, on his arrival in Paris, amid an innovative circle of vanguard artists. This style is ultimately traceable back to his eighteenth-century Hasidic forefathers' ecstatic revival within Judaism, where old chants may have inspired Chagall's images. David Burliuk's *My Mother,* 1909, depicts a similar whimsy of animals and peasants, edging his canvas like hieroglyphs, beside upside-down houses.

Worth noting is that our early Chagall painting shared a context of German patronage with Hartley and the Austrian Oskar Kokoschka. Walden's gallery, Der Sturm, was the site of a Chagall exhibition in 1914. The painting's dashlike, colorful strokes in the flowers and foreground elements undoubtedly spoke to new elements emerging from the German appreciation for Van Gogh as well as for Expressionists like Kokoschka, who himself designed a poster for Walden's periodical *Der Sturm*

in 1910—an encoded self-portrait in which he points to a slashed wound in his side, indicative of initial negative reaction to his often anguished artwork.

The heightened treatment of the body as crucible of the modern condition is to be found in the Rose's early drawing of an emaciated nude, 1910, by Kokoschka, which echoes the tense existential renderings of his compatriot Egon Schiele.

Recent new research on the pre-Nazi period of vanguard German collectors has recuperated the wide appeal of artists such as Chagall at this early moment in his career. To that end, Chagall's *Woman with Flowers* has recently been exhibited anew in Germany: in the Frankfort Jewish Museum, in the exhibit *Chagall and Germany*, 2004, and more recently in 2006–7, in Dresden, in an exhibition highlighting the work's original context within the private collection of Ida Bienert.[1] Bienert hid the works during the Nazi period, and was forced to sell them off bit by bit; thus our Chagall entered an American collection. It is to none other than Samuel Beckett, who visited the Bienert collection in 1937 and noted her paintings in his diary, that we owe our comprehensive overview.

In the case of Juan Gris, Spain came to Paris, drawn by Picasso's circle. The obsession with common daily objects as central to Cubist still life developed in the period 1908–14. Such a device appears in a most remarkable early Gris painting in the Rose collection, *Le Siphon*, 1913. This much-exhibited work depicts the siphon bottle on a pink-veined, marble-topped table at a café, with wood wainscoting and a bentwood chair to the right. The human presence is indicated only by the evocative curve of the empty chairback. The siphon exudes its fizz, and bubbles of blue graphic marks on white and gray initiate a circular effervescence that rhymes with the bentwood chair and enlarges in the flattened tabletop. The refracted planes of Cubism convey the texture and color of the objects in space, or as brief perceptual slices of reality. One searches hypothetically for a human face or form lingering as double image within the gray and black jaunty rectangles or the blue bottle itself. The donation came from Edgar Kaufmann, Jr., heir to the famous residence Falling Water designed by Frank Lloyd Wright, and he was also the first head of the Department of Design at the Museum of Modern Art. Well before Kaufmann owned it, the oil was appropriated during World War I, as part of the stock of the German national Daniel-Henry Kahnweiler, who had given the first Cubist exhibition anywhere in Paris in 1908.

An American artist whose Parisian sojourn (1905–9) reflected the most profound absorption of Cubism of any American master was Max Weber, whose

works are extensively represented in the Rose. His *Seated Woman* of 1916 is an excellent example of the ways in which he had closely absorbed the Cubist analysis of the figure. Weber's woman combines the voluptuous circles of breasts and circle-hinged wrist holding a fan, to the lower right, with a cubified head at the center. The head clearly relies upon geometric, masklike distortions and evokes the African tribal art that was widely collected during this epoch in Paris. Weber returned to New York with two small African statuettes, a reflection of the serious aesthetic regard in which these ethnographically rich objects were held. Out of Weber's many works at the Rose, one other deserves mention. *Figures in Landscape*, 1912, indicates most strongly his allegiance to Picasso. It clearly echoes that famous harbinger of Cubism, *Les Demoiselles D'Avignon* (1907, Museum of Modern Art), which remained in Picasso's studio for a decade after its creation. Their mutual studio visits and a brief friendship developed at Gertrude Stein's house full of modernist painting gave Weber unique access. His early work highlights his important role in carrying Cubism across the Atlantic, which was seconded by the decision of the Museum of Modern Art to give Weber the first-ever retrospective of an American artist, in 1930.

The *Landscape near Frankfurt (with Factory)* of 1922, painted by Max Beckmann, documents the ambivalent postwar modernist dream of utopia in Germany. An air of bleak, jagged harshness in the denuded tree and tilted poles, paired with factory smokestacks, pervade what should be a cheerful scene of cabbage patches and sunflowers, tended by industrious burghers who stir up intense clouds of dust. In contrast, the two smokestacks stand by, idle. Beckmann, highly honored in his prewar career as one of the greatest of early modern German painters, intensified his Expressionist style after the shock of wartime duties and created a densely symbolic, graphic figure style. Branded as a maker of "degenerate art" by his own government in 1937, his immigration first to Holland and later to the United States helped further define his Expressionist iconography.

If landscape can be seen as symbolic of the embodied space of new worlds or old, certainly Reuven Rubin's *Near Jerusalem* of 1924, with its purposeful recollections of quattrocento castellated walls linked to a primitivizing style, encompasses his outsider sense of entering a utopian landscape. Rubin's mapping of important modernist styles includes his arrival in Paris from Romania before World War I, and his travels to New York, where he cultivated a sophisticated circle of Jewish patrons that included Alfred Stieglitz and Helena Rubinstein. Rubin settled in Palestine in 1923, a pioneer artist of the Eretz Israel generation.

The Rose collection possesses a Braque still life and a Surrealist-period Picasso. Each of these is later than

the Cubist work they pursued together prior to 1914. The Rose's quiet, gray-toned Georges Braque still life, *Peaches, Grapes, Pear, Jug*, 1924, which mixes sand with oil on canvas, represents a distinct moment in the history of still life painting after Cubism. Drawn from a series for the mantelpiece, the Braque demonstrates his particular way with closely valued color. The avocado green, gray, yellow, and pinkish beige of this shadow-filled quiet space give off their own warm harmony. Cubist dislocation only gently unsettles the white/gray division of the pitcher, and the ghostly flutter of the cloth recalls Cézanne's still life as it surrounds the flat knife and sensuously halved fruit.

Pablo Picasso's *Reclining Nude* of 1934 depicts the curvilinear contour of a woman, whose body is marked with the artist's own inner projections about creativity, and its obstacles. The Picasso, another generous bequest to the Rose, encodes the presence of his mistress Marie-Thérèse Walter with a palette employed only for her—the lavender-toned face and body, apple-green breasts, and yellow hair. The breasts may be read as a double image of body and still life, whereas the sign of her genitalia, displaced as a slash against both belly and the side of her head, reveal the very embodiment of an erotic anatomy. Her sleeping form is here crammed into a small, claustrophobic box of a dark room decorated with flower-sprigged, fussy wallpaper. His observation of her sleeping,

a frequent motif in his Surrealist-dream interpretations of the *tabula rasa* of her fecund voluptuousness (in this very year, 1934, she bore his child, their daughter Maia) can be found in earlier work of this period where the figure dominates, indeed presides, over her pictorial space.

Later works from the 1930s, by Americans John Marin and Stuart Davis, represent more travel to Paris and strong influences of both its architectural form and vernacular street scenes. Upon his 1912 return from France, Marin would begin a series of New York watercolors focusing on the Brooklyn Bridge, lower Manhattan, and views down Fifth Avenue. *Looking Toward the Brooklyn Bridge*, 1937, is a reprise of Marin's meditations on this theme. Here, he looks simultaneously down into the city streets and at the bridge in the distance, breaking the illusion of spatial recession as form bursts forward in colored patches.

Stuart Davis, not a Stieglitz circle protégé like Marin or Hartley, traveled to Paris in 1928–29 and there met Fernand Léger, Cubist artist of mechanical forms and himself an admirer of New York's urbanscape (from a 1925 trip). The Rose owns Léger's *La femme bleue*, 1929, a nude who confidently ambles forward from her backdrop of blue-black, an enlargement of the shape of her wavy hair. Both Davis and Léger shared a love of ordinary objects, and a jazz-era microphone, with serpentine cord, floats improbably in the bright space below Léger's

eerily smiling woman. The Davis painting, *Still Life: Radio Tube,* 1931, centers on mass communication and the very source of music, which Davis savored as he painted. *Radio Tube* presents the interior workings—colorful cylinders, mesh, and wiring—of the amazing new machine as an upright anthropomorphic form. Davis's early 1930s focus on the packaging and unpacking of daily objects anticipates Pop Art imagery, an affinity which Roy Lichtenstein emphasized, reaching back to comprehend the energies of Léger.

Paris, Berlin, and finally New York are the centers that comprise the Rose Art Museum's modernist map. The superb examples of innovative work donated to the Rose Art Museum since its earliest years create a history of European artists uprooted by war and revolution, and also show the corresponding sense of American parochialism searching for innovative expression. Later, many of the same exiles and émigrés (Chagall, Léger, Lipchitz,

among many others) would seek sanctuary in New York. The Rose Art Museum collection of early twentieth-century artists charts an impressive path through the disrupted geography of the modernist experience and the persistent desire to tear down the old in order to build anew.

NANCY SCOTT, ASSOCIATE PROFESSOR OF Fine Arts, is an art historian who has taught classes on aspects of early twentieth-century European and American modernism for many years at Brandeis, a particular favorite of hers being "Paris/New York: The Revolutions of Modernism." She has written on Giorgio de Chirico, Arthur Dove, and Georgia O'Keeffe as well as on nineteenth-century sculpture and academic art. She is now writing on J. M. W. Turner, the influence of John Ruskin on American artists and art patrons, and the reception history of *The Slave Ship* in New York and Boston.

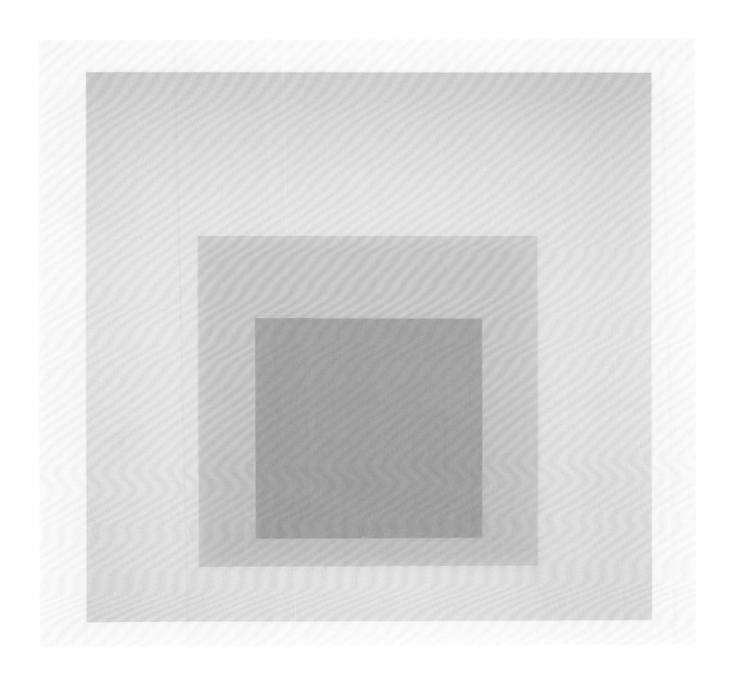

JOSEF ALBERS, American, born
in Germany, 1888–1976
Arctic Bloom, 1965
Silkscreen, 11 x 11 inches
Charna Stone Cowan Student Loan
Collection, 1971

Josef Albers found the perfect vehicle for his lifelong examination of color interaction in his prolific series *Homage to the Square.* Begun in 1950, during Albers's highly respected teaching career, the *Homage* paintings and prints use a precise arrangement of squares to examine color's perceptual effects in a neutral armature. *Arctic Bloom* is from a portfolio of ten screen prints titled *Soft Edge–Hard Edge.* "Hard edge" refers to the sharp boundaries at which two distinct colors meet, while "soft edge" describes the apparent dissolution of those boundaries resulting from visual perception. These prints demonstrate Albers's famous maxim, "In visual perception a color is almost never seen as it really is—as it physically is." The year this print series was created, 1965, was also the year in which Albers received long overdue recognition for his painting by his inclusion in the perceptual and kinetic art exhibition "The Responsive Eye," at the Museum of Modern Art, New York.

NEIL K. RECTOR

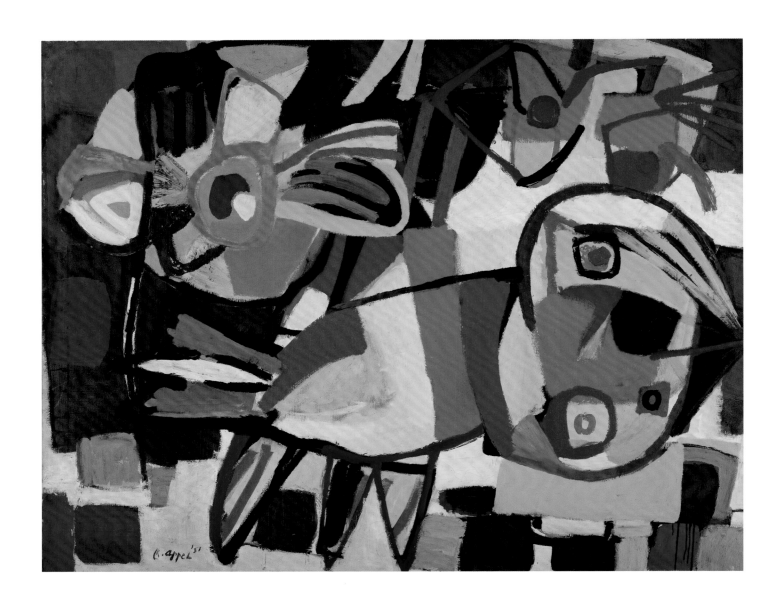

KAREL APPEL, Dutch, 1921–2006
Untitled, 1951
Oil on canvas, 44 ⅞ x 57 ½ inches
Gift of Mr. and Mrs. Samuel M. Kootz,
New York, 1963

As did many European artists who came of age after World War II, Karel Appel rebelled against a Modernism that represented the European culture which had nearly destroyed the Continent. He and his colleagues turned to the art of children, the naïve, and "the insane," seeking a raw, primal expression of humanity. In 1948, he and other antimodern artists Pierre Alechinsky, Corneille, Asger Jorn, and Lucebert, along with the writer Christian Dotremont, formed CoBrA (an acronym for Copenhagen, Brussels, and Amsterdam, the cities from which they came), a group that expressed the psychological impact of the war on Europeans. Appel said, "The CoBrA group started new, and first of all we threw away all these things we had known and started afresh like a child—fresh and new. . . . But, for me, the material is the paint itself. The paint expresses itself. In the mass of paint, I find my imagination and go on to paint it." In this early painting, one can see the rough slashes of bright pigment that suggest grotesque animals and figures that are staples of Appel's artistic vocabulary.

JOSEPH D. KETNER

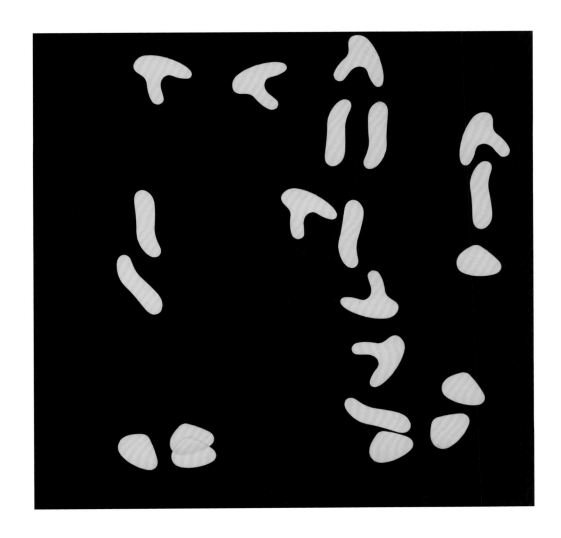

JEAN ARP, French, born in Germany, 1886–1966
Untitled from "Collection 64" for edition MAT, 1964
Plywood, white felt, Plexiglas, 64/100, 15 x 15 inches
Gift of Mr. and Mrs. Herbert C. Lee, Belmont, Massachusetts, 1976

Jean (Hans) Arp was a pioneer of abstract art. While part of the Dada, Surrealism, and Constructivism movements, Arp was primarily concerned with his own investigations of biomorphism and ways of incorporating nature into art—specifically through the development of universal elements and shapes that he repeated throughout his career. One of those elements was a white, exquisitely organic, seemingly primordial ovoid form that evoked life on both a cellular and cosmic level. This ovoid shape, derived from the human navel and used starting in the 1920s, appeared mainly in reliefs called *Constellations*, and reappeared in later works such as the collage *Untitled from "Collection 64" for edition MAT*, in which white felt cutouts are arranged on a black plywood surface. The tactility of this collage, the concern for simplicity and the organic, and the repetition of a preconceived form connect it with Arp's sculptural work, which was a major component of the artist's oeuvre.

ADELINA JEDRZEJCZAK

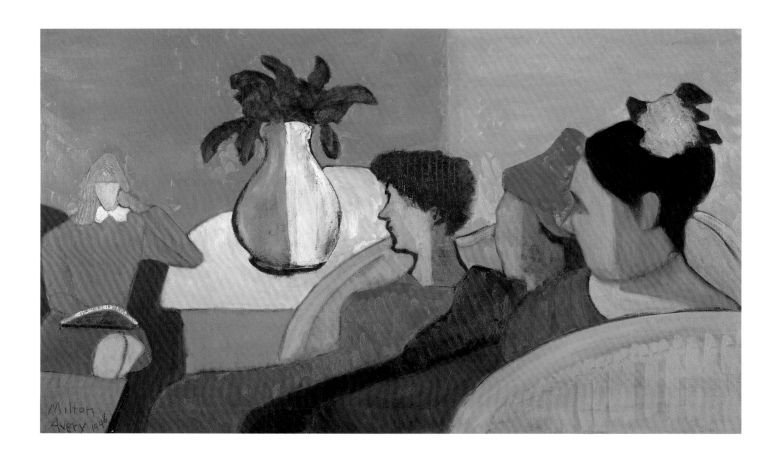

MILTON AVERY, American, 1893–1965
Party at Sylvia's, 1948
Oil on muslin canvas, 25 x 42 inches
Gift of Mrs. Sylvia Carewe, New York

Manhattan-based artist Milton Avery typically employed a bright palette and painted subjects drawn from his surroundings such as landscapes or figures. A close friend of other artists of the period such as Marsden Hartley, Mark Rothko, and Adolph Gottlieb, Avery was a significant figure in the mid twentieth-century New York art scene. Sylvia Carewe (1906–1981), depicted here and the donor of the painting, was another contemporary artist with whom Avery was in contact. Like Avery, Carewe painted semiabstract New York cityscapes and genre scenes, exhibiting both in Europe and New York. Although the title of the work reveals that Carewe was one of the sitters, the facelessness of the figures creates an absence of certain identity and a sense of universality, thus allowing the viewer to project his own features and thoughts onto the canvas.

KAREN CHERNICK '06

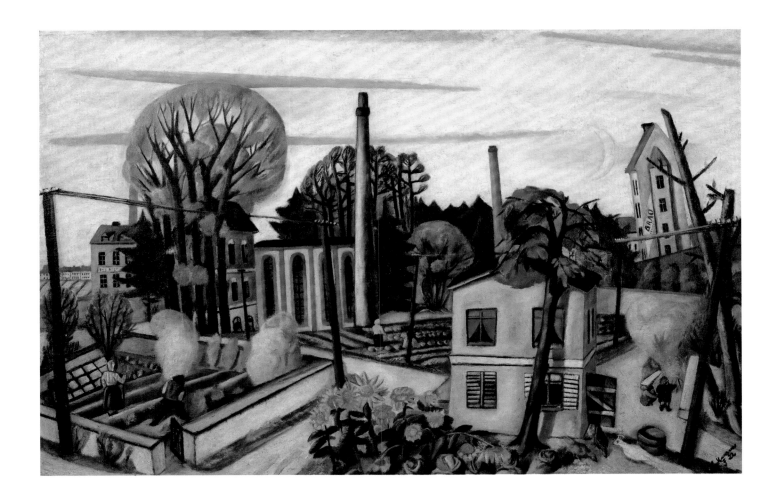

MAX BECKMANN, German, 1884–1950

Landscape near Frankfurt
(The Factory), 1922

Oil on canvas, 26 x 39 ¾ inches

Gift of Mr. and Mrs. Harry N. Abrams,
New York, 1960

Max Beckmann painted a small but important group of landscapes of Frankfurt, Germany, after World War I that marks an important transitional moment in his career. During the war, Beckmann served as an orderly on the Belgian front, where he suffered a nervous breakdown in 1915 and was discharged and sent to recover in Frankfurt. Within two years, he was fit to resume painting and created many of the haunting images influenced by his war experiences that expressed "the horrible cries of pain of a deluded people." At the same time, he embarked on a series of sunny views of Frankfurt and its surroundings that are fraught with a dynamic tension created by his rigorous compositions. In *The Factory*, the tightly interlocking houses, personal gardens, and factory leave no room for air, while the barren trees, smokestacks, and telephone poles awkwardly dance across the picture plane. *The Factory* indicates the prevailing influence of the *Neue Sachlichkeit* (New Objectivity) in Germany in the 1920s and prefigures the new formalism in Beckmann's own work that he describes in his 1938 lecture *On My Painting*, "It is not the subject that matters but the translation of the subject into the abstraction of the surface by means of painting."

JOSEPH D. KETNER

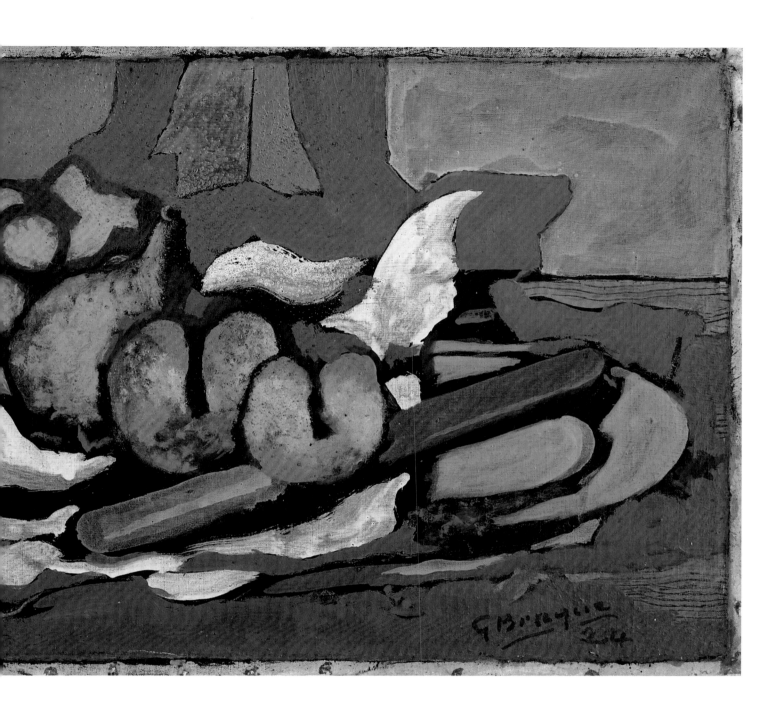

GEORGES BRAQUE, French, 1882–1963

Pêches, Raisin, Poire, Cruche
(Peaches, Grapes, Pear, Jug), 1924
Oil on canvas; 11 x 26 ¼ inches
Bequest of Helen Serger in honor
of Jack I. Poses and Lillian L. Poses, 1991

The fertile collaboration between Georges Braque and Pablo Picasso in the Cubist movement was interrupted by the outbreak of World War I in 1914. Returning to painting after recovering from injuries suffered in battle, Braque built on the innovations he and his Spanish colleague developed in the prewar years. But unlike Picasso, who tried a dizzying variety of styles, Braque tended to narrow and deepen the focus of his vision. *Pêches, Raisin, Poire, Cruche* is a classic example of his newfound style, one that absorbs much of the vocabulary of Cubism but that also looks back to the great still-life tradition of Chardin and Cézanne. Employing a muted palette of grays and ochers—one that recalls the Analytic Cubism of 1909 to 1911—Braque concentrated on simplified, abstracted forms. The most obviously Cubist passage is the jug, where an abrupt diagonal line slashes the porcelain vessel into two improbable zones of light and shade, but such cerebral gamesmanship is less vital to the experience of the work than is its tactile sensuality and quiet, meditative mood—all typical of Braque's mature work.

MILES UNGER '81

DAVID BURLIUK, American,
born in Ukraine, 1882–1967
My Mother, 1909
Oil on burlap, 27 x 20 ⅛ inches
Bequest of Louis Schapiro,
Boston, 1950

David Burliuk, known as "the father of Russian Futurism" for his contribution to Russian literary Futurism as a writer and polemicist, was also an accomplished painter and poet. After studying painting in Munich (where he met Wassily Kandinsky) and Paris, Burliuk returned to Russia and, from 1908, promoted emerging modern Russian art by organizing exhibitions and writing articles extolling Western modernist ideals.

My Mother, painted in 1909, depicts the artist's mother, Ludmila Josifovna née Mikhnevich, surrounded by rural scenes of fields, horses, cows, and farmers, reminiscent in style of both the Blaue Reiter group, of which Burliuk was part, and of his contemporary Marc Chagall. Other paintings from 1908 and 1909 also utilize domestic themes, such as houses and horses, but this one specifically employs the dreamlike quality of depicting those symbols scattered around the portrait, irrespective of orientation. One of the earliest works acquired by the museum, *My Mother* is a personal expression of family and the artist's Ukrainian homeland, which he subsequently left for Japan before immigrating to the United States.

ADELINA JEDRZEJCZAK

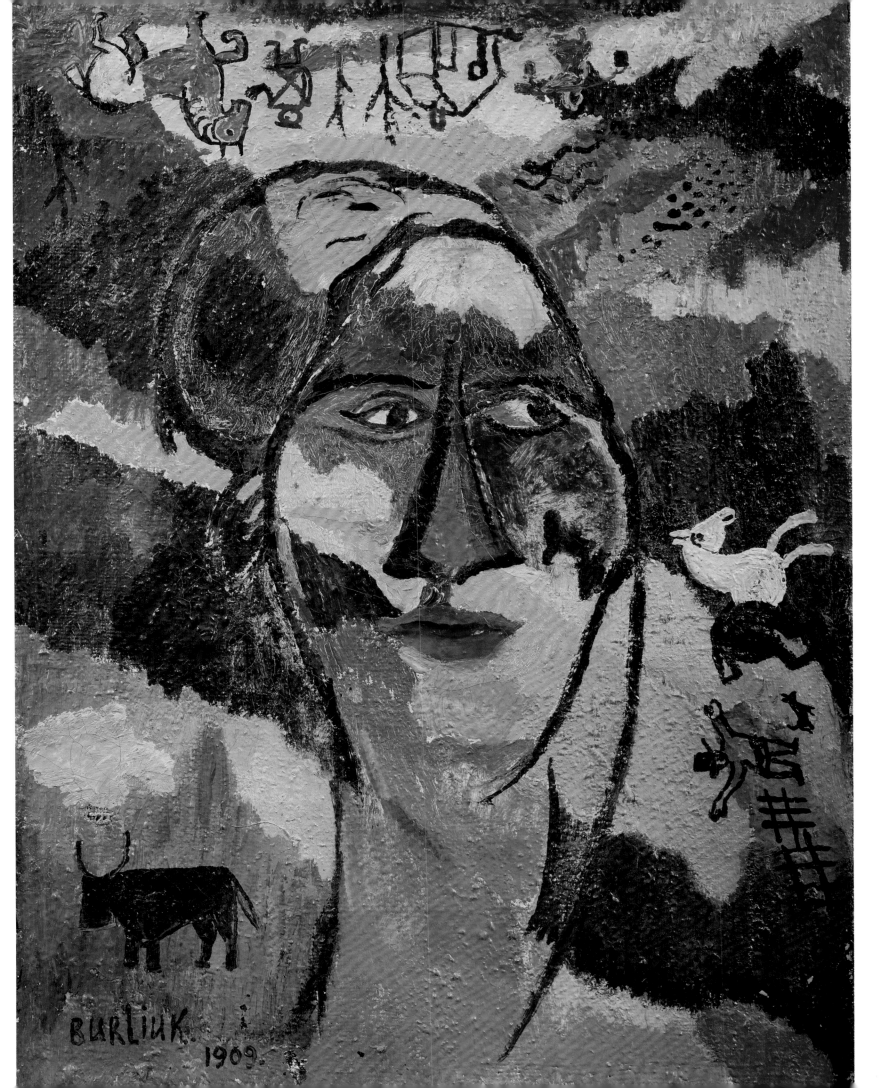

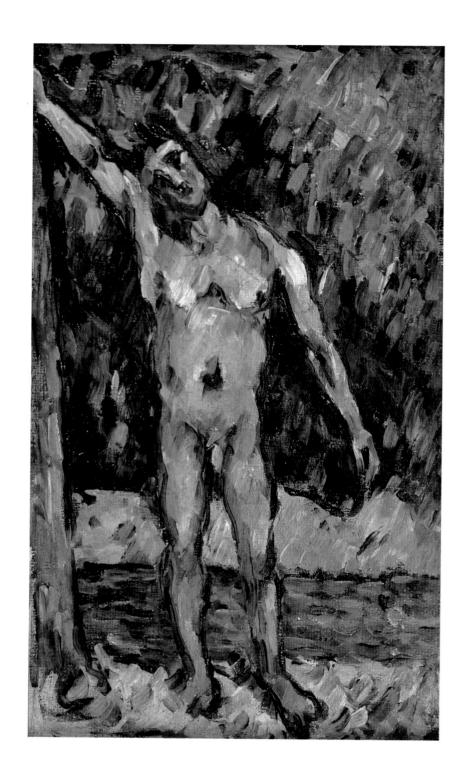

PAUL CÉZANNE, French, 1839–1906

Nu de Jeune Baigneur (Young Nude Bather), c. 1875–77

Oil on canvas; 9 ½ x 5 ½ inches

Bequest of Helen Serger in honor of Jack I. Poses and Lillian L. Poses, 1991

The nude figure is recurrent throughout the career of Paul Cézanne—from his earliest work, with its violent subject matter, to small oils of individual figures, such as this painting at the Rose, to the *Grandes Baigneuses* (82 x 98 inches) painted in the last seven years of his life. *Young Nude Bather* is related both to the larger-scale *Bather* at the Museum of Modern Art, New York, and to the *Bather with Outstretched Arm*, which art historian Theodore Reff discusses in psychoanalytic terms, with its possible allusion to Cézanne's own "solitary condition." Similar figures appear in Cézanne's sketchbooks and in several of his bather compositions, which are among the more puzzling and contentious of his works, unlike the magisterial landscapes and spatially complex still lifes that so influenced the Cubists and others. Cézanne struggles in this painting to reconcile the nude with the landscape. Set in a lush wood, and painted with the large, evident brushstrokes typical of his work of the mid 1870s, the pose of this man with his outstretched arm is troubled and troubling.

JUDITH WECHSLER GLATZER

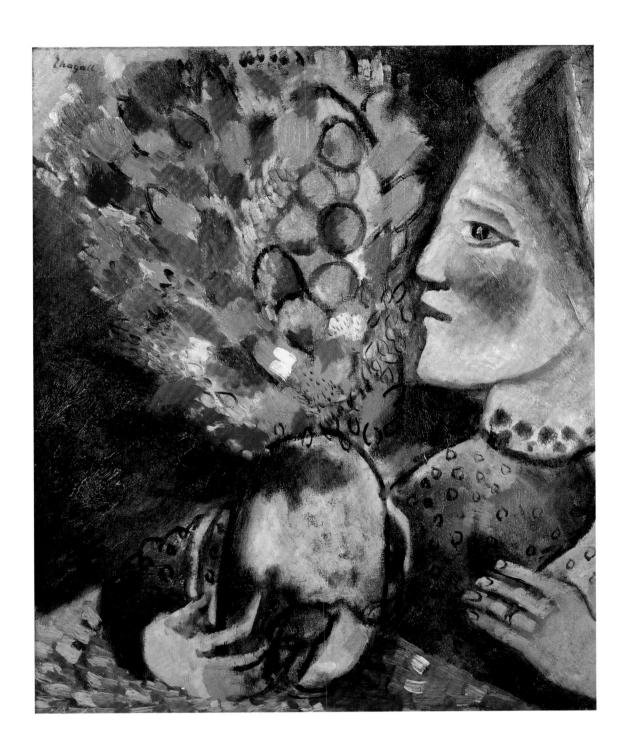

MARC CHAGALL, French, born in
Russia, 1887–1985
Femme au Bouquet de Fleurs
(Woman with Flowers), 1910
Oil on canvas, 25 ½ x 21 ¼ inches
Bequest of Helen Serger in honor of
Jack I. Poses and Lillian L. Poses, 1991

Marc Chagall was born in Belarus and studied art in St. Petersburg from 1907 to 1910 before moving to Paris. His early paintings in Paris used color to convey emotion rather than to create a sense of materiality in his objects. This painting shows a similar subject in Chagall's work at the time: a woman in profile next to a bouquet of flowers. In this image, the woman is holding a vase of vibrant flowers to her face, seeming to smell their aroma. Her eyes look up, as if there is a greater experience at work than the simple act of smelling the flowers. The flowers are not a distinguishable species, but rather an experiment in dynamic strokes of color. This painting was featured in the Rose Art Museum exhibition "Selections from the Permanent Collection" (1991–92) and was displayed in the Brandeis University Admissions Office from 1994 to 1998.

SARA TESS NEUMANN '07

STUART DAVIS, American, 1892–1964
Still Life: Radio Tube, 1931
Oil on canvas, 50 x 32 ⅛ inches
Bequest of Louis Schapiro, Boston, 1955

"Some of the things that have made me want to paint," Stuart Davis declared, "are . . . movies and radio; Earl Hines hot piano and Negro jazz music."[2] The artist often listened to jazz while painting, and even noted specific radio programs in his diary. The music and machines that energized American contemporary life inspired *Radio Tube*; in fact, it debuted in an exhibition titled "The American Scene" at The Downtown Gallery, New York, in 1932. Davis used the language of European Synthetic Cubism, with its flat shapes and crosshatching, to celebrate American technology. He isolates and makes heroic the small vacuum tube that was critical to the expansion of radio broadcasting and high fidelity sound reproduction. Undulating horizontal lines evoke the transmission of radio waves. In 1940, he re-created this composition in gouache (Arizona State University Art Collections, Tempe), retaining the shapes but choosing different colors and patterns. Like a jazz musician, Davis frequently composed variations on a theme.

ROBIN JAFFEE FRANK '77

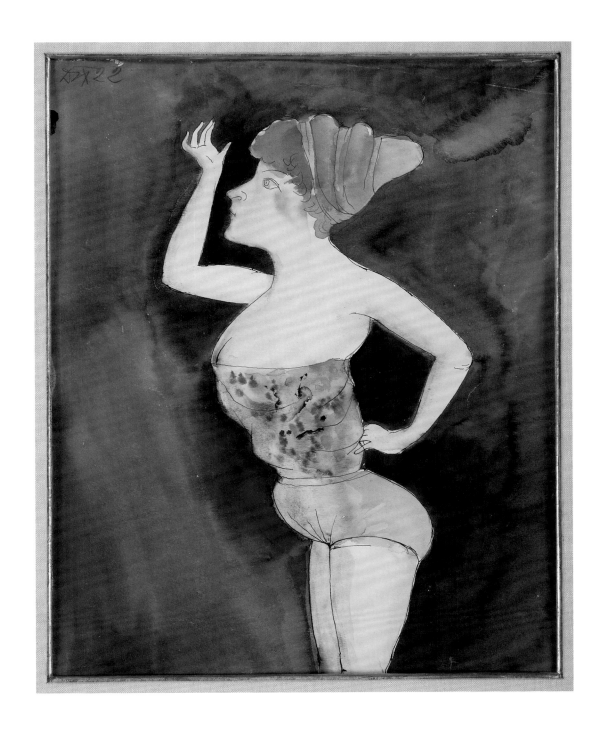

OTTO DIX, German, 1891–1969
La Soubrette, 1922
Ink and watercolor, 17 ⅝ x 14 inches
Gift of Samuel A. Berger, New York,
1958

Exhibited multiple times on the Brandeis campus since it was accessioned by the Rose, *La Soubrette* is an example of the working-class nudes that German painter Otto Dix often painted in the early 1920s. Having enrolled in the Dresden Akademie in 1920, following his voluntary military service as a machine gunner in World War I, Dix drew nudes in a realistic style in addition to depictions of the war and portraits. In *La Soubrette*, a portrayal of a lady's maid, realism borders on caricature. The maid is rendered with fine lines and a realistic color palette; however, her proportions are slightly exaggerated. The woman's thin arms and small fingers accentuate her robust torso, and her cinched waist highlights her round buttocks. Her disproportionate silhouette is accentuated by the dark blue background, which is darkest around her figure.

KAREN CHERNICK '06

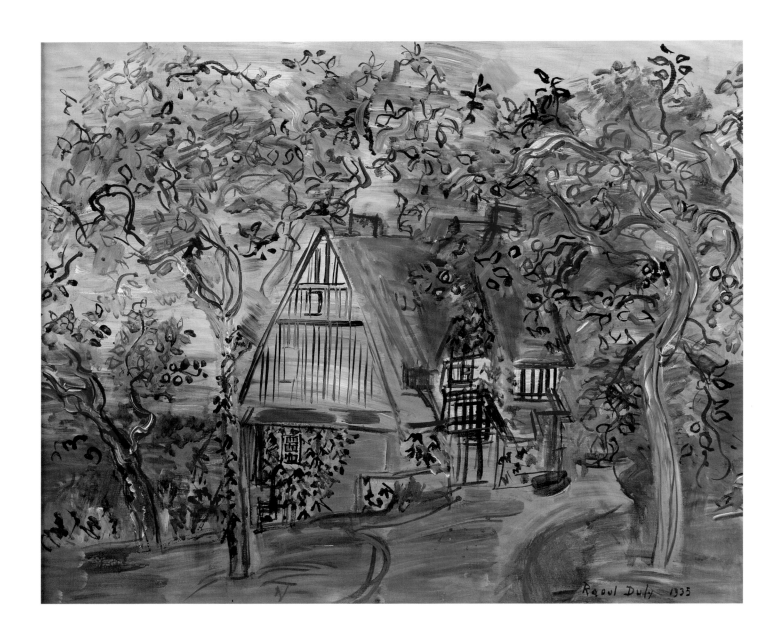

RAOUL DUFY, French, 1877–1953
Maison du Vallon, 1925
Oil on canvas, 20 ½ x 20 inches
Gift of Robert Edelmann, Chicago,
Illinois, 1964

French Fauvist painter and decorative artist Raoul Dufy traveled extensively during the 1920s, including multiple trips to southern France. In this depiction of a home in Vallon, a town in the south of France, decorative and playful natural elements are juxtaposed with the straight, rigid lines of a man-made home. Although the brown hue of the home is used in the coloring of some of the wild trees and, conversely, ivy grows on certain exterior walls of the house, the separation between the two realms is distinct. The house is constructed out of stiff lines and geometric shapes (much like the forms that Dufy admired in the work of Cézanne), yet is haloed by a realm of whimsical, multicolored organic contours.

KAREN CHERNICK '06

FRITZ GLARNER, American, born in Switzerland, 1899–1972
Relational Painting No. 87, 1957
Oil on canvas, 50 x 46 inches
Gift of Mr. and Mrs. Max Abramowitz, New York, 1965

Fritz Glarner chose the term "relational painting" in 1946 as an English equivalent of *peinture relative*, and used it to refer to all of his works since. His relational paintings possess highly organized surface structures reminiscent of works by Piet Mondrian—Glarner's colleague from the American Abstract Artists group in the late 1930s and 1940s—and derive from the Constructivist tradition. Relational paintings, of which *Relational Painting No. 87* is an excellent example, are based on an irregular grid covered by numerous rectangles and wedges of color with a 15-degree slant of lines, creating a dynamic and rhythmic optical sensation of pulsating color and movement. Glarner referred to this optical effect as "pumping planes." The graphic and architectural aesthetic of this work was appreciated by Max Abramowitz, donor of this painting and architect of the original Rose Art Museum building.

ADELINA JEDRZEJCZAK

JOHN D. GRAHAM, American, born in Russia, 1886–1961
Painting, 1941
Oil on canvas, 30 x 24 inches
Bequest of Louis Schapiro, Boston, 1950s

John Graham was instrumental in bringing European modernism to America through his understanding of Cubism and Surrealism, his writing, and his mentorship of younger Abstract Expressionist artists. While Graham explored a variety of themes and styles, his own painting functioned on the verge between abstraction and representation. *Painting*, from 1941, unifies abstract and representational elements, juxtaposing Fauvist vibrancy of color—reminiscent of the portrait *Woman with Hat* by Henri Matisse (1904–5)—against decorative qualities of the background surrounding the figure, while employing a cryptic iconography that resonates through the artist's work. Graham's vast knowledge of art history and interest in Renaissance forms and primitive art are visible in this composition. The unsettling qualities of this portrait represent a multifaceted artist deeply fascinated by the occult and the belief that art should embody the mystical while challenging the viewer. *Painting* marks the beginning of Graham's transition away from modernist abstraction toward academically representational works, which led to his larger reexamination of figurative painting, especially portraiture, starting in 1942.

ADELINA JEDRZEJCZAK

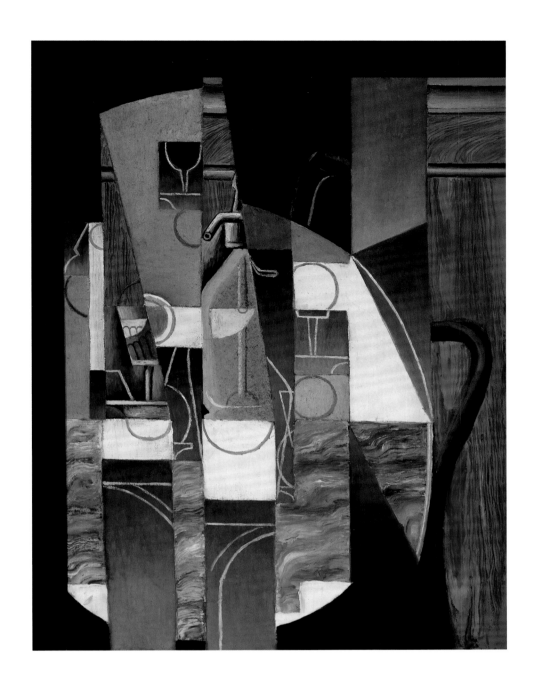

JUAN GRIS, Spanish, 1887–1927
The Siphon, 1913
Oil on canvas, 31 ⅝ x 23 ⅝ inches
Gift of Edgar Kaufmann, Jr., 1959

Juan Gris, along with his fellow countryman Pablo Picasso and the French artist Georges Braque, was one of the pioneers of the early twentieth-century movement known as Cubism, in which visual reality was subject to increasingly abstract, geometric analysis. *The Siphon* is a fine example of so-called Synthetic Cubism, in which those visible forms that had been dissolved almost to the point of indecipherability were reconstituted, but in ways that allowed for playful distortions. In *The Siphon*, the glass vessel and the table on which it sits are immediately recognizable, but they appear to have been shattered and rearranged in arbitrary ways. The wood grain of the table and transparency of the glass are rendered with complete fidelity, but as discrete characteristics, unmoored to the forms to which they belong; line and contour are also liberated from their normal context. It is as if the various components that normally make up a drawing or painting—line, color, texture, etc.—were treated as free-floating elements, able to assert their own independent existence. In some sense this allows for a more complete transcription of reality than is possible in more traditional approaches. Every aspect of the still-life scene is vividly present, even if the viewer must put in a little work to figure out the puzzle.

MILES UNGER '81

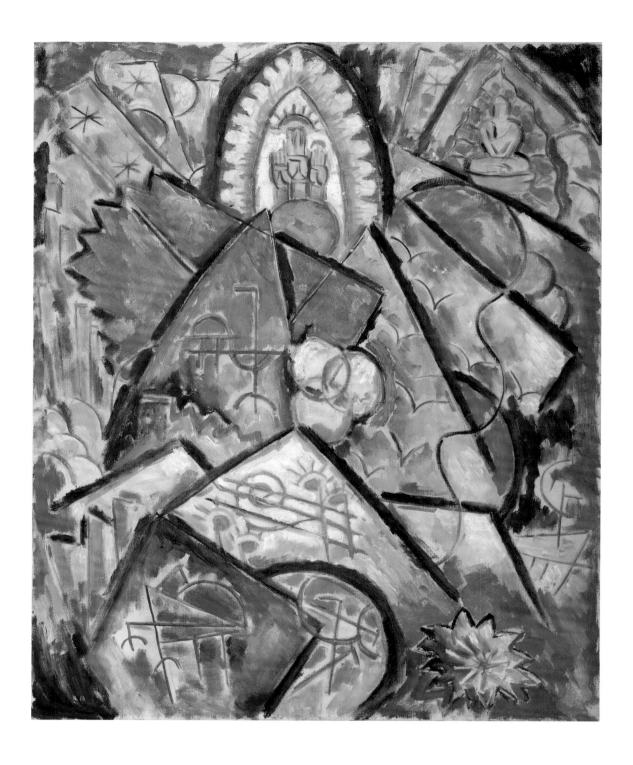

MARSDEN HARTLEY, American, 1877–1943
Musical Theme (Oriental Symphony), 1912–13
Oil on canvas, 39 ³/₈ x 31 ¹/₄ inches
Gift of Samuel Lustgarten, Sherman Oaks, California, 1952

Born in Maine and promoted by legendary New York dealer Alfred Stieglitz, Hartley led a peripatetic life. He visualized his spiritual yearnings and the sensations produced by music in a series of abstractions begun in Paris in 1912. This series was influenced by the writings of artist Wassily Kandinsky, mystic Jakob Böhme, philosopher Henri Bergson, and the American transcendentalists. Hartley described his compositions as "a kind of cosmic dictation . . . a harmony of shapes and colors—with a sense also of the color of sound as I get these feelings out of music."[3] In *Musical Theme*, musical staffs, clefs, and notes intermingle with eclectic religious signs: eight-pointed stars representing cosmic transcendence in multiple cultures; Egyptian hieroglyphics; a meditating Buddha; three hands, an Indian gesture meaning "have no fear" set within a mandorla shape that traditionally surrounded the body of Christ; and three interlocking spheres symbolizing the Trinity. Hartley's luminous washes of repeating bright colors play across the canvas like musical chords, bathing the painting in a mystical glow.

ROBIN JAFFEE FRANK '77

WASSILY KANDINSKY, Russian,
1866–1944
Kleine Welten (Small Worlds),
Plate IV, 1922
Lithograph, sheet, 13 ¼ x 11 ⅜ inches
composition 10 ½ x 10 ⅛ inches
Gift of Mr. and Mrs. Abraham Kamberg,
Longmeadow, Massachusetts, 1977

Kandinsky's *Small Worlds*, a series of works created in 1922 (the year he joined the Bauhaus) represents the mature Kandinsky who had begun to turn toward abstraction in 1908. The *Small Worlds* prints are indeed small worlds: suggestions of ships, waves, islands; mysterious markings of sea and land are rendered with the swiftness of single strokes or the definitive lines of geometric forms. This type of reduction lay at the heart of Kandinsky's impulse toward abstraction: his desire to express an emotional connectivity to the world of spirit and imagination as opposed to rendering precise accounts of the world as we see it. Visible here, too, is his subtle sense of color (the green-grays, suggestive of the sea and muted yellows and stark black). His use of geometric forms, reminiscent of Kazimir Malevich and Piet Mondrian, two other pioneers of abstraction, offers a grounding to the "world" which otherwise is intentionally tilted off balance as if moving through the vast void of space.

MICHAEL RUSH

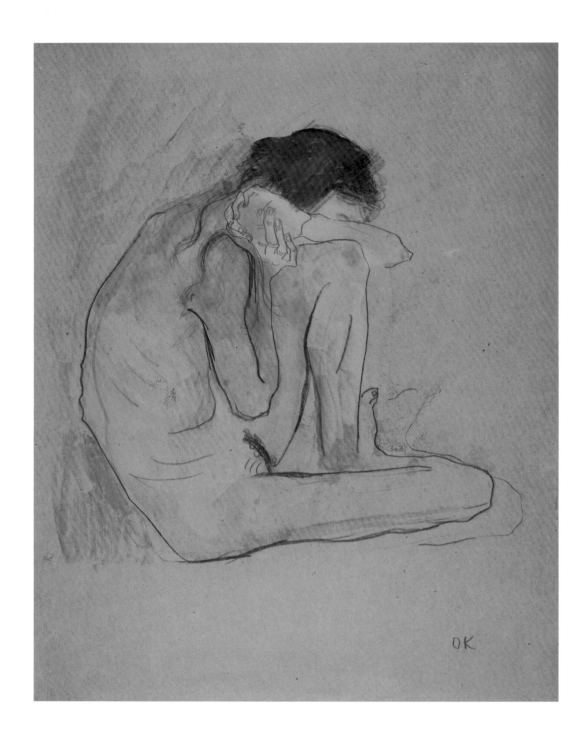

OSKAR KOKOSCHKA, Austrian,
1886–1980
Untitled, n.d.
Pencil and sanguine drawing, 15 x 11 ½
inches
Gift of Mrs. Teresa Jackson Weill,
New York, 1975

The fine and decorative linear contours in this nude drawing by Austrian painter and writer Oskar Kokoschka reveal his inspiration by Gustav Klimt and Jugendstil artists. These contours are especially evident in the hands, which cover the face and shift the focus to the body of the sitter. Although she is nude and her genitals are exposed, the figure is not sexual and her depiction is somewhat grotesque. Her ribs and spinal vertebrae push through from under her skin, rendering her almost skeletal. Her hands, however, which are beautifully drawn with great detail and highlighted by a white wash that differentiates them from the rest of the nude form, replace the face and body as both the focal point and identifying feature of this nude woman.

KAREN CHERNICK '06

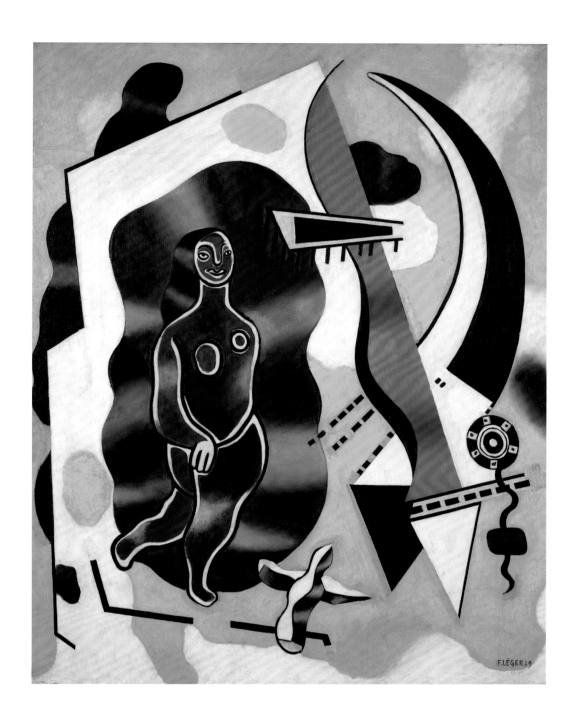

FERNAND LÉGER, French, 1881–1955
La Femme Bleu, 1929
Oil on canvas, 36 ⅛ x 28 ⅞ inches
Gift of Mr. and Mrs. Harry N. Abrams,
c. 1950

Fernand Léger, born in Normandy, was a draftsman in an architect's office before studying fine art in Paris beginning in 1903. He chronicled his life in drawings while serving in World War I. After the war, he focused on mechanical imagery and geometric paintings. In the late 1920s, Léger began focusing less on tight geometric arrangements and began painting objects that floated unrestrained on the picture plane; he stated, "I took an object, I did away with the table, I put the object in the air, without support and without perspective. . . . This is a simple game of rhythm and harmony made up of primary colors and planes, conducting lines, distances and contrasts." In this painting, the objects are free-floating, but the main figure, the blue dancer, has one foot planted as if on solid ground. This painting has been featured in thirteen Rose Art Museum exhibitions, most recently "Selections from the Permanent Collection" (1991–92).[4]

SARA TESS NEUMANN '07

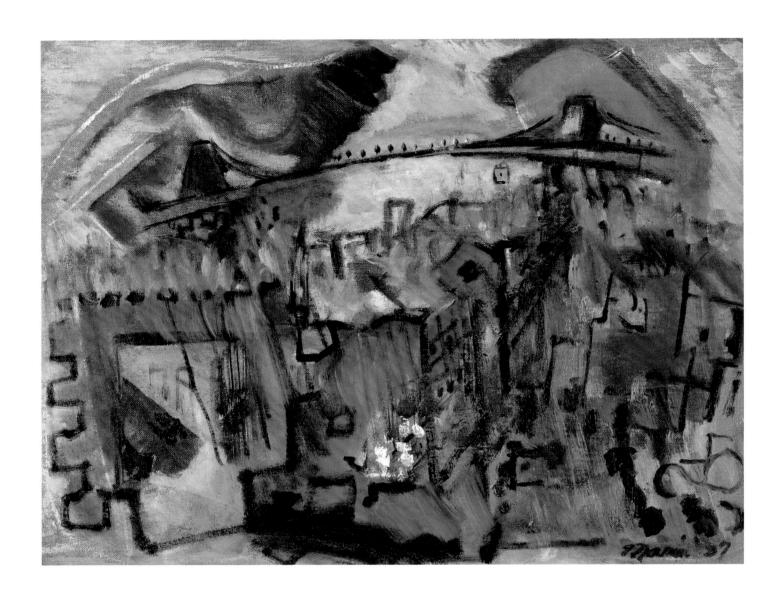

JOHN MARIN, American, 1870–1953
Looking Toward the Brooklyn Bridge, 1937
Oil on canvas board, 14 x 18 inches
Gift of Mrs. Mathilda S. Goldman, 1983

Throughout his career, John Marin devoted himself to decidedly American subjects—from New England seascapes to New York's icons, particularly the Woolworth Building and the Brooklyn Bridge. Such structures symbolized America's industrial power. Contemporary critics drew analogies between the nation's engineering feats and the way that Marin, who was trained as an architect, built his pictures. In his personal variant of French Cubism, forms push against one another to convey the dynamism associated with New York City. His exuberant watercolors brought him fame in the teens and 1920s, but in the 1930s, Marin executed some of his most innovative work in oil, including this painting. From a high vantage point, he created an abstracted view of the crowded buildings in the streets below. The Brooklyn Bridge majestically soars above them in the distance; it emerges from the clouds and spans the scene like a stone-and-steel rainbow.

ROBIN JAFFEE FRANK '77

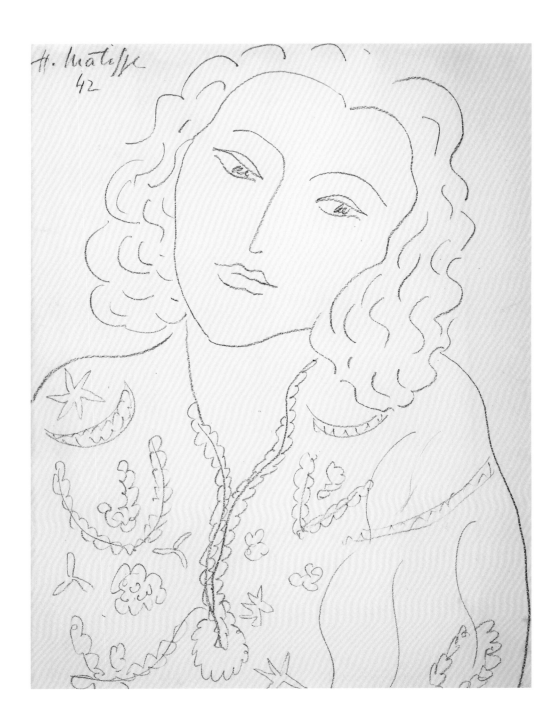

HENRI MATISSE, French, 1869–1954
Untitled, 1942
Black pencil, 19 ¼ x 14 ¾ inches
Bequest of Bertha C. Rose Estate, 1980

Henri Matisse made thousands of drawings—they were essential to his way of looking and working. From the late 1920s on, his drawing takes on increasing importance and becomes ever more interesting as he simplifies his medium, giving up tonal gradation and hatching. His unshaded and gestural line is characteristic of the drawings from the 1930s and 1940s, such as this one. As Pierre Schneider notes, Matisse's abbreviated shorthand style is the "briefest indication of the character of a thing." Matisse understands the essence of his subject, most often the female form, in these sensual and intimate drawings. His contour drawing, with its unbroken line, conveys rhythm and momentum. The tilt of the head, downward glance, and set mouth suggest pensiveness; the slightly raised shoulders indicate the figure's own containment. The figure fills the page, focusing our full attention on the remarkable line and its evocation of the woman, which goes beyond description. Matisse notes, "These drawings emerge in one stroke. . . . My line drawing is the purest and most direct translation of my emotion."

JUDITH GLATZER WECHSLER

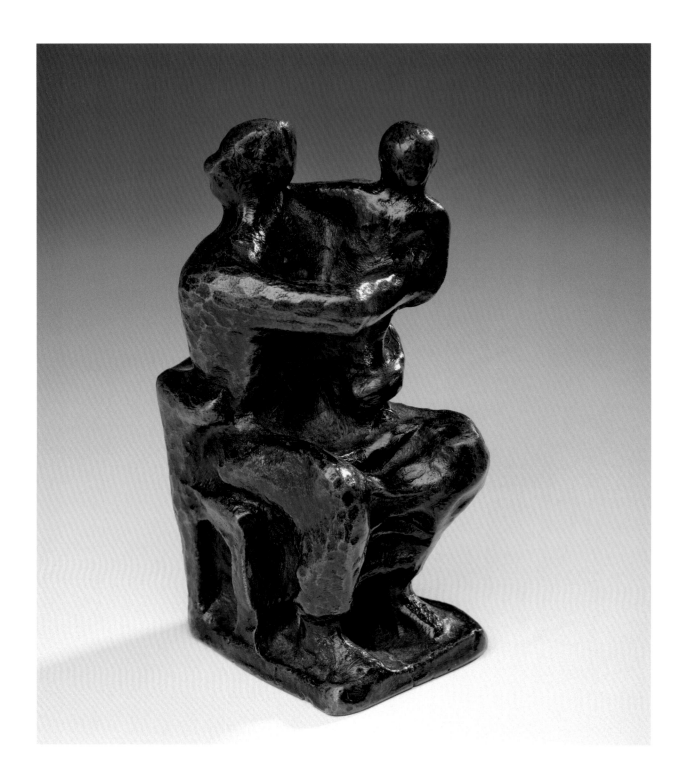

HENRY MOORE, English, 1898–1986
Mother and Child, c. 1945
Bronze, 5 ³⁄₈ inches
Gift of Edward S. Ryan, Southern Pines,
North Carolina, 1983

The subject of a mother and child preoccupied Henry Moore from his earliest days as a sculptor. One in carved stone from 1924–25 has two compressed figures that resemble a Cubist artwork. A 1983 print has a large-bodied woman playing on the floor with her delighted child. The Rose's piece, only several inches tall, is from an edition of seven casts from one of eleven maquettes that the artist made for a commission of a *Madonna and Child* for a church in Northampton, England. Here the mother, large even in this small version, looks lovingly at her son, who appears to be resisting her a bit in a playful way. This small gem is much more personal than the church's final *Madonna and Child*, which is a monumental work with an austere Madonna holding her Son quite formally while he looks out toward the viewer.

MICHAEL RUSH

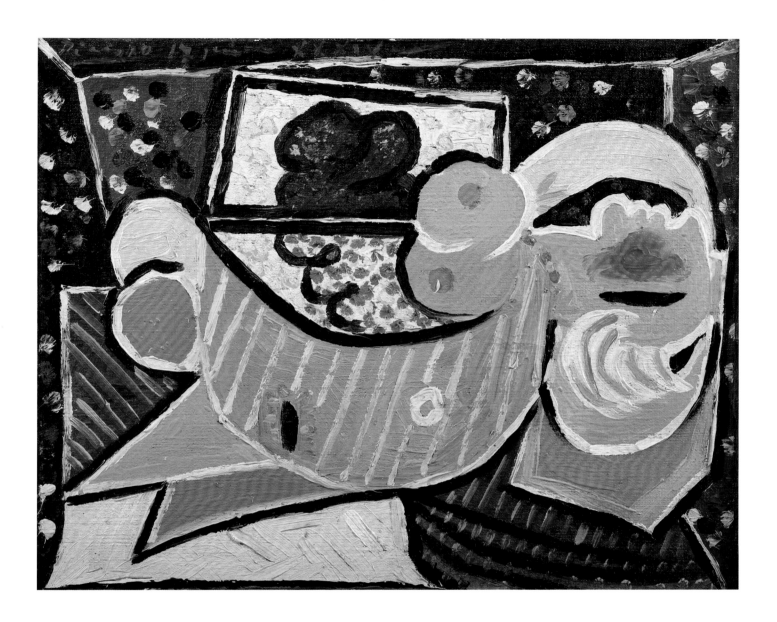

PABLO PICASSO, Spanish, 1881–1973
Reclining Nude, 1934
Oil on canvas, 15 ¼ x 18 ½ inches
Bequest of Helen Serger in honor of
Jack I. Poses and Lillian L. Poses, 1991

In the early 1930s, Pablo Picasso celebrated his then lover's curvaceous and willing body with a colorful mimetic idiom. *Girl Before a Mirror* (1932, Museum of Modern Art, New York) is the best-known example of this period. A *Reclining Nude* from the summer of 1933[5] is imbued with similar delight. Marie-Thérèse Walter is arrayed on a textured surface—perhaps a rattan mat or wood floor—in a languorous repose. The serenity of her face is reflected in the calligraphic lines of her unclothed figure. But in the 1934 version, a grotesque smear of rouge colors her cheek. Her breasts are colored in a pasty green and red, her sex is a coarse black paraphrase. She is exposed despite her cheery blue dress and bright beads. The dark, oppressive interior inhibits any sense of abandon. Her vulnerability is made complete. In 1934, Picasso returned to a Spain turbulent on the eve of civil war. The Rose's *Reclining Nude* surely signals his own, inner anguish following that bittersweet homecoming.

SYDNEY RESENDEZ '88

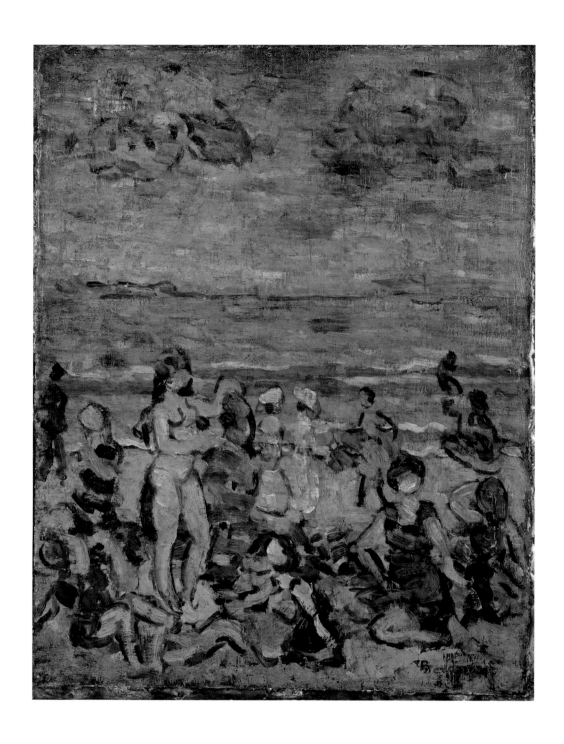

MAURICE BRAZIL PRENDERGAST,
American, born in Canada, 1859–1924
Bathers on the Beach, c. 1916
Oil on canvas, 18 ¾ x 14 inches
Gift of Mrs. Charles Prendergast,
Westport, Connecticut, 1984

Maurice Prendergast and his brother, Charles, were American artists active during the late nineteenth and early twentieth centuries in both New England and Europe. Prendergast was best known as a member of a group of artists called The Eight, who challenged the limited scope of artistic styles accepted by the National Academy of Design. He was influenced by European modernism during his many trips to Paris, Venice, and the Brittany coast, and particularly by the works of Cézanne and Matisse. *Bathers on the Beach* is typical of his many depictions of bathers in the early 1910s, a period during which he frequently painted nudes and the female form. Classical imagery was also characteristically prevalent in Prendergast's nudes of this period, which can be viewed here in the contrapposto of the standing figure on the left and in the reclining poses of the nudes in the foreground.

KAREN CHERNICK '06

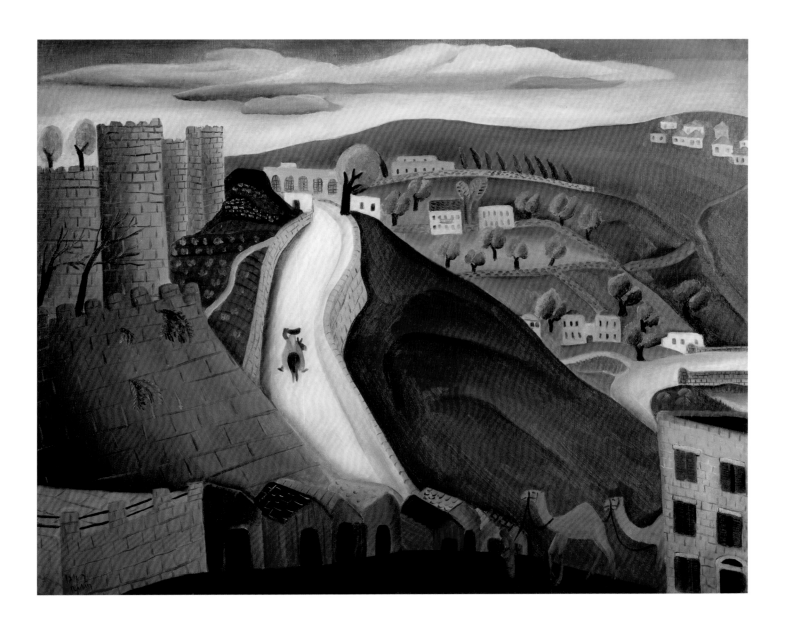

REUVEN RUBIN, Israeli, born
in Romania, 1893–1974
Near Jerusalem, 1924
Oil on canvas, 24 x 29 inches
Collection of Rose Art Museum,
Brandeis University, before 1958

In this depiction of Jerusalem by Romanian-born Israeli artist Reuven Rubin, we are *near* Jerusalem, not *in* Jerusalem, revealing the artist's awe and detachment before the holy city. Rubin, who settled in Israel a year before painting *Near Jerusalem*, would forever visually hover over Jerusalem (contrary to his depictions of other cities) and thus differentiate himself from the native Arabs, who are rooted and tonally camouflaged into the palette of their surroundings. Stylistically, Rubin emphasizes the ancient existence of Jerusalem as juxtaposed with his new experience by employing a unique blend of Italian Renaissance minute details and modern flat planes. Thus, the painting illustrates the ambivalence and duality of Rubin's newfound Israeli existence—he is neither present nor absent, and relies upon foreign methods of seeing to illustrate his own surroundings. It is these twin aspects of his identity, however, that enable him to record the wonder and awe that result from the conclusion of a pilgrimage.

KAREN CHERNICK '06

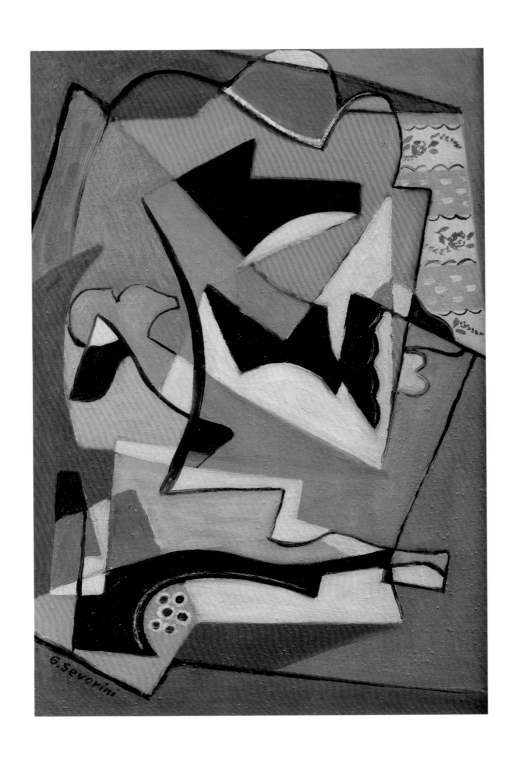

GINO SEVERINI, Italian, 1883–1966
Still Life, 1919
Oil on board, 15 ⅞ x 10 ⅜ inches
Gift of the Glickstein Foundation, 1982

Gino Severini achieved fame as an Italian Futurist. F.T. Marinetti, who founded Futurism in 1909, regarded Italy's devotion to its cultural past as stultifying, urging artists to embrace modernity, especially its characteristics of speed and motion. Propagandizing through multifarious manifestos, Marinetti believed war and violence would encourage the establishment of a new culture. Living in Paris as a Futurist, Severini fashioned a somewhat Cubist-inspired lyrical and decorative Futurist style to describe urban and military themes, eventually creating Divisionist-indebted abstractions exploring movement, color, and light. The horrors of World War I chastened many artists, as Severini rejected anarchic syntax and bellicose subjects in favor of Renaissance-inspired work. *Still Life* reflects another response: Cubism tempered by geometrical theory. At this time, Severini exhibited at the Galerie de l'Effort Moderne, known for display of an orderly, synthetic postwar Cubism which, for some, led to Purism. *Still Life* reads as a buoyant and colorful abstract arrangement of flat forms defined by curved and straight contours.

GERALD SILK '70

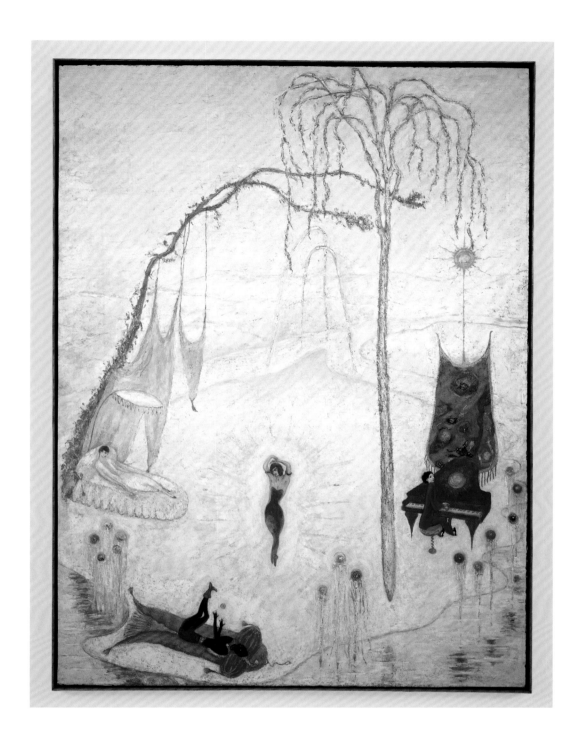

FLORINE STETTHEIMER, American,
1871–1944
Music, c. 1920
Oil on canvas, 69 x 50 ½ x 1 ¾ inches
Gift of Joseph Solomon, New York, 1956

Florine Stettheimer lived with her wealthy mother and sisters in New York City, where they reigned over a salon that attracted avant-garde artists, writers, musicians, and theater personalities. Family and friends also inhabit her paintings, which resemble both dreamscapes and stage sets. Drawn with a sinuous line, *Music* stars dancers Vaslav Nijinsky and Adolph Bolm in an imaginary performance attended by the dreaming artist. In the central spotlight, a weightless, androgynous Nijinsky in a strapless leotard dances *en pointe*, accompanied by a pianist, at right, seated below a decorative cloth that hangs from a starburst. In the foreground Bolm, dressed as the Moor from Igor Stravinsky's *Petrouchka*, lies on his back on a carpet and juggles. The artist reclines on a diaphanous canopied bed. Ethereal trees float in a snow-covered landscape or backdrop. Brightly colored costumes and props— including clusters of balls that hover over a meandering river—punctuate the whiteness. Stettheimer wove elements of modern and folk art, Freudian psychology, and theater design into an inventive, idiosyncratic style.

ROBIN JAFFEE FRANK '77

MAX WEBER, American, born in
Russia, 1881–1961
Seated Woman, 1917
Oil on canvas, 40 ⅛ x 24 ¼ inches
Gift of Mrs. Max Weber and her children,
Maynard and Joy, Great Neck, New York,
in memory of Max Weber, 1966

In 1909, Max Weber returned to New York from Paris carrying a small collection of contemporary artworks and two African statuettes and, with that, bringing the first glimpse of European avant-garde art to America. Weber lived in Paris for four years, during which he became familiar with art movements such as Fauvism and Cubism and the work of prominent European artists such as Cézanne, Matisse, and Picasso. The significant influence of Cubism and Picasso is clearly visible in *Seated Woman*, a portrait composed of flat, irregular planes typical of Cubism, and a masklike treatment of the face clearly influenced by African art. The portrait also evokes Picasso's first Cubist sculpture, *Head of a Woman (Fernande)*, 1909, which Weber saw in photographs published by his close friend Alfred Stieglitz in 1912. Weber received an honorary degree from Brandeis University in 1957, and several of his paintings are included in the university's art collection.

ADELINA JEDRZEJCZAK

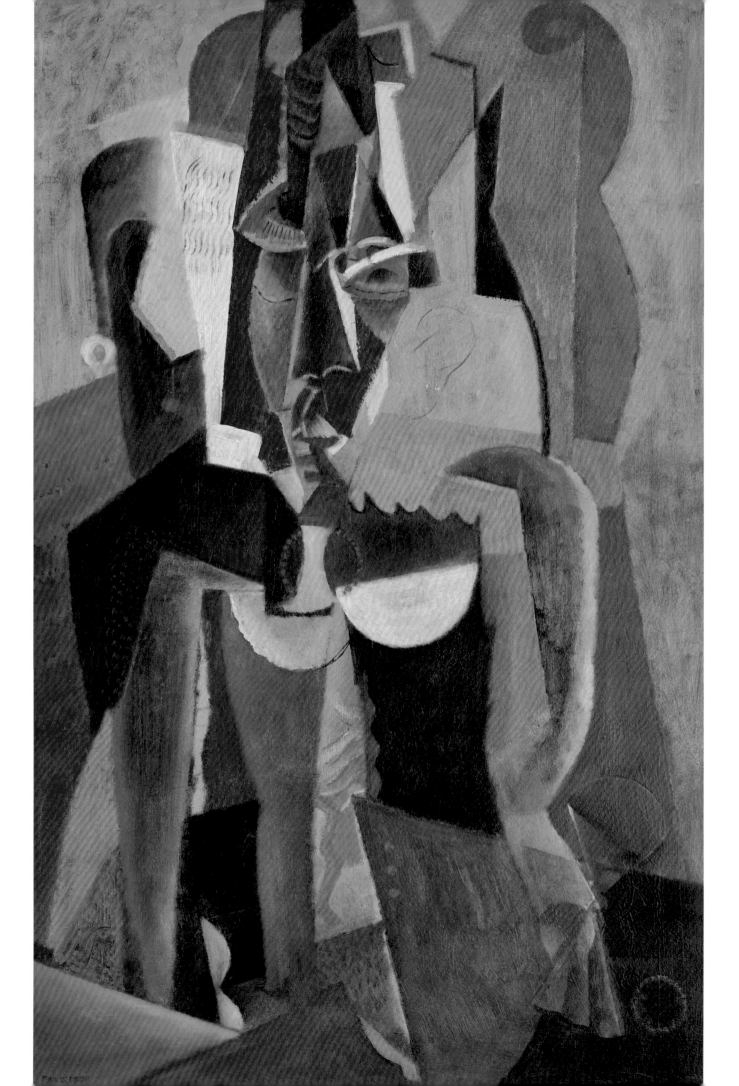

SOCIAL REALISM AND SURREALISM | *By Ilene Susan Fort*

Art is a social creation.

The interwar era witnessed the birth of Social Realism and Surrealism. Different aesthetics, they shared common attitudes that definitely marked each as modern. Both responded to the issues of their day, believing in the revolutionary character of art to transform. The movements eventually would be overshadowed by Abstract Expressionism, but each prospered for several decades and contributed to post-1945 developments.

The Great War—the first modern debacle on such a devastating scale—left many skeptic concerning traditional values. Such broad concepts as patriotism, honor, and conformity seemed to have spiraled the nations of the West into the insanity of a worldwide holocaust. Solutions were sought throughout Europe and North America to prevent this from ever occurring again, and artists searched beyond the confines of their individual canvases for answers, rejecting the art for art's sake philosophy of the late nineteenth century. The German Bauhaus and Russian Constructivists sought to create a utopian paradise for the masses in a visually pure formal world. Others, such as some American Realists, understood the need to change their own existence but used their art not to redesign their physical environment but to indicate aspects that needed correction. The Surrealists, on the contrary, proposed what initially seemed the most escapist avenue, preferring to find enlightenment in the world of the subconscious.

Whatever their initial course, by the 1930s most artists had come to realize the important relationship between art and society. In 1936, the young art historian Meyer Schapiro, speaking at the First American Artists' Congress held in New York City, summarized this attitude: "If we examine attentively the objects a modern artist paints and the psychological attitudes evident in the choice of these objects and their forms, we will see how intimately his art is tied to the life of modern society."[2] The decade before, French poet André Breton had explained the Surrealist frame of mind was "specifically modern" because it "plunges its roots into life . . . *the life of this period*."[3] For many, modern art signified radical change. The Mexican muralist Diego Rivera insisted that "the man who is truly a thinker, or the painter who is truly an artist, cannot, at a given historical moment, take any but a position in accordance with the revolutionary development of his own time," while Breton admitted, "Surrealism was not afraid to make for itself a tenet of total revolt . . . of sabotage . . . and . . . it still expects nothing save from violence."[4] Both men, under the influence of Marxism as espoused by Leon Trotsky, would go

on to sign the *Manifesto: Towards a Free Revolutionary Art* in 1938.

Social Realists and Surrealists agreed about the relevancy of art. The two groups might dispute the type or degree of political activism, but both considered the transformative power of art essential. In essence, both aesthetics became largely antiestablishment. They did so in part through the aesthetic of Realism. The portrayal of ordinary, everyday life emerged the century before in France with the naturalistic paintings of Gustave Courbet, the scientifically accurate, perceptual interpretations of the Impressionists, and the philosophy of Historic Materialism. By the early twentieth century, a number of Americans in Philadelphia and New York City were encouraged by the earlier French examples to turn to their own environs for subject matter. Many of these artists, who eventually became associated with the Ashcan School—so named because they were willing to depict objects as ordinary as the trashcans along the streets and in the backyards of working-class neighborhoods—began their careers as newspaper illustrators. Hence, early American Realists incorporated a somewhat documentary attitude in their selection of themes and an illustrative character in their formal presentations. Although today's viewer might consider their scenes as attacks or at least commentaries, early American Realists rarely intended to be critical. The extremely popular prints of boxing matches by George Bellows, for example, were devoid of admonishments.

Social commentary in the United States developed slowly after World War I, but that was not the situation in Europe. In postwar Germany, *Neue Sachlichkeit* (New Objectivity) erupted in response to the embarrassment of the country's defeat and the toll of heavy reparations demanded by the Allies. George Grosz attacked life in the Weimar Republic. So it is not surprising that when he immigrated to the United States in 1932, Grosz transferred his condemnations from German to American capitalists. The three lost souls in *Unemployed* have no permanent homes and are forced to live in fleabag hotels and spend their days dejected, aimlessly wandering the streets. So accustomed are they to lining up for jobs that they walk almost blindly, one after the other, toward a barbed wired area of rubble (which perhaps hints at the potential for another war). The insanity of the situation is clearly marked on their faces.

Although Grosz arrived in the United States at the height of the Depression, Americans still lagged behind Europeans in terms of social consciousness. American Scene Painting—the general term applied during the 1930s to realist depictions—included Regionalism, Urban Scene Painting, and Social Realism. Regionalism referred to art created in or about the Midwest and West that was chauvinistic in attitude; its greatest exponent,

Thomas Hart Benton, began promoting cultural nationalism in the 1920s in a series of epic murals. Themes were largely rural and ranged from bucolic farming images and pristine ranches to quaint Main Street small towns. Urban Scene painters and most Social Realists were city-based; although the latter tended to be more concerned with people's living and working circumstances, the ideological differences between the two groups were more a matter of degree. Social Realism was not so much a style—although some degree of Realism was involved—but rather an attitude toward the role of art in life. Whether Marxists, Communists, fellow travelers, or humanitarians, most Social Realists were politically concerned and believed that art should be used to underscore and protest the inequities of life, particularly those relating to the lower working class and the capitalists. Reform was their objective, and in this respect they diverged from earlier Realists. They were often criticized as propagandists; Thomas Craven, the apologist for the Regionalists, blamed Rivera and Communism for encouraging artists to abandon originality for illustrations of economic theory.[5] Social Realism has become "a standard catchall to describe . . . [art] produced between the wars with some kind of leftist content" that tends to criticize the body politic or to propose an ideal community.[6]

During the initial years of the Depression, Philip Evergood, William Gropper, and Reginald Marsh,

leading Social Realists, focused primarily on domestic aspects, thereby demonstrating the attitude of American isolationism. Marsh recorded popular forms of entertainment, movie theaters and dance halls, as in *Tuesday Night at the Savoy Ballroom.* He was responding in part to the Harlem Renaissance, a literary and fine arts movement instigated by African Americans to promote their own art and culture. More than any other white American artist, Marsh captured racial intermingling in crowded buses, subways, and other public arenas during a time when the United States was still basically segregated. Although the wide, grinning black figure was already an overused, stereotyped caricature of African Americans, Marsh applied it to Caucasians to underscore white America's obliviousness to racism. It was as if Marsh was claiming that the end of the Roaring Twenties and the "good days" were already gone, as indicated by the partial red Exit sign. While Marsh was often humorous, Gropper tended to be more searing, paralleling the tone of his attack with a seemingly awkward expressionist brushwork. Art dealers were a favorite theme, his cynical attitude to the business aspect of his trade clearly in evidence.

By the late 1930s, Social Realism had expanded its viewpoint, considering issues such as European militarism, and by the time war began had assumed universal implications. This development was most evident in the art of Evergood. *Twin Celebrities* may have been based on

the Soyer twins, Raphael and Moses, artist-friends of Evergood, but their individual identity as well as the specific location of the setting were actually irrelevant. Evergood repeatedly used the device of coupling figures to underscore the theme of shared political ideologies. With the Western countries joining sides to fight another world war, cultures and nationalities took second place to more international ideologies. The leafless trees in the glen behind the twins and the barren mountain with dead trees in the distance refer to this world situation.

Growing out of Social Realism, but heavily influenced by Grosz and other German Expressionists, there was a tendency during the 1940s to emote intense subjective feeling through strident color and thick, angry brushwork. Along with Evergood, Hyman Bloom was often identified with this humanistic trend. Bloom's *Corpse of Man* is both intensely personal and universal. His jewel-like color sparkling among the violent slashes of paint is quite disarming in this modern crucifixion, a critique on the folly of war.

As fantastic as some of the commentary became, none equaled the absurdity of the world of Surrealism. Unlike the Social Realists, the Surrealists were programmatic, consisting of semiorganized groups of writers and artists that followed specifically defined doctrines. Although the movement came to include artists from many different countries in Europe and the Americas,

Surrealism is most often identified with France, as the group first gathered around André Breton in Paris during the 1920s. Realists and Social Realists transformed subject matter and its significance, but the Surrealists' aims were grander—to revise the entire concept of art, both its source of creativity as well as the creative process itself. They considered traditional art bankrupt, as meaningless as the political logic that led to World War I. Breton—having studied with Sigmund Freud and written his first book, *Les Champs magnetiques*, 1921, as an experiment in unconscious writing—believed the future lay in the "resolution of . . . two states, dream and reality . . . seemingly so contradictory, into a kind of absolute reality, a *surreality.*"[7] Delving into the unconscious and using images derived from dreams released the Surrealists from the confining, proscribed world of reason and social and aesthetic mores.

The juxtapositions of seemingly unrelated objects in meticulously painted illusionistic scenes became the hallmark of much Surrealist painting, in particular the canvases of Salvador Dalí and René Magritte. Dalí even incorporated backgrounds thematically incongruous to his sitters in commissioned work, as demonstrated by the tiny figure of a nude equestrian galloping through a barren plain in several portraits from the early 1960s, including one devoted to Louis Sachar, the brother of Brandeis University's first president. Magritte presented

a similar random amalgamation in *L'Atlantide*: A water basin and a pile of cloth sit in front of a large expanse of black nothingness. Drapery, pulled aside in the tradition of eighteenth- and nineteenth-century portraiture, reveals another world, an upside-down exterior with a staircase leading to a door and windows. Stairs, apertures, and long corridors became a popular Surrealist motif similar in function to the rabbit hole and tunnel in *Alice in Wonderland*—giving the perception of leading somewhere but actually only creating more confusion and mystery.

Surrealism was never associated with a single style. André Masson retained references to the earthly world in *Grasshoppers and Flowers,* but transformed it into a haunting battleground by confusing the scale of the insects and plants, simplifying the forest into garish hues, and applying the paint as if attacking the canvas. He created a true Expressionist nightmare, visualizing his growing fears over the increased political tensions in Europe.

During the 1930s, Americans became familiar with Surrealism through articles in general magazines and art journals as well as through exhibitions in New York City—at the Museum of Modern Art and the Julien Levy Gallery—and elsewhere. A handful of European artists visited the United States at the time of these shows, but it was not until the outbreak of the war that more immigrated to the Americas. In 1941 Breton arrived with his wife, artist Jacqueline Lamba, and they were met and assisted by Yves Tanguy and his American-born artist wife, Kay Sage. In their lives and paintings, this international couple exemplified the transmission of Surrealism to the United States. One of the French pioneers, Tanguy had already established a mature abstract language, but in the United States populated his nebulous worlds with larger, more complex amoebalike configurations. Sage con-structed an equally empty place, but one emphasizing architectonics—beams and walls—perhaps thereby alluding to the technologically advanced character of her birthplace.

After World War II, Abstract Expressionists in the United States and *Art Informel* artists in Europe became Surrealism's true heirs. Breton's focus on pure psychic automatism enabled them to abandon all logic and conscious control. The concept encouraged free association and spontaneity, further liberating both process and iconography. In 1952 the American critic Harold Rosenberg dubbed postwar abstract art Action Painting, thereby underscoring the physicality of process.[8] Creativity based on improvisation became a performance art in the hands of painters such as Hans Hofmann, Jackson Pollock, Antoni Tàpies, and others who slashed, swirled, dripped, doodled, and graffitied pigment onto canvas. At times, their actions took on a ritual dimension.

Rosenberg explained that the act of painting

was "inseparable from the biography of the artist," but insisted that "what matters always is the revelation contained in the act."[9] Encouraged by the theories of Sigmund Freud and Carl Jung, these artists explored myths, magic, and the collective unconscious in order to express universal truths rather than individual experiences. For example, murky nights are pregnant with meaning, as William Baziotes and Tàpies suggested in their nocturnal images, which hark back to the turn-of-the-century Symbolist love of twilight and the color blue. The title and large sentinel figure on the left of Baziotes's *Night Watch* implies that absolute knowledge may be attainable through careful attention to the subconscious and the spiritual despite any difficulty in comprehending veiled and nonmimetic forms. Matta became the paradigm of this last phase of Surrealism. Creating cosmic abstractions of remarkable luminosity in which organic and crystalline shapes—often hybrid animal or mechanical creatures—float, merge, and collide, he advanced the surreal exploration of the microcosm and macrocosm to a new dimension. An architect by training, Matta incorporated ideas from technology and space exploration to construct a vast new metaphorical universe. Such unlimited potential of the psychic became a new standard for future art.

DR. ILENE SUSAN FORT IS THE GAIL AND John Liebes Curator of American Art at the Los Angeles County Museum of Art. She has published extensively and organized and participated in many exhibitions on American art and the interactions between American and European movements. Her most recent essay appeared in *Dalí and Film* (Tate, 2007). She is presently organizing *Manly Pursuits: The Sporting Images of Thomas Eakins* (2010), *Rodin and America* (2011), and *In Wonderland: The Surreal Adventures of Women Artists in Mexico and the United States* (2011).

WILLIAM BAZIOTES, American,
1912–1963
Night Watch, n.d.
Pastel, 18 ½ x 24 ½ inches
Transferred from The Charna Stone
Cowan Collection, 1966

The work of Surrealist painter William Baziotes is characterized by biomorphic shapes and the use of automatism, both of which are illustrated in *Night Watch*. Although the shapes are abstract, the form on the left resembles a figure much like the figures that Baziotes painted in *Cyclops*, 1947, and *Night Form*, 1947. In all three works, a circular shape is used to indicate the head, and *Cyclops* is further similar to the figure in *Night Watch* in that a triangular area is used to indicate genitalia. Baziotes's depictions of such figures evolved from his drawings of large nudes at the National Academy of Design in New York in 1936.

KAREN CHERNICK '06

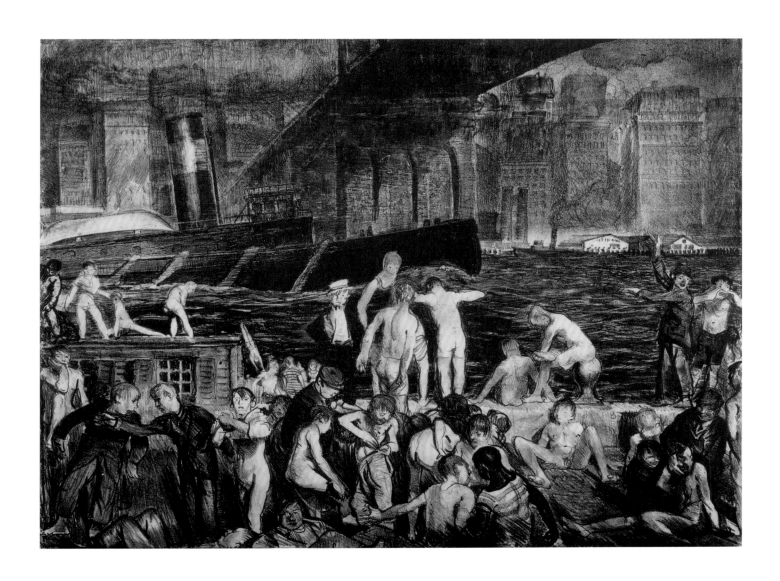

GEORGE BELLOWS, American,
1882–1925
Between Rounds, No. 1, 1916
Splinter Beach, 1916
Lithography, 16 ¼ x 20 ½ inches (*Between Rounds*); 15 x 19 ¾ inches (*Splinter Beach*)
Gift of Bernice and Joseph Tanenbaum,
2000

During the early twentieth century, prizefighting was illegal where admission was charged. Certain clubs dodged the law by charging general membership fees, and prizefighting continued in an underground circuit. George Bellows took to painting images of these fights. By the early 1920s, boxing was legalized and considered to be a respectable sport. Bellows was commissioned to paint several fight scenes. In 1916, Bellows installed a lithography press in his studio and began to focus on printmaking as his primary medium of choice, paying close attention to structure on the picture plane. *Between Rounds, No.* 1, 1916, is one of the earliest lithographs in Bellow's oeuvre. To relay the tense circumstance in the scene, Bellows focused his attention on the placement of the figures and the blocking of the activity. Bellows employed effective use of foreshortening here, particularly in the construct of both fighters' bodies. The scene engages the viewers, inviting us to become part of the thunderous energy in the moment depicted.

TAMAR FRIEDMAN '07

THOMAS HART BENTON, American,
1889–1975
Sketch for "Retribution," n.d.
Tempera on paper, 26 x 14 inches
Gift of Mrs. Teresa Jackson Weill,
New York, 1975

Recognized as one of the most significant muralists and teachers of the 1920s and 1930s, Thomas Hart Benton consciously countered the abstract and European modernist trends of his peers through his painting style and subject matter. The artist portrayed the American heartland and its citizens, conveying a sense of deliberate energy. It was the "painter's conviction that energy was the hallmark of American life." [10] Between 1919 and 1924, Benton executed studies and sketches to prepare for his later commissions. One such example, *Sketch for "Retribution,"* illustrates his trademark handling of figures and compositional devices outside the countryside context of many of his other works. The sculptural, elongated human forms pay homage to the Mannerist painter El Greco, whom Benton surely studied at the Art Institute of Chicago (1907) and the Académie Julian in Paris (1909). *Sketch for "Retribution"* has been part of the Rose Art Museum's collection since 1974, and was included in exhibitions on the Brandeis University campus in 1975 and 1992.

HELENE LOWENFELS '05

HYMAN BLOOM, American, born in
Latvia, 1913
Corpse of an Elderly Male, 1944
Oil on canvas, 72 ¼ x 34 ¼ inches
Gift of Henry Crapo, Hull, Massachusetts,
1961

A visionary meditation on spiritual desolation and the absurdity of the human condition, Hyman Bloom's *Corpse of an Elderly Male* is a masterpiece of Expressionist figuration. The painter's characteristic dense palette and graphic force add to the haunting, provocative power of the work. Conceived during the darkest, most anxious days of World War II, Bloom's subject can be read as an essay on the grim reality of human mortality and the inevitable collapse and destruction of society as a whole. Despite the fact that his painting did not achieve wider recognition, Bloom's complex work is a conceptual antecedent for many contemporary artists who claim the body as the arena for psychic turmoil.

JUDY ANN GOLDMAN '64

SALVADOR DALÍ, Spanish, 1904–1989
Portrait of Louis Sachar, 1961
Oil on canvas, 36 x 24 ¾ inches
Gift of Mrs. Frances Sachar, New York,
1986

Haloed with an ethereal glow in this portrait, Louis Sachar (brother of Brandeis University's legendary first president, Dr. Abram Sachar) steadfastly stands against what Surrealist painter Dalí described as "the blue sky of the future."[11] At first glance it may appear odd that the sitter occupies so little space in his own portrait, yet Dalí devoted three-quarters of the composition to the sky in order to illustrate Sachar's "constructive spirit."[12] Sachar, a successful entrepreneur in the field of textiles and real estate, commissioned the portrait in 1960, and it was thereafter proudly displayed in his Park Avenue home for twenty years.

KAREN CHERNICK '06

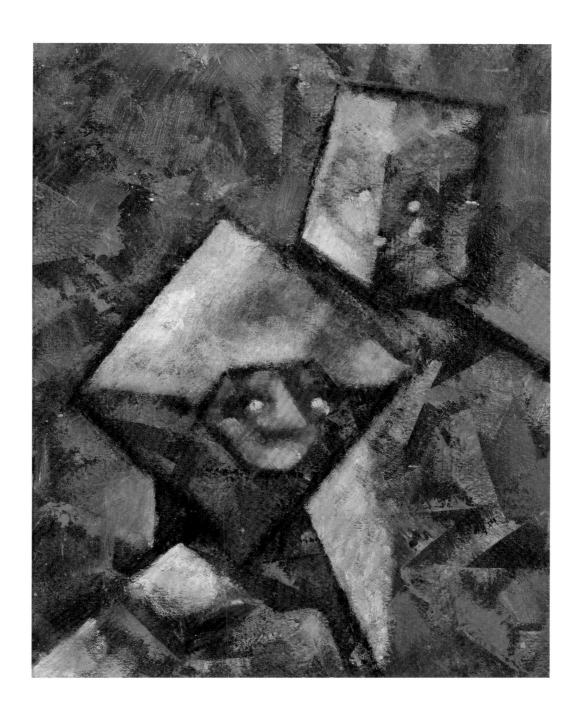

MAX ERNST, American, born in
Germany, 1891–1976
The Mask, n.d.
Oil on wood, 10 ¼ x 8 inches
Gift of Arnold L. Weissberger,
New York, 1959

Max Ernst was a major contributor to the Surrealist movement. His own painterly aesthetic was rooted in an amalgamation of several schools of artistic thought (Expressionism, Surrealism, Dada), and seasoned with his own reflections on art and society. Like many of his contemporaries, Ernst allowed the personal impact of war to be reflected in his artwork. His paintings are often loaded with dark satire.

In the early 1920s Ernst painted a series of canvases imbued with a dreamlike quality typical of Surrealism. While the date of *The Mask* is unknown, this painting seems to relate closely to that documented series. The painting comments on what Ernst found to be the restrictive nature of the society he was immersed in during his youth. Its title evokes the barriers between the "real" and that which is conveyed in bourgeois society. The dark palette and general chaos in the painting leave us feeling misplaced, as Ernst felt during his early years.

TAMAR FRIEDMAN '07

PHILIP EVERGOOD, American,
1901–1973
Twin Celebrities, 1942
Oil on canvas, 44 x 24 inches
Gift of Mrs. Ella Baron, New York, 1964

This striking double portrait shows the twin brothers Moses and Raphael Soyer, born 1899. Like Philip Evergood, the Soyers were Jewish artists who participated in Social Realism, a movement that carried on the Ashcan School tradition of documenting the realities of modern life. Evergood esteemed the two brothers highly as artists, and late in his career wrote an essay dedicated to his friend Moses's work. In it he states, "Once I painted *Twin Celebrities*, a rather free portrait of Moses and Raphael standing intense and small and sad and young and alive in a forest. This expressed to me the kind of lonely struggle people have against the oppressive forces, the mysterious shadowy dangers of life."[13] The unsuitability of business attire for painting, combined with all three artists' low output of landscapes, suggests that this setting may be entirely metaphorical.

CAROLINE WEITZMAN '08

WILLIAM GROPPER, American,
1897–1977
Artist and Dealer, c. 1942
Oil on canvas on cradled panel,
20 ⅛ x 26 ⅛ inches
Gift of Mrs. Ella Baron, New York, 1964

William Gropper was a cartoonist, painter, lithographer, and muralist born on the Lower East Side of New York City, where his parents worked in the garment industry. He was known for depicting social injustices, especially ones present in the daily lives of laborers. In *Artist and Dealer*, Gropper cynically portrayed one of his favorite subjects—art dealers. Using the sharp wit of a cartoonist, Gropper explored the social inequality between an apparently humble artist and an uninterested, perhaps arrogant art dealer as a means of exposing the mechanics of the business aspects of his trade. Gropper was a founding member of the American Artists' Congress (1936–43), an organization with a mission to combat both the economic distress of artists emerging from the Depression and the spread of Fascism. By embracing Socialist ideologies, Gropper engaged issues of his time in a universal way, expressing the concerns of humanity in any age.

ADELINA JEDRZEJCZAK

GEORGE GROSZ, German, 1893–1959
Unemployed, n.d.
Ink and watercolor on paper,
23 ½ x 17 ¾ inches
Gift of Harry N. Abrams, New York, 1950

George Grosz was the political satirist of the German Expressionists in post World War I Germany. In 1932, disillusioned by the rise of Hitler, he left Germany for New York, becoming an instructor at the Art Students League in 1933. He had a lifelong affection for the United States, but soon after arriving noted the same huge imbalances in the economic lives of poor and wealthy Americans. As he had done in Berlin, he depicted out-of-work and out-of-luck men as they wander aimlessly in a city with few options. In this heartfelt portrait, three men appear to shuffle aimlessly in front of a dilapidated hotel in New York, past homeless men (rendered in soft lines) huddled near an air vent. Two have their hands in their empty pockets, the third carries a piece of paper that may be some kind of welfare check. With street litter gathering at their feet, we see the plight of so many unemployed men and women during this period.

MICHAEL RUSH

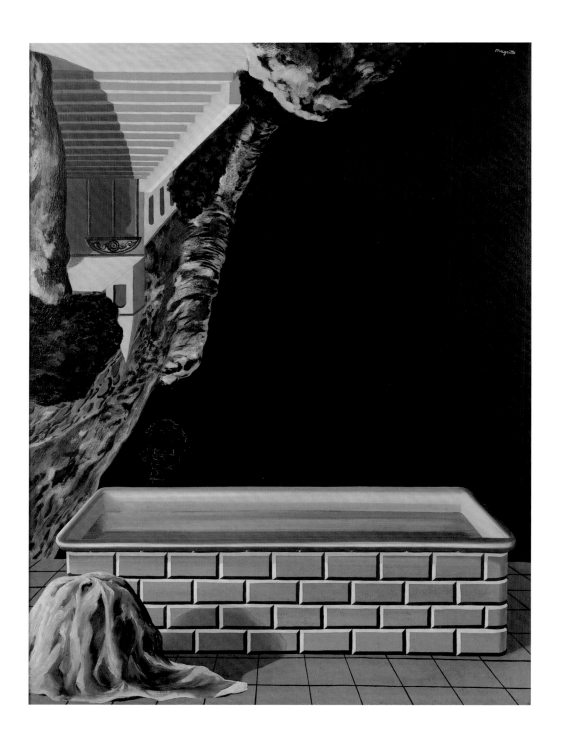

RENÉ MAGRITTE, Belgian, 1898–1967
L'Atlantide (The Reflection), 1927
Oil on canvas, 39 ½ x 28 ½ inches
Gift of Mr. and Mrs. Eric Estorick,
London, 1967

Belgian artist René Magritte began his career as a commercial artist, as is evident in the sharpness and clarity of *L'Atlantide*. The black backdrop, as well as the upside-down landscape, suggests a pulled-back curtain that frames the bathtub and cloth-covered object. This painting obscures what is tangible and real in the scene. By displaying ordinary objects in unordinary contexts, Magritte is able to question the operations of the unconscious mind by inverting the landscape. The detailing in the bathtub and landscape exemplify Magritte's representational style, which distinguished his work from the automatic Surrealist style. Magritte painted *L'Atlantide* while living in Belgium, just following his 1926 move to Paris, where he befriended Surrealist artist André Breton. With a long provenance beginning with his solo show at the Galerie L'Eoque in Brussels in January 1928, *L'Atlantide* is one of the Rose's most desired and treasured works of art.

DANIELLA GOLD '07

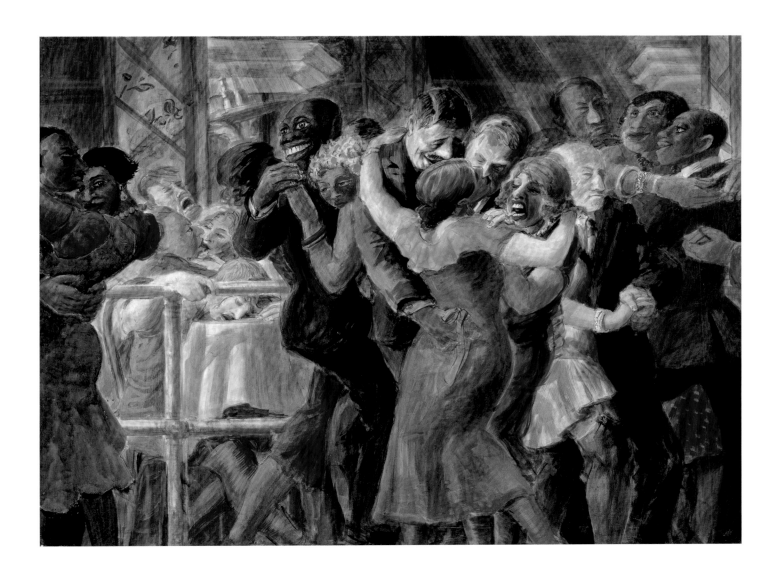

REGINALD MARSH, American, born in France, 1898–1954
Tuesday Night at the Savoy Ballroom, 1930
Tempera on composition board, 36 x 48 ⅛ inches
Gift of the Honorable William Benton, New York, 1962

Reginald Marsh, who was trained as an illustrator, often painted New York scenes. Here, his expressive line captures the sensual mood of the dancers. He places us in their midst; the woman in a blue dress, at left, looks over her shoulder and smiles at us as we glide into a space on the packed dance floor. By incorporating us into the scene, Marsh demands our reaction to those around us. Near the center, a man embraces a redhead while she kisses another man; his blond girlfriend shouts at her. At the table, a couple kisses while their intoxicated companions pass out. The hot colors of the dresses, the flash of a garter holding up a stocking, and the physical intimacy evoke the hedonistic liberation associated with the jazz clubs and rhythmic music of the 1930s. At a time when many nightspots remained segregated, Marsh shows black and white couples dancing close to one another, recording the loosening of racial strictures in places like Harlem's Savoy Ballroom.

ROBIN JAFFEE FRANK '77

ANDRÉ MASSON, French, 1896–1987
Grasshoppers and Flowers, c. 1933
Oil on canvas, 15 ⅛ x 11 ⅜ inches
Gift of Mr. and Mrs. Edwin E. Hokin,
Highland Park, Illinois, 1965

Grasshoppers and Flowers illustrates the strong color palette that French Symbolist and Abstract Expressionist painter André Masson used in the late 1920s and early 1930s, and is part of a series of insect pictures he painted while in Spain. Insects, and particularly praying mantises, were of interest to many Surrealists because the cannibalistic behavior of females after coitus demonstrated the connection between sexuality and violence, a theme in Surrealist art. Masson was the most consistent painter of these insects, depicting them in paintings such as *Summer Divertissement*, 1934. Menacing insects with anthropomorphic qualities are depicted here in a microcosmic hostile environment of razor-sharp plants and clashing colors. At once isolated and poised to come together, the mantises in *Grasshoppers and Flowers* reveal the tension before a vicious sexual encounter.

KAREN CHERNICK '06

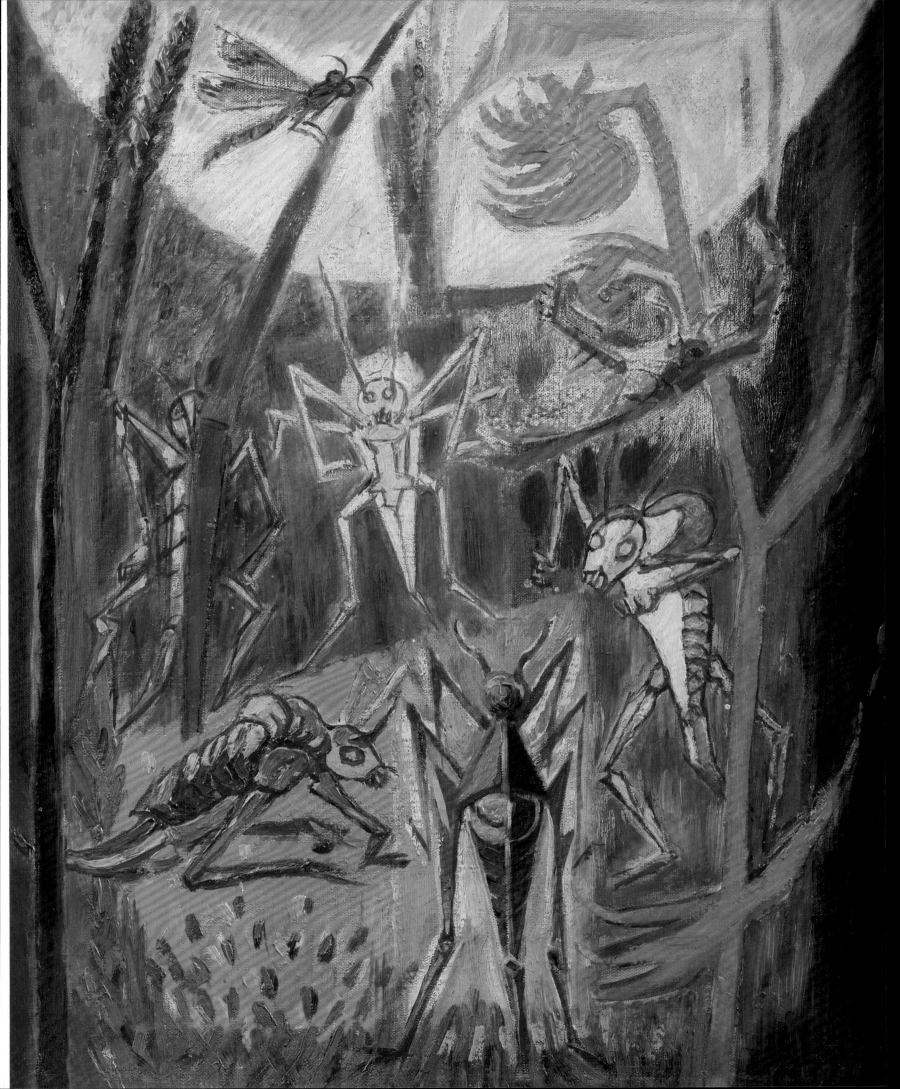

MATTA, Chilean, 1912–2002
Untitled, 1956
Oil on canvas, 80 ¾ x 248 ¾ inches
Gift of Mr. and Mrs. William Mazer,
New York, 1963

Born in Chile, Matta trained in the Paris studio of Le Corbusier, where he came to know Salvador Dalí and other European Surrealists. Unhappy with the rigid drawings demanded by his work as an architectural draftsman, he became preoccupied with illustrating the landscape of the inner mind. In 1938, with World War II looming, Matta moved to New York, where he worked closely with the Abstract Expressionists, including Arshile Gorky and Jackson Pollock. The dreamlike rendering of space and the fantastical, amorphous composition in *Untitled* is inhabited with narrative elements. The work creates an aura of mystery and otherworldliness. Whether Matta is focused on creation or destruction is left to the imagination. He not only concentrated on imagining otherworldliness on canvas, but created an "automatic" technique in which he attempted to work with free brushstrokes and draw without conscious thought.

DANIELLA GOLD '07

KAY SAGE, American, 1898–1963
This Silent World, 1955
Oil on canvas, 18 ¼ x 15 ⅛ inches
Gift of the Estate of Kay Sage Tanguy,
1964

Kay Sage was one of the premiere female Surrealists, and one of the few Americans working in this largely European style. While her paintings often involve misty landscapes with infinite horizons much like those of her husband, Yves Tanguy, her architectural and figural elements are closer to the imagery of Giorgio De Chirico. In *This Silent World*, blank buildings topped with vertical cylinders are clustered in an indistinct setting. Sharp contrasts of highlights and shadows define the volumes of the forms; buildings and settings are rendered in the low-saturation tonality seen in much of her work. Devoid of human presence and receding in ambiguous space, these windowless structures give the work a desolate, eerie, and ominous air. Despite the menace and isolation hinted at in her paintings, Sage was a significant support to other Surrealists, arranging exhibitions and bringing many artists to America during World War II.

ELLEN C. SCHWARTZ '69

BEN SHAHN, American, born
in Lithuania, 1898–1969
Jazz, 1955
Watercolor on paper,
13 ¼ x 13 ¼ inches
The Charna Stone Cowan
Collection, 1971

This small, monochromatic watercolor shares some important features with the artist's 1956 tempera *When The Saints. . . .* The slide trombone divides the painting diagonally. Musicians' hands, the fingers simplified to cylinders, seem to hold the eloquence of the music in their grasp. Music, musicians, and the instruments themselves are a repeated subject in Shahn's work.

Edward R. Murrow commissioned Shahn to do some drawings on musical themes for an edition of his television program *See it Now*, that spotlighted Louis Armstrong, in 1955. *Jazz* was painted for a record album, *Chicago Style Jazz*, Columbia Records. Lines, partially rubbed out by the artist, live like ghosts in the paper, in the rich smoky grays and blacks. Left intentionally, these graceful "mistakes" are like the beautiful lucky notes that seem to just happen as a clarinetist improvises. Shahn's musicians are not portraits, but soulful archetypes reflecting his affinity for those who work hard with their hands, their instruments, enriching our world.

JOEL MOSKOWITZ '76

YVES TANGUY, American, born in
France, 1900–1955
*Land of the Sleepers (Terre des
Dormeuses)*, c. 1948
Oil and tempera on canvas, 12 ½ x 10 inches
Gift of the Estate of Kay Sage Tanguy,
1964

Despite its diminutive proportions, Tanguy's panel painting packs a powerful visual message and is a brilliant distillation of the artist's cosmic vision. Tanguy's hallucinatory landscape consists of a dusky skyline that blends seamlessly into the foreground terrestrial space. A collection of vaguely figural lapidary forms inhabits this ambiguous world, but whether these personages are animate or inanimate is unclear. They appear to resemble the dolmens and menhirs of prehistoric times, but they could also have been inspired by the raw desert landscape the artist observed on a trip he made to the American Southwest. Tanguy's exquisite work, a Surrealist masterpiece, is a window onto an astonishing dream world encompassing limitless dimensions in time and space.

JUDY ANN GOLDMAN '64

ANTONI TÀPIES, Spanish, born 1923
Enchanted Night, n.d.
Oil on canvas, 80 ¾ x 248 ¾ inches
Gift of Mrs. William H. Fineshriber, Jr.,
New York, 1962

Enchanted Night belongs to a group of paintings Tàpies made during his affiliation with the Surrealist journal *Dau al Set* (1948–51) in post–Civil War Barcelona. Indeed poet Joan Brossa, fellow Catalan and the journal's cofounder, has been credited with providing titles for some of Tàpies's work from this time. Whereas the artist's graphic, heavily incised paintings initially described a sinister violence, *Enchanted Night*'s vast sky is painted with glowing moons and planets, astrological constellations. The play of shadowy forms—limbs and shamanistic animals—amongst the trees hint within, to the subconscious. An oversize, luminous, and energetically painted bird keeps company in this still, magical reverie. Tàpies's enduring investigations of the very materials on the canvas surface are hinted at in the horizontal lines drawn across the *Enchanted Night* sky.

SYDNEY RESENDEZ '88

Chapter 3

POSTWAR AMERICAN ART AND ABSTRACT EXPRESSIONISM

David Anfam

The writer Gertrude Stein famously described certain Americans who experienced their nation's coming-of-age during the decade of World War I by saying, "You are all a lost generation."[1] Stein's remark implied a two-fold sense of her artist friends' alienation. Firstly, she was probably thinking of the gulf between their avant-garde modernism and a philistine United States under President Warren Harding's "return to normalcy." Secondly, their inherited values no longer obtained in an utterly changed postwar situation. As F. Scott Fitzgerald's character Amory Blaine in his novel *This Side of Paradise* (1920) expressed the zeitgeist, he had "grown up to find all gods dead, all wars fought, all faiths in man shaken."[2] Yet worse lay ahead. A subsequent artistic generation had to reckon with further upheavals, starting at home with the Great Depression, the rise of Fascism and Nazism in Europe, the Spanish Civil War, World War II itself, the revelations of the death camps, and the atomic cataclysms at Hiroshima and Nagasaki. In the broad view, this was the matrix for postwar American art and its foremost tendency, Abstract Expressionism.

As its much-contested name may imply, Abstract Expressionism sought to fuse varying degrees of abstraction with the expression of meaningful content. Adolph Gottlieb summarized the aims of this loose-knit movement when in 1947 he wrote that "different times require different images . . . our obsessive, subterranean and pictographic images are the expression of the neurosis which is our reality. To my mind, certain so-called abstraction is not abstraction at all. On the contrary, it is the realism of our time."[3] This notion of "realism"—that is, of content and physical immediacy rather than superficial mimesis—holds for nearly all the works in the Rose Art Museum's collection grouped under the rubric of Abstract Expressionism.

Their range extends from the twilit runes of Gottlieb's *Water, Air, Fire*, 1947, through Alfonso Ossorio's visceral *Making of Eve*, 1951, to Robert Motherwell's *Elegy to the Spanish Republic, No. 58*, 1957–61, and James Brooks's *Rodado*, 1961. On the one hand, it might be a "realism" of facture, as with Brooks's calculated pictorial gestures and vivid palette, not to mention Hans Hofmann's automatist paint flow in his *Arcade*, 1952. On the other hand, it could be a psychological "realism": witness Gottlieb's delving the mind's recesses and transformative repetition in the mysterious symbols of *Water, Air, Fire*.[4] Motherwell's *Elegy* contains both—the image's dramatic blackness, with its diverse cultural associations, allied to the titular allusion to a tragic event (reinforced by brutally truncated phallic and testicular shapes). Motherwell explained, "The 'Spanish Elegies' are not 'political,' but my private insistence that a terrible death happened that should not be forgot."[5] Here is a confluence of historical reality (the Spanish Civil War) and individual conscious-

ness (my private insistence) that stands at the crux of Abstract Expressionism.

In times of crisis, such as those surrounding the advent of Abstract Expressionism and its figurative counterparts, the last exemplified by the wasted individual of Philip Evergood's *Forgotten Man*, 1949,[6] human beings tend to impose shape upon what is perceived as external chaos in order to rationalize senselessness.[7] Among these shaping fictions, dialectic is an especially recurrent pattern. Of the myriad intellectual influences upon Abstract Expressionism, few outdid those of three leading prophets of modernity—Karl Marx, Friedrich Nietzsche, and Sigmund Freud.[8] Despite these thinkers' huge differences, their outlooks were alike profoundly dialectical: Marx's Hegelian narrative of progress as thesis and antithesis; Nietzsche's opposition of the Apollonian form-giving urge to Dionysiac emotion; and Freud's divisions that pitted the ego against the id, Eros versus Thanatos. Abstract Expressionism was rife with these and kindred polarities.

In 1944, Motherwell discerned in his methods "a dialectic between the conscious (straight lines, designed shapes, weighed color, abstract language) and the unconscious (soft lines, obscured shapes, automatism) resolved into a synthesis which differs as a whole from either."[9] In his numerous *Elegies*—which interlock black and white, equivocate between abstraction and associativeness, and fuse order and improvisation—Motherwell took such a

synthesis to its conclusion. Likewise, in 1956 Gottlieb went so far as to write a list of oppositions that included the words "*Dialectic*—to resolve these opposites into a state of equilibrium," titling it "Polarities."[10] Gottlieb's *Rising*, 1962, belongs to the *Bursts* series, begun in 1956, that climaxed his long-standing preoccupation with binary relations. In the Pictographs, this was implicit in the vertical/horizontal axes of their grids. In the Bursts it acquired an epic pulse: a bright supernal disc levitating above dark terrestrial matter, hot versus cool colors, precise forms balancing inchoate marks, and so forth. Underlying these motifs was one of the great issues of the period: the transformation of matter. This idea preoccupied both science and art, ranging from Albert Einstein's theory of relativity and Freud's concept of metamorphic psychic energy to the obsession with formal flux and process in Abstract Expressionism itself.[11] While the elemental iconography of *Water, Air, Fire* may suggest alchemical change,[12] *Rising* refines this theme into formal dynamics, a cosmic ideogram. A similar observation applies to Alfred Jensen's graphlike *Opposites Are Complementary*, 1978. By comparison, Franz Kline's *Crossways*, c.1955, exhibits another type of dualism. Typical of Kline's vision are the reduction to two colors, an ambiguous hovering between architectonic organization and an indecipherable sign, and the impression of an incipient compositional grid thrown into careering disarray.[13] As Kline summarized

his dialectic, "To think of ways of *dis*organizing can be a form of organization, you know."[14]

Whatever the precise meaning of Philip Guston's carnivalesque *Allegory*, 1947, it maintains the period fixation with dialectical forces, in this case seesawing between individual and cosmos. Guston's personage, hand raised as if to ward off evil, appears torn between the contesting emblems of sun and moon. Comparably, Ossorio's *Making of Eve* adopts Jackson Pollock's poured and dripped technique—with its strong kinesthetic implications of what the latter artist memorably called "energy and motion made visible"—to evoke the biblical generation of woman from Adam's rib. Again, bifurcation is at stake. Ossorio's glossy red enamel paint obviously connotes blood. In turn, Sam Francis's *Untitled*, 1954, is composed of luminous corpuscle-like shapes with attendant drips, harking back to the artist's studies in botany and medicine as well as his long hospitalization.[15] More generally, the Abstract Expressionist view of human consciousness and external reality as twin polarities fostered its emphatic physicality. In an early statement of this implicit credo, Mark Rothko asserted that "If previous abstractions paralleled the scientific and objective preoccupations of our times, ours are finding a pictorial equivalent for man's new knowledge and consciousness of his more complex inner self."[16]

The upshot of Abstract Expressionism's focus upon inwardness was that the body, especially the skin, became the crucial locus where whatever lies within met the outside.[17] Thus, Rothko subsequently compared his classic rectangular veils to "skins that are shed and hung on a wall."[18] Such a presumption made skin into the threshold of subjectivity, of the "inner self" externalized. Tellingly, too, Ossorio's earliest efforts included designs done in 1939 to signify the twelve Apostles: Among them is the self-explanatory *Flayed Skin, Symbol of St. Bartholomew.*[19] If this hypothesis about skin sounds farfetched, a particularly graphic work in the collection indicates how Abstract Expressionism overlapped with contemporaneous representational art. Hyman Bloom's *Corpse of an Elderly Male*, 1944, assumes skin as its veritable subject. Furthermore, the ecstatic putrescence of Bloom's dermal textures continued Abstract Expressionism's syntax of antitheses and mutability: The artist explained that "the paintings are emblems of metamorphosis, as the living organisms which inhabit the body in death transform it into life in another form."[20]

A subtler involvement with the somatic informed the art of Guston and Willem de Kooning. Guston's figurative compositions of the 1940s had sometimes presented tightly tangled anatomies and limbs. Apart from referencing the Holocaust, such imagery may hint at traumatic memories of the death from gangrene of the artist's brother, Nat, in the early 1930s after his leg was run over in an accident. Perhaps by no coincidence, sickly gangre-

nous tones marked Guston's ensuing abstraction of the early 1950s.[21] From within their palimpsest there began to emerge in the early 1960s the ghosts of long-forgotten figures, as in the shadowy *Heir*, 1964. The paintings and drawings that followed confirmed that these phantasmal presences, such as *Heir*'s dark mass, were indeed nascent anatomies. *Two Heads*, 1969, also in the Rose's collection, renders that suspicion explicit. Literally "skinheads" in their shocking pink featurelessness, these are a late and bluntly ironic retort to Rothko's earlier model of art as "consciousness of [man's] more complex inner self." *Two Heads* represents selfhood as utterly external, all that there is to see of the human is on the surface.

De Kooning's pictorial dialogue between interior and exterior was analogous to Guston's, although his protagonists differed. For De Kooning, the twin agencies were woman and landscape. Having explored his angst concerning the feminine in his ferocious *Woman* series, 1950–53, he increasingly turned to the reparative realm of nature. In *Woman as Landscape*, 1955, the two melded: "The landscape is in the Woman, and there is Woman in the landscapes."[22] Thereafter, the velocity of the sweeping brushstrokes in the *Abstract Parkway*[23] series articulated the feel of the landscape seen in terms of speeding glimpses from that by-now nearly ubiquitous American phenomenon, the automobile.[24] By the artist's own admission, his theme here was "the metamorphosis of

passing things."[25] *Untitled*, 1961, is the apotheosis of this fleetness. But while its sky blues and corn yellow speak of pastoral lyricism and light, the expanse of pink is a telltale reminder of De Kooning's old obsession, the female body.[26] Few artists explored the color pink as extensively as did De Kooning, and its significance is clear from his exclamation, "flesh was the reason why oil-painting was invented!"[27]

However, by the early 1960s Abstract Expressionism's moment had passed, as had the cultural context that spurred it. The "age of anxiety" of the 1940s and the Cold War years had segued into the Kennedy era's affluence, consumerism, and New Frontiers. Several works in the collection offer a succinct coda by indicating what happened "after Abstract Expressionism"—to quote the significant title of a 1962 essay by the critic Clement Greenberg. In a nutshell, Greenberg argued that the successor to Abstract Expressionism was an art that took its attention to surfaces that were indexed to the bodily self in the opposite direction. Hence, according to Greenberg, Color-Field or Post Painterly Abstraction liberated the pictorial integument from the burden of subjectivity. Instead, it could celebrate color-space alone.[28] While Greenberg's strictures may not do full justice to the disembodied radiance of Morris Louis's *Number* 3, 1961, the optical riot of Gene Davis's *Moondog*, 1965, Larry Poons's preposterously encrusted *#30A*, 1976, or Helen Frankenthaler's dreamlike

Yellow Line, 1982—which evince ties to a larger climate of excess, hedonism, and physical frankness in the America of these decades—they do capture the spirit of a renewed objectivity.[29] In its formality, literalness, and flatness, this new spatial paradigm no longer had room for the self that had once lodged itself in Abstract Expressionism's layered, manifold surfaces.[30]

DAVID ANFAM IS COMMISSIONING EDITOR FOR Fine Art, Phaidon Press, London. His many publications include *Abstract Expressionism* (Thames & Hudson, 1990) and *Mark Rothko: The Works on Canvas—A Catalogue Raisonné* (Yale University Press, 1998). Most recently, Anfam curated *Abstract Expressionism—A World Elsewhere* at Haunch of Venison New York (2008).

JAMES BROOKS, American, 1906–1992
Rodado, 1961
Oil on canvas, 57 x 78 inches
Purchased with funds from the Gevirtz-
Mnuchin Purchase Fund, 1962

James Brooks, a pioneering abstract artist, is best known for his experiments in diluting oil paints with water to stain canvas, which became a popular technique of Abstract Expressionism. Especially in the 1950s and early 1960s, Brooks created works with fluid forms and bold colors. *Rodado* is no exception. Big, bright, and vibrantly blue, the painting was one of the original highlights of the Rose Art Museum. *Rodado* was purchased in 1962 as one of the twenty-one major acquisitions made by Sam Hunter as part of the Gevirtz-Mnuchin Purchase Fund. As part of the original permanent collection of the Rose, *Rodado* was featured in numerous Rose exhibits, most notably "American Art Since 1950" in 1960 and "New Directions in American Painting" in 1964. A representative work of abstract painting, *Rodado* has been on loan to many art institutions around the country.

NICOLE EATON '01

ALEXANDER CALDER, American,
1898–1976
Corn Meal, 1977
Tapestry, 62 x 84 inches
Anonymous gift, 1983

As early as the third century BCE, tapestries adorned the walls of public buildings, serving both an aesthetic and utilitarian function. At Brandeis University, Alexander Calder's *Corn Meal* hangs in the atrium of the Shapiro Campus Center, which serves as the central hub of student life. The tapestry, produced a year after his death, employs Calder's signature palette and sense of design. The bold play among red, blue, and yellow pays homage to Piet Mondrian, whom the artist met and befriended early in his career. After visiting Mondrian's Paris studio in 1930, Calder abandoned representational imagery and adopted the Dutch painter's theories of abstraction and the use of primary color. *Corn Meal*'s chief focus is on color and line, differentiating it from his hanging mobiles and three-dimensional sculpture. Calder nevertheless achieves a sense of movement through the inclusion of two prominently placed spiral forms, which reference his wire constructions.

HELENE LOWENFELS '05

BRUCE CONNER, American, 1933–2008
Light Shower, 1963
Mixed media collage on pressed board,
65 x 51 ½ inches
Gift of Mr. and Mrs. Lionel Ziprin, 1965

In 1965, the Rose Art Museum organized one of the first solo museum shows on the East Coast of the young assemblage artist Bruce Conner. (It was coincidentally the first exhibition I saw at the Rose Art Museum as an entering freshman.) Although Conner is closely associated with San Francisco and its "Beat" school of poets, musicians, and artists, he was living in the Boston area on a Guggenheim Fellowship making films when the Rose exhibition opened. Many of the collages and assemblages Conner made at the time featured common objects and imagery cut out of popular magazines, including what were then called "girlie" magazines. *Light Shower* lacks such associative objects and imagery, however, making it one of Conner's more abstract works. The curtain ruffle applied to both left and right sides of the work suggests that the work might be seen as a window—one that opens onto the mind of the artist (or viewer) rather than on any view outside.

DAVID BONETTI '69

NICOLAS DE STAËL, French, born
in Russia, 1914–1955
Poppies, 1953
Oil on canvas, 32 x 25 ½ inches
Gift of Paul Rosenberg and Company,
New York, 1961

Painted in 1953, *Poppies* was created in the same year that Russian-born Nicolas De Staël signed an exclusive contract with Paul Rosenberg for the sale of his work in New York (a decision that led to great commercial success). Rosenberg, a prominent French art dealer who came to New York during World War II, donated the work to the Rose Art Museum in 1961. Stylistically, *Poppies* illustrates De Staël's method of applying thick paint with a palette knife in order to create a textured surface, a technique he developed in the mid-1940s. Although the subject of the work is obviously a vase of poppy flowers, De Staël blends both abstract and representational art. The dramatic red hues of the poppies interrupt the otherwise serene neutral harmony of the rest of the composition.

KAREN CHERNICK '06

JOSEPH CORNELL, American, 1903–1972

La Petit Magicienne #2; *Cupid and Psyche*; *Untitled (2 Girls Skipping Rope)*; *Untitled*, n.d.

Paper collages on fiberboard,

14 ¼ x 11 ¼ inches; 12 x 9 inches; 12 x 9 inches; 12 x 10 inches

Gift of the Joseph and Robert Cornell Memorial Foundation, 2005

Untitled, Gift of Dr. and Mrs. Arthur Kahn, New York, 1985

Of the ten collages in the Rose Art Museum's collection, this quartet well illustrates Cornell's commingling of high and material culture in the expression of favorite themes—youth and love. His coy eighteenth-century lady (*La Petit Magicienne #2*) floats elusively on an ethereal landscape. In *Cupid and Psyche*, the frisson is laid bare: Psyche is surrounded by waves of pastel-colored washes as Cupid passes unhindered between her legs. These reference Cornell's delight in playful entendre but *Untitled (2 Girls Skipping Rope)* and *Untitled* show the sanctity of childhood as a sober topic in his hands. *Untitled (2 Girls Skipping Rope)* was certainly made in conjunction with *For Emily Dickinson* (1953; Peabody Essex Museum, Salem, Massachusetts). The latter is part of a series Cornell produced in homage to the poet; the almost identical vertically split imagery in both reflects his work with film. Unlike most of his collages, where the support lends earthy texture, in *Untitled* a fragile tissue is sandwiched between two panes of glass. Here decals speaking Cornell's cipher for love (and/or *l'art*) are paired with an Edenic landscape detail he knew as part of Van Eyck's *Adoration of the Mystic Lamb*. This "one" perhaps made just tangible the loss of his beloved brother Robert in 1965 with a tender prayer for peace.

SYDNEY RESENDEZ '88

WILLEM DE KOONING, American, born in Holland, 1904–1997
Untitled, 1961
Oil on canvas, 80 ⅛ x 70 inches
Gift of Joachim Jean and Julian J. Aberbach, New York, 1964

Throughout his career Willem de Kooning claimed to walk a "tightrope between what is called figurative painting and abstraction." A Dutch immigrant, De Kooning struggled as an artist, beginning in the W.P.A and then in 1936 moving to New York, where he received his first solo exhibition only in 1948. By the 1950s, he rode the cresting wave of international critical acclaim awarded the New York School of Abstract Expressionist artists. The bold brushwork and technical bravura of his *Woman* series and abstract urban landscapes earned him financial success and recognition as one of the most influential painters of his generation. By 1961, he was spending most of his time in the Hamptons, where he created abstract landscapes in which the harsh psychic energy of the 1950s gives way to a gentle, sweeping lyricism. In this untitled painting, one can see the strong horizontals and verticals of the dock that anchor the composition in the midst of the brilliant blue sea and golden glow of the sun. In his Hampton landscapes, De Kooning works with a breadth and assurance of brushstroke that indicate the influence of his close friend Franz Kline.

JOSEPH D. KETNER

SAM FRANCIS, American, 1923–1994
White Ring, 1966
Acrylic on linen, 118 x 158 inches
Gift of the Sam Francis Estate, 2001

Samuel Lewis Francis was in his early twenties when he committed himself to the pursuit of art. He had intended to study medicine, but changed his plans after contracting spinal tuberculosis while serving in the army. Francis initially experimented with artistic theory stemming from Abstract Expressionism and Surrealism, and eventually expanded into his own school of creativity.

Francis's early canvases are conservative in size, characterized by explosions of color dancing on monochrome planes. A visit to Japan in the late 1950s influenced his work. Inviting a quiet tranquility after the fashion of Japanese art, he allowed more white space to creep onto his canvases, which were also expanding in size. The negative space in *White Ring* is expansive. Francis allowed white acrylic paint to dominate this canvas, evoking stillness. He restricted the incorporation of color to the very boundaries of the painting, where golds, blues, and reds emerge, creating context for the white surface within.

TAMAR FRIEDMAN '07

HELEN FRANKENTHALER,

American, born 1928
Yellow Line, 1982
Acrylic on canvas, 56 ½ x 83 inches
Rose Purchase Fund, 1983

Best known as the inventor of the soak-stain method, Helen Frankenthaler describes herself as "an artist of paint, making discoveries." She has worked in various two- and three-dimensional media and revisited many ideas and motifs over the course of her long career. The layering of color and the horizontal line in *Yellow Line* are several of these. Here, paint covers the canvas in horizontal and vertical swaths, applied with various implements to the unstretched canvas on the floor. The bright colors of the acrylic paint, which she began using in 1962, show her variation in application from the washes and thicker applications of the reds and blues to the heavier impastos of the dots. A nonobjective piece dealing purely with color and shape, *Yellow Line* exhibits the tension between drawing and painting often discussed by critics. Frankenthaler exhibited paintings from the 1950s at the Rose in 1981; Brandeis awarded her an honorary Doctor of Fine Arts degree in 1982.

ELLEN C. SCHWARTZ '69

ADOLPH GOTTLIEB, American,
1903–1974
Rising, 1962
Oil on canvas, 72 1/8 x 48 inches
Gevirtz-Mnuchin Purchase Fund, 1962

Purchased from the Sidney Janis Gallery in the year of its making, this signature work by Adolph Gottlieb was included in two retrospectives of the artist's oeuvre: the 1967 show organized by the Whitney Museum of American Art in association with the Guggenheim Museum, which appeared at the Rose, and the 1979 Joslyn Art Museum survey, which traveled to Arizona and Kansas. It was also illustrated in Irving Sandler's seminal treatise on postwar painting, *The Triumph of American Painting* (New York, 1970). *Rising* is a prime example of Gottlieb's best-known Bursts series, whose imagery derives from sketches made years before in the Arizona desert. Inspired by the unassailable evolution of natural forms, the work's floating shapes evoke eternal forces of nature and the dynamic interplay of constancy and change. A potent expression of postwar sublime, *Rising* juxtaposes the slow time of coalescing forms on an ever-expanding field with the immediacy of vigorously brushed splashes.

ANNETTE DIMEO CARLOZZI '75

100

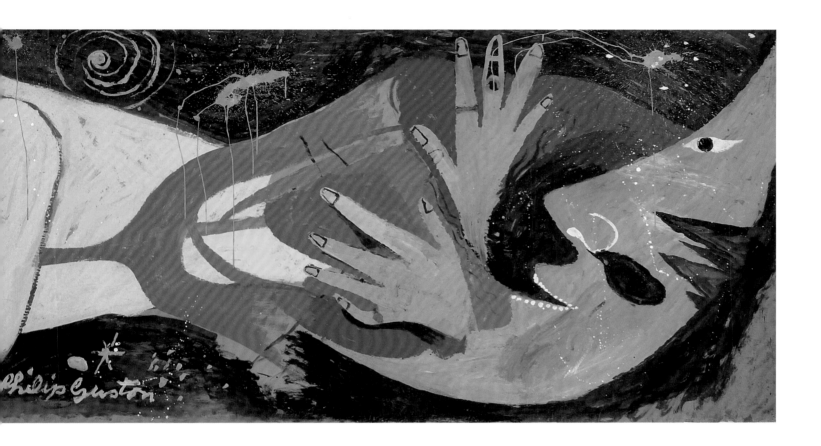

PHILIP GUSTON, American, 1913–1980
Allegory, c. 1947
Casein on brown paper mounted on
canvas, 46 ³⁄₄ x 182 ¹⁄₂ inches
Gift of Mr. and Mrs. Harry N. Abrams,
New York, 1963

Philip Guston's career as a painter was characterized by constant self-evaluation. Although best
known today for his break with abstraction in the late 1960s to pursue an idiosyncratic, personal style
of figurative painting, this was not the first major transition in his career. Before turning to abstract
painting, Guston worked as a muralist, and the size and broad strokes of *Allegory* suggest a link with
his work for the WPA in the 1930s. Key motifs in the drawing—the sun, the trumpet, the elongated
and oddly positioned figure—appear in other works dating from the late 1940s, when Guston was
teaching at Washington University in St. Louis. Even with its clear, celestial symbolism, *Allegory* remains
somewhat ambiguous in meaning and in tone, but this, too, is not unusual for works from this time.
This fascinating, monumental drawing speaks to a transitional period in Guston's career, one that would
soon resolve itself in the visual language of abstraction.

ESTHER ADLER '99

AL HELD, American, 1928–2005
Yellow Up, 1966
Acrylic on canvas, 48 ⅛ x 35 ⅛ inches
Gift of the Martin Foundation, New York,
1967

A glance through Al Held's oeuvre reveals years of evolution in style. In his early years, Held was involved in the Abstract Expressionist movement. Over time, his style shifted as his paintings became more defined and clear. Eventually, his work was loosely grouped with Post-Painterly Abstraction. Held was still painting subject and matter without form or definition, but his work was spatially contained and crisp.

Held aimed to evoke, in particular, that which cannot be experienced, seen, or felt, but only imagined. Like other works by the artist, *Yellow Up* is a painting without perimeters of interpretability. Properties of perception compel us to discern foreground and background here. The yellow identifies itself as the figure in the foreground, with white behind it, and a tan background as the foundation of it all. The colors here become form, supply context for the mood of the painting, and stand in for the subject that one might see depicted in a more realistic portrait or still life.

TAMAR FRIEDMAN '07

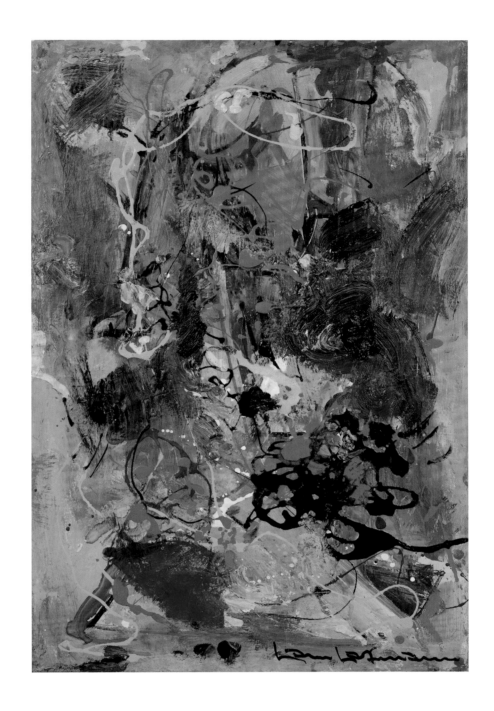

HANS HOFMANN, German, 1880–1966

Arcade, 1952

Oil on wood, 20 ½ x 15 inches

Gift of the Estate of Udo Reinach,
New York, 1960

German-born Abstract Expressionist painter Hans Hofmann, equally well known for his teaching and his art, was a prominent figure in the American art world from the 1930s through the mid 1960s. He trained in a multitude of styles during his studies in Munich and Paris. *Arcade* demonstrates both the vivid colors and drip painting characteristic of Hofmann's later work—work that was partially inspired by the techniques employed by Jackson Pollack, whom the artist met in the early 1940s. Textural patches of bright color form the background for spontaneous lines of dripped paint, which together create a compositional melody of layers, shapes, and tones.

KAREN CHERNICK '06

ALFRED JENSEN, American,
1903–1981
Opposites Are Complementary, 1978
Oil on linen, eleven panels,
this panel 63 ½ inches wide
48 ½ x 632 ½ inches
Gift of the artist, 1980

Alfred Jensen's eleven-panel painting *Opposites Are Complementary* was included in the 1980 exhibition "Aspects of the 70's: Mavericks" at the Rose, and the artist gave it to the museum at that time. The work is a signature example of the theories and ideas that Jensen worked into his highly diagrammatic paintings throughout his career. Referencing the Nobel Prize winning–physicist Niels Bohr and an ancient Chinese calendar system, the mural is simultaneously indecipherable and a revelation, a fact acknowledged by the artist. Each work, he said, "is a structure complex and not easy to unravel, nor can the truth inherent in its build-up easily be read. . . . My art represents wholeness, a free time and space structure, a color and form realization equal to a vision beyond verbal explanation."[31]

ESTHER ADLER '99

JASPER JOHNS, American, born 1930
Drawer, 1957
Encaustic and assemblage on canvas,
30 ¾ x 30 ¾ x 2 inches
Gevirtz-Mnuchin Purchase Fund, 1962

Jasper Johns was, along with Robert Rauschenberg, among the first artists to react against the overheated introspection of the Abstract Expressionist generation. Instead of seeking meaning in the tormented recesses of his own soul, Johns turned his sights outward, to the banal and everyday. *Drawer* is characteristic of Johns's approach. Nothing could be more mundane than this fragment of a dresser set into a canvas and covered with leaden strokes of gray encaustic paint. But, as always in Johns's best work, the apparent ordinariness conceals a more subversive, more disquieting reality. There is a fetishistic quality—made all the more palpable by the repetitive, sensual application of the paint—that invests the banal with vague longings and unfulfilled desires. This fetishizing of the everyday is reminiscent not only of such Surrealist classics as Meret Oppenheim's fur-covered teacup, but also of such nineteenth-century American trompe l'oeil artists as William Harnett and John Peto. Johns's approach is reserved, even deadpan, but there is a tenderness to his touch and an obsessiveness to his approach that invest the ordinary with poetic dissonance.

MILES UNGER '81

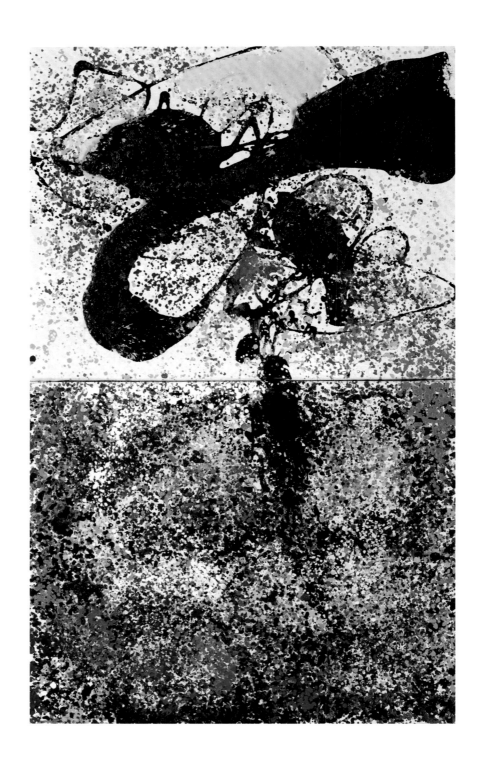

ASGER JORN, Danish, 1914–1973
The Vegetable Cell and Its Private Properties, 1961
Oil on canvas, 42 ³/₄ x 25 ³/₄ inches
Gift of Joachim Jean and Julian J. Aberbach, New York, 1963

Danish artist Asger Jorn was involved with the CoBrA group, which promoted freedom of expression in painting while emphasizing color and brushwork, in the 1940s, and with the Situationist International movement from 1957 until 1961. The ideological principles of both movements are clearly visible in *The Vegetable Cell and Its Private Properties*, which is composed of two sections and features gestural brushwork in vibrant colors. As Jorn wrote in a 1949 credo about his work, "By means of this irrational spontaneity, we reach the vital core of being."[32] Jorn's first New York exhibition, in 1962 at the Lefebre Gallery, presented a contrast of his Northern European Expressionism—already famous in Europe—with nascent American Minimalism and its extreme simplification of the canvas, de-emphasis of composition, and removal of emotionality. While not adapting to the prevailing aesthetic of the 1960s, Jorn also chose to reject the institutionalization of the New York art world, most visibly by rejecting a Guggenheim International Award given him in 1964.

ADELINA JEDRZEJCZAK

ALEX KATZ, American, born 1927
Ada with Superb Lily, 1967
Oil on canvas, 46 x 51 ½ inches
Gift of the Herbert W. Plimpton
Foundation, 1978

Alex Katz met Ada Del Morco in 1957 and the two married the following year. The paintings of her are emblematic of their relationship, the evolution of American culture, and the changing roles of women in society. In *Ada with Superb Lily*, Katz employs a smooth, monotone quality that belies the elegant simplification of his subject. Katz dramatically emphasizes the flatness of the picture plane with blocks of bright colors and strong contour lines. The bleached-out, high-key look glamorizes his wife in a way similar to that in which a fashion magazine would treat its sitter. Katz's work constitutes a distinctive style of modern realism, which combines aspects of figurative painting with Abstract Expressionism.

DANIELLA GOLD '07

ELLSWORTH KELLY, American,
born 1923
Blue White, 1962
Oil on canvas, 103 x 106 inches
Gevirtz-Mnuchin Purchase Fund, 1962

Ellsworth Kelly believes in a correlation between abstraction and nature. *Blue White*, his seminal early 1960s painting, as well as many of his other works, derived from shapes observed directly during everyday life—architectural motifs, shadows, or the human body. Kelly's optical perception was first honed during his time in the camouflage division during World War II, and later through formal art training and exposure to European artists while living in Paris between 1948 and 1954. The work of artists such as Jean Arp and Piet Mondrian provided aesthetic points of reference and aided Kelly in the development of his unique visual language through investigations of color, form, and abstraction. In *Blue White*, Kelly explores the inherent tension between the painted shape and ground, and the optical reflections those create, by engaging organic forms painted in flat, saturated areas of color, delineated by clearly defined edges, and void of pictorial depth. As an artist, Kelly remains unclassifiable: His individual approach to Geometrical Abstraction, while influencing Hard-Edge Painting, Post-Painterly abstraction, Color Field, and Minimalism, do not fully belong to any of those movements.

ADELINA JEDRZEJCZAK

FRANZ KLINE, American, 1910–1962
Crossways, c. 1955
Oil on canvas, 60 x 96 inches
Gift of David Breitman, Boston, 1968

Franz Kline was an Abstract Expressionist artist whose imagery appears to isolate and monumentalize characteristics and techniques associated with the gestural or action wing of the movement, which may relate to the breakthrough procedure of enlarging much smaller brush drawing sketches. In this, *Crossways* is typical, comprised of broad strokes of black paint that move with heft and velocity from edge to edge. Forms seem cut off by the borders of the support, implying extension past its confines. Still, these strokes lumber more than speed, evoking the thrust, tension, and support of architectural members from the urban and industrial worlds. Kline discouraged, though he did not rule out, the associations that these "figure forms," as he labeled them, might produce. The title of this painting is meant to describe the intersections of black paint, covering but occasionally overlapped by brushy areas of white, as forms and space produce a tension between instability and potential resolution.

GERALD SILK '70

LEE KRASNER, American, 1908–1984
Untitled, 1938
Oil on paper, 18 ⅞ x 24 ⅞ inches
Gift of Mr. Samuel Shapiro, Swampscott,
Massachusetts, 1977

Lee Krasner was one of the originators of Abstract Expressionism, along with her husband, Jackson Pollock, creating all-over imagery by unorthodox applications of paint, such as dripping. While this oil study from her student days predates those developments, it indicates the direction her art will take. The abstracted still life reflects the Cubist style she learned from Hans Hofmann, along with the influence of Cézanne. In what Hofmann called the "push-pull," colors create the space in the work—from the warm foreground hues to the cool tones of the background. The geometric shapes linking front and back (reflecting crumpled cellophane backdrops), the equal density of forms spread across the lower half of the composition, the lack of outlines, and the obvious application of paint will take center stage in the following decades. While Krasner paintings from this era are not rare, they are not often exhibited. *Untitled* allows a glimpse of her style in its formative stages.

ELLEN C. SCHWARTZ '69

ALEXANDER LIBERMAN, American,
born in Russia, 1912–1999
Light Flow, 1966
Oil on canvas, 81 x 124 ⅜ inches
Gift of the artist, 1966

Alexander Liberman's painting *Light Flow* departs from his usual brightly colored compositions comprised of circular forms. The donation of the painting was solicited by William Seitz, who became the Rose's Director after curating the 1965 MoMA exhibition "The Responsive Eye," which included Liberman's work. The title probably refers to the painting's absorption of light—i.e., to the fact that light flows into the painting (rather than being emitted by it). It is interesting to note that Seitz selected a painting whose title refers to the perception of light and related optical effects, since those were central themes of "The Responsive Eye." In addition to his career as a painter and sculptor, Liberman was the longtime Editorial Director of all Condé Nast Publications, including *Vogue* magazine. Liberman used his position to commission projects for the magazine from numerous artists, thereby helping introduce fine art to a wide public audience.

NEIL K. RECTOR

JACQUES LIPCHITZ, American, born in Lithuania, 1891–1973
Pegasus (Birth of the Muses), 1949
Bronze, 61 ½ x 88 inches
Gift of the Lester Avnet Foundation and the Jack I. and Lillian L. Poses Foundation, 1971

Jacques Lipchitz left his native Lithuania in 1909 to study in Paris, where he met Brancusi—who in turn introduced him to Picasso. Lipchitz adopted the Cubist style of three-dimensional art, influenced also by his friend Juan Gris. His interests gradually shifted to abstraction and then to intensive involvement with Greek myths. In the 1930s, as war was becoming inevitable with the rise of Hitler, Lipchitz found in the Greek myths meaningful ways of dealing with the horrors he was observing, especially as a Jew. *Pegasus* was originally commissioned by Nelson Rockefeller for his home. The sculpture at the Rose, where it has for years stood as a rather terrifying greeting to students as they enter the Fine Arts building, was made from the same mold as the Rockefeller sculpture. It is both powerful and peculiar in that the sinewy figure surrounded by multiple snakelike limbs looks more like Medusa than Pegasus and that there are no Muses evident anywhere.

MICHAEL RUSH

MORRIS LOUIS, American, 1912–1962
Number 3, 1961
Acrylic on canvas, 94 ½ x 31 inches
Gevirtz-Mnuchin Purchase Fund, 1962

In 1953, Morris Louis and his close friend Kenneth Noland visited the studio of Helen Frankenthaler, where they saw, and were impressed by, her stain painting *Mountains and Sea*, 1952. From that moment, Louis began to experiment with varying ways of paint application, which served as a point of departure for his mature style. As Louis himself said, Frankenthaler created "a bridge between [Jackson] Pollock and what was possible." Shortly thereafter, Louis produced his first series of paintings, called Veils, in which transparent layers of color were poured, superimposed, and stained directly onto unprimed canvas. This innovative method of working, through which Louis produced more than 600 canvases, represented a new direction in painting and a radically new approach to paint and canvas. Between 1961 and his untimely death in 1962, Louis created a series of *Stripe* paintings, in which he poured more intense stripes of undiluted color into tightly grouped sequential bands, reminiscent of a rainbow effect. *Number 3* is a leading example.

ADELINA JEDRZEJCZAK

CONRAD MARCA-RELLI, American,
1913–2000
Gunsmoke, 1961
Oil and collage on canvas,
71 1/8 x 72 inches
Gift of Mr. and Mrs. Samuel M. Kootz,
East Hampton, New York, 1967

Conrad Marca-Relli was a first-generation member of the New York School, an affiliation of Abstract Expressionist artists active in the 1950s and 1960s. *Gunsmoke* embraces Marca-Relli's signature collage and oil paint style. The fabric pieces—tan, largely vertical and rectangular—become more clustered toward the center of the composition. A blue background is glimpsed through spaces in the layering of collage elements. The top half is eclipsed by a circular splotch of black paint, reminiscent of fellow New York School painter Adolph Gottlieb. The composition works as a unified whole, although each piece of fabric or spot of paint is a singular entity. Further, the color palette is reminiscent of Analytical Cubism, and one gets a sense of that style's deliberateness in *Gunsmoke*'s construction. *Gunsmoke* was donated to the Rose by Marca-Relli's longtime dealer, Samuel Kootz, and his wife.

NEIL K. RECTOR

ROBERT MOTHERWELL, American
1915–1991
Elegy to the Spanish Republic, No. 58,
1957–61
Oil on canvas, 84 x 108 inches
Gift of Julian J. and Joachim Jean
Aberbach, New York, 1964

When the Spanish Civil War broke out in 1936, Robert Motherwell was a twenty-one-year-old philosophy student. He went on to study art history with Meyer Schapiro, who encouraged him to become a painter. The atrocities of war made an enduring impression on the young artist and prompted him to produce in excess of 170 works devoted to the theme. *Elegy to the Spanish Republic, No. 58* is an important example. For Motherwell, the war became a metaphor for all injustice, thus making the series both a memento mori and an abstract commemoration of all human suffering. The series, sparked by a small drawing Motherwell made in 1948 to accompany a poem by Harold Rosenberg, shares a common compositional motif of ovoid shapes suspended between, or compressed by, rectangular bar shapes in a contrasting, mostly black and white palette, evoking somberness through its starkness. According to the artist, the *Elegies* became "a funeral song for something one cared about," expressed in visual terms.

ADELINA JEDRZEJCZAK

LOUISE NEVELSON, American, born
in Russia, 1899–1988
Landscape, 1957
Wood assemblage, diameter
33 ½ inches
Riverside Museum Collection,
Rose Art Museum, 1971

As a child, Nevelson said, "I want to be a sculptor. I don't want color to help me." And, indeed, she is best known for her monochromatic assemblages using found objects such as driftwood, balusters, and other wood debris. Landscape is a collection of forms in a circular shape, a format Nevelson used occasionally in the late 1950s to early 1960s. It contains both sawn boards and found pieces, all painted a matte black. The vertical/horizontal contrast forms a subtle grid, while spaces create almost drawn lines. Drawing had long been a concern of hers, and negative spaces take on a major role in later works. Like *Landscape*, Nevelson's assemblages were mostly covered in black paint to unify the disparate objects and focus attention on the overall form; she later used gold and white paint in a similar manner. Nevelson had her first solo museum exhibition in 1967 at the Rose; she was given the Brandeis University Creative Arts Award in Sculpture in 1971.

ELLEN C. SCHWARTZ '69

ALFONSO OSSORIO, 1916–1990

Making of Eve, 1951

Oil and enamel on canvas,

76 ³/₄ x 51 ¹/₄ inches

Gift of Dr. and Mrs. David Abrahamsen,

New York, 1967

The scion of a wealthy Filipino family, Alfonso Ossorio is best known for the box assemblages he made from the late 1950s. Unlike the chaste works of Joseph Cornell, Ossorio's boxes, which include shells, bones, driftwood, glass eyes, ceramic knobs, dice, costume jewelry, antlers, horseshoes, mirror shards, and toys, among other things, frequently tumbled over into kitsch. *Making of Eve* comes from the period soon after the artist met and was influenced by Jackson Pollock. The painting exhibits the same dynamic drip technique Pollock copyrighted. Along with Pollock and other members of the nascent New York School, Ossorio was driven to create an art that reached back to pre-Renaissance archetypes. While other artists sought "the tragic and timeless" in the ancient world, Ossorio, a devout Catholic, looked to the Judeo-Christian myth for sources. Here, he depicts Eve's creation from Adam's rib as an erotic act as much as one of birth.

DAVID BONETTI '69

LAWRENCE POONS, American, born
in Japan, 1937
#30A, 1976
Acrylic on canvas, 107 x 64 ½ inches
Gift of Morton and Charlotte Friedman
in honor of Lois Foster, 1995

Lawrence Poons's early canvases, like so many other American works of art created in the 1960s, reflect the turbulent mind-set of the time. His geometric "dot" paintings employed bold color combinations within a gridlike structure that altered the viewer's visual field. Poons, who never considered himself a true member of the Optical movement, adopted the mores of Lyrical Abstraction in the late 1960s through the mid 1970s. Marked by a loose and spontaneous quality, this style of painting emerged as an alternative to strict Hard-Edge, Minimalist, and pure Geometric Abstraction. It was, however, influenced by the Color Field School and Abstract Expressionism. The paintings Poons created during this later phase of his career successfully diverged from his earlier style. They became noticeably less calculated and more gestural. By pouring paint directly onto his canvases, Poons infused his works with movement and texture, always paying close attention to color. *#30A* is one of the artist's signature drip paintings.

HELENE LOWENFELS '05

FAIRFIELD PORTER, American,
1907–1975
View of Barred Islands, 1970
Oil on canvas, 40 x 50 inches
Herbert W. Plimpton Collection, 1993

Fairfield Porter was a painter as well as a noted art critic. His paintings reveal an understated extraordinariness found within everyday moments. He was primarily self-taught, and his use of bold pools of color, merged with a realist sensibility, serves to highlight the subtle moods of his subjects. Much of Porter's body of work is set within wooded areas of Maine and the Hamptons, and it largely captures portraits of friends and family, homes and their interiors, and the surrounding landscapes. His approach to image making is plainly revealed by his own words: "When I paint, I think that what would satisfy me is to express what [Pierre] Bonnard said Renoir told him: Make everything more beautiful."

SAMARA MINKIN '94

RICHARD POUSETTE-DART,

American, 1916–1992

Untitled, 1961

Oil on wood panel,

13 ½ x 18 ⅜ inches

Gift of Dr. and Mrs. Arthur E. Kahn,

New York, 1982

Richard Pousette-Dart (the unusual combination of his father's name, Pousette, and his mother's, Dart) holds a unique place in American art history. Included among the first generation of New York Abstract Expressionists, his art has little resemblance to what we associate with the muscular gestures of this movement. More Symbolist than Expressionist, his canvases are marked by thick applications of paint that look like color bursts of stucco. More concerned with the spiritual relationship between light and nature than with the physicality of painting, Pousette-Dart produced canvases that reveal an abstract cosmology. In this *Untitled,* a bright mass of light (a whitened sun or a comet) dominates a field of Pointillist blues, reds, greens, and whites. It is a mystical painting that suggests the infinity of the universe. The crusty density of the paint hints at an ancient galaxy that is both disintegrating and rejuvenating itself right before our eyes. Pousette-Dart influenced generations of painters during his years of teaching at Columbia, Sarah Lawrence, Bard, and the Art Students League in New York.

MICHAEL RUSH

ROBERT RAUSCHENBERG, American, 1925–2008
Second Time Painting, 1961
Oil and assemblage on canvas,
65 ¾ x 42 inches
Gevirtz-Mnuchin Purchase Fund, 1962

Maturing in the artistic ferment of New York in the 1950s, Robert Rauschenberg challenged the hegemony of Abstract Expressionism and pushed the nature and limits of art. A student of the German Modernist Josef Albers at Black Mountain College and a colleague of the antimodern John Cage, Rauschenberg learned the tenets of Modern art and worked to undermine them. In the mid 1950s, he began to create his *Combine* paintings, literally combining a wide variety of found materials on his chosen surface. Breaking with the sanctity of painting, Robert Rosenblum anointed Rauschenberg as one of "the Holy Trinity that led us from the Old Testament to the New" (also including Jasper Johns and Frank Stella). *Second Time Painting* is one of a group of three works that Rauschenberg created as a performance at the American Embassy Theater in Paris in 1961. Staging a parody of the infamous painting performance by *art informel* artist Georges Mathieu in 1958, Rauschenberg turned the backs of the canvases to the audience, who only heard the voice of the artist as he painted the works, then the alarm that announced the completion of the work.

JOSEPH D. KETNER

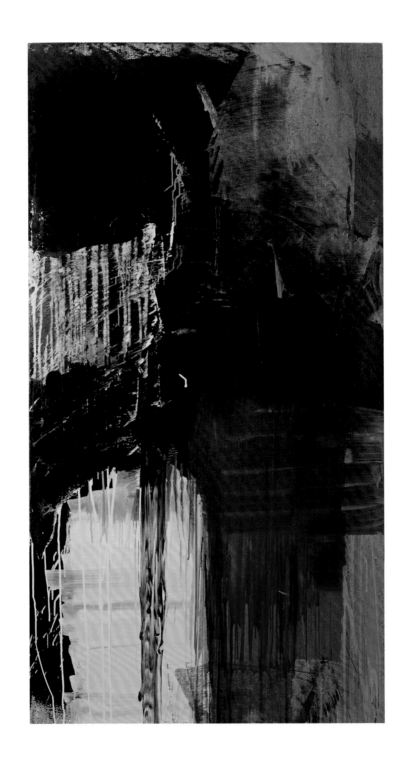

DAVID REED, American, born 1946
#1, 1972
Oil on canvas, 76 x 38 x 1 ½ inches
Gift of Johanna Butler-Tenenbaum, 2003

#1 was painted early in David Reed's career, shortly after he settled permanently in New York. The peculiar vertical dimensions of the painting echo the size of the door into the downtown loft he sublet that summer, and its marks and their locations relate to the gestures and movements attendant with opening a door. Responding to the pervasive influence of process art and Minimalism, Reed employed mundane, repetitive actions and a phenomenological awareness of the body's occupation of space to evolve a new abstract painting language. The first of an overarching series that has been numbered to this day, *#1* showed the artist novel effects of color and transparency that were formative. Today, Reed's works are among the most intelligent and nuanced works of art to extend the history and language of painting. This canvas is one of several owned by the Rose; together, they comprise one of the most significant public holdings of the artist's works.

ANNETTE DIMEO CARLOZZI '75

DAVID SMITH, American, 1906–1965
Table Torso, 1942
Bronze sculpture,
10 x 4 ¼ x 5 ⅝ inches
Charna Stone Cowan Collection, 1975

Striking in its combination of living and inanimate, insect and human, *Table Torso* is significant in the development of the influential American sculptor David Smith. The compositional use of a table form bridging the insect/animal configuration above and the plantlike, tripod-shaped base in this lost-wax bronze casting foreshadows Smith's later, large-scale welded iron and steel works. *Table Torso* has been interpreted as a visualization of Sigmund Freud's theories of totemism. Yet the combination of breasts on one side of the "torso" and a phallus on the other also brings to mind Carl Jung's belief that we each possess features of both sexes—an idea famously explored by Smith's colleague Jackson Pollock in the painting *Male and Female*, created, like *Table Torso*, in 1942. Today, the hybrid character of *Table Torso* invites fresh associations, such as with genetic experimentation. In its delicate forms and strange combinations of elements, *Table Torso* is at once elegant and disturbing—contradictory qualities that give this small sculpture its big impact.

REVA WOLF '78

LEON POLK SMITH, American,
1906–1996
George Washington Bridge #2, 1979
Acrylic on canvas, 80 x 220 inches
Gift of Mr. Gerald Lennard, 2000

Leon Polk Smith's monumental painting of the suspension bridge that connects New York and New Jersey stretches more than eighteen feet over three canvases. Despite its descriptive title, however, the work is a signature example of the artist's studies in geometric abstraction. As he stated in 1982, "The content of all of my works for over forty years has been mainly concerned with space and color."[33] With the utmost simplicity of line and a limited palette, Smith uses modern means to mimic the three-point perspective of the Renaissance, as his central circular panel seems to swing away from us, while the two on the ends remain in our space. His exploration of the curved line, in this case both in the shape of his canvases as well as his composition, provided Smith with ample material during his later career.

ESTHER ADLER '99

THEODOROS STAMOS, American,
1922–1997
The Divide II, 1958
Oil on canvas, 70 x 70 inches
Gift of Louis K. and Susan P. Meisel, 2007

Theodoros Stamos was the youngest of the first generation of American Abstract Expressionists. A close friend of Mark Rothko's, Stamos carved his own path of exquisitely color-charged canvases whose content, no matter how abstract, was most often based on nature. In 1967, Stamos was appointed the third Maurice and Shirley Saltzman Artist-in-Residence at Brandeis, following Jacob Lawrence and Philip Guston. The notion of the "divide" (between earth and sky, life and death) preoccupied Stamos throughout his life. In *The Divide II*, his identification with nature extends into topography, with shapes suggestive of aerial views of the land. He began visiting Greece in 1948 and became captivated by the colors and textures of the island of Lefkada, from which his family had emigrated. Here, the rich browns and blues he would have encountered appear on the canvas hugging a black surface to the left. It is significant that the year of this work, 1958, was also the year Stamos was included in the seminal exhibition "The New American Painting" organized by the Museum of Modern Art in New York.

MICHAEL RUSH

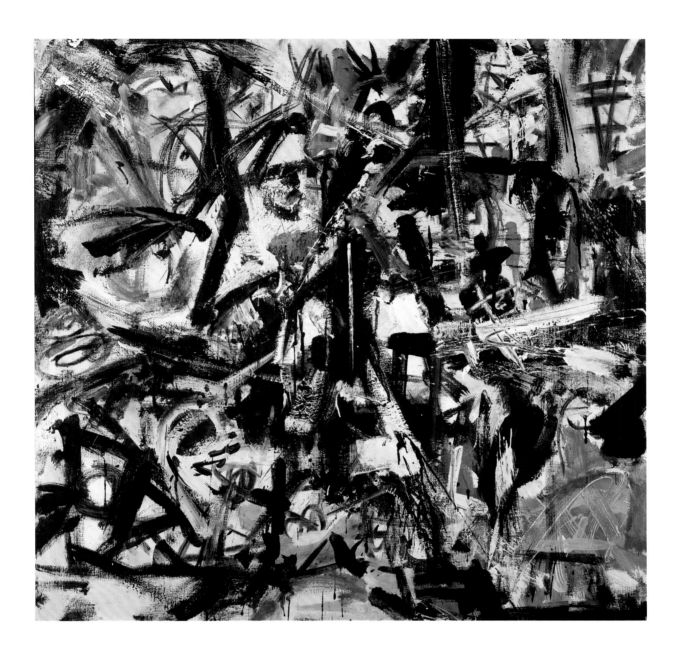

EMILIO VEDOVA, Italian, 1919–2006
Immagine Del Tempo No. 2, 1958
Oil on canvas, 43 ⅛ x 43 ¼ inches
Gift of Howard Wise, New York, 1966

Emilio Vedova, the self-taught Italian painter and printmaker, positioned his work as a response to contemporary social upheavals. While akin to the Futurist movement in emotionality, Vedova's stance differed from the Futurists' celebration of the energy of societal conflict, instead conveying the horrors of man's assault on mankind. The artist's political consciousness first emerged in the late 1930s, when he began painting in response to the Spanish Civil War. Through feverish brushstrokes and impasto paint, discernible in *Immagine Del Tempo No. 2*, Vedova combined his sociopolitical reasons for painting with the formal qualities of allover composition, lack of pictorial depth, and dramatic brushstrokes of Abstract Expressionism, reminiscent of Franz Kline and Jackson Pollock. From 1948, Vedova produced several series of dynamic works, of which *Immagine Del Tempo No. 2* was part. The 1951 painting *Immagine Del Tempo* is in the permanent collection of the Solomon R. Guggenheim Museum.

ADELINA JEDRZEJCZAK

POP AND MINIMALISM, MORE OR LESS | *By Gerald Silk*

The Rose Art Museum has a fine array of works classifiable as Pop or Minimalism and there are reasons why these developments appear in the same chapter. Both arose in response to art and culture in the post–World War II years and are key examples of a succession of named art movements that emerged up through the early 1970s. At first they may appear worlds apart, but links do exist. Both rejected and retained ideas and practices fundamental to Abstract Expressionism. For example, both claimed avoidance of the subjectivism, high-pitched emotion, and metaphysical and sublime ambitions of Abstract Expressionism, especially as embodied in painterly pieces issuing from a muscularly physical process. Pop and Minimalist artists adopted instead an arguably cool and mechanical approach defined through preconception rather than through "psychochoreographic" action.

In an age when the formalist critical approach putatively reigned, some discounted Pop's potentially loaded subject matter, viewing its bold, sharp-edged, sometimes reduced forms as similar to Minimalism (and by extension to two-dimensional work in related categories such as Op, Hard Edge, Color Field, and Post-Painterly Abstraction). Pop mined media intermediaries: The three-dimensional world had already been translated into two, and this flatness corresponds to Minimalist practice and theory. Rather than interpreting Pop as aspiring to

formalist abstraction, one might construe some abstract painting of this time as tied to the commercial, popular, and corporate domains of arresting, emblematic, and graphic imagery that Pop probed. As artists competed for recognition and scrutinized "signature" style, this signature might correspond to signage. That said, the relationship between these two movements is hardly clear-cut, and an examination of artists and works—some from the Rose collection—may help untangle issues.

As a labeled movement, Pop came first, allied to the tremendous growth in popular culture and mass media, fueled by prosperity in the United States in the postwar years. Unlike the Abstract Expressionists, who generally eschewed this world, Pop artists addressed themes from contemporary consumer and technological culture, often rendered in ways influenced by mass media, such as glossy advertising, modern packaging, gritty newspaper photography, and eye-catching billboards. Pop initially arose in Great Britain in the mid 1950s, as its artists expressed envious fascination with the mass urban culture so virulent in America but nascent in the nations devastated by the war.

This may not be the forum to determine who precisely fits the Pop moniker, but Jasper Johns and Robert Rauschenberg, considered in another chapter (and sometimes called Neo-Dada), and Larry Rivers shared an

interest in common and popular imagery. Their nod to painterly gesture or its mere flicker bonds with or critiques Abstract Expressionism, distinguishing their work from tighter Pop styles. Rivers had it both ways: From commercial culture he culled images with origins in the fine arts, so a loose rendition of a Dutch Masters cigar logo permits copying a Rembrandt masterpiece. His *Webster Superior*, 1961, a smeary depiction of a cigar box label bearing a portrait of Daniel Webster (most likely from a Matthew Brady photograph), indicates how branding had already conflated the fine and vernacular. If Pop elevated common objects to fine arts heights, insinuating how both function as commodities, then the commercial world cited important art and people to lend class to its products. As a cigar aficionado and distinguished statesman, Webster seemed a sensible choice even though his appreciation of smoke and drink probably prevented his admission to Harvard (he went to Dartmouth). Through words like "Masters" or "Superior," Rivers further plays with high-low hierarchies.

Webster was not the only famous historical figure to grace a cigar box. George Washington appeared as well, in one instance seen crossing the Delaware, a subject Rivers raided in his most famous painting, referencing this mythic narrative and its representation in an 1852 painting by Emanuel Leutze. In this spirit, several artists in the Rose engage in appropriational banter within and across chapters. African-American artist Robert Colescott uses punning images and titles to explore race, recasting George Washington Carver into this historical event. In *I Gets a Thrill Too When I Sees De Koo*, 1978, Colescott inserted a smiling "Aunt Jemima" face into his quotation of Willem de Kooning's iconic *Woman I*, 1950–52. With its title derived from risqué black lingo and Mel Ramos's series *I Still Get a Thrill When I See Bill* (another reworking of *Woman I*), he surveys the relationship in art and history between inclusion and exclusion, artist and model, original and copy, fine and vernacular, and good and "bad." For Ramos, art-historical images of the female nude became apt habitats for his softcore, *Playboy*-type figures, as in his *You Get More Salami With Modigliani*, 1977, which pilfers from Modigliani while harking back to Ingres and Velázquez. These recontextualizing homages elevate De Kooning to near Old Master status, acknowledging the high-low friction and synergy in his study for the controversial Woman series containing a collaged photo of a woman's mouth from a Camel cigarette ad.

Appropriation punctuates Pop, and co-options from art history permit dialogue and entry into this history. Through multiplied images of the Mona Lisa, Warhol (in the spirit of Marcel Duchamp) remarks on its saturation as a reproduction, putting it on a level playing field with other people and things like Marilyn Monroe, Mao, or bottles of Coke. To Warhol, everything was a packaged

commodity: Leonardo's art, Jackie Kennedy's grief, a can of soup, and ultimately his own work. Canned soup was worthy because it brought comfort to him and his generation akin to what the Madonna provided to earlier cultures. He spoke sardonically of painting the outside of the can while the Abstract Expressionists painted the inside: He's interested in the surface of things, not in inner emotions, humorously conjuring up visual approximations between noodle soup and the look of a Pollock.

Branding his studio the "factory," where assistants might make the art, using a screenprinting technique, exploiting banal and popular motifs, and claiming to want to be like a machine, Warhol epitomizes the apparently deadpan Pop sensibility. *Saturday Disaster*, 1964, raises paradoxes, however. Part of his Death and Disaster series, with topics such as race riots, the electric chair, suicide, the atomic bomb, political assassination, and the quotidian dangers of eating canned food (tainted tuna rather than soothing soup) and driving a car (on a weekend night for fun and entertainment), the piece hardly seems neutral. Warhol argued that repetition of even horrific images deflates their impact. During an age of contentious activism and unrest, this expression of dispassion offers observations—like those of other contemporary social philosophers and theorists—about a jaded world glutted with images that can engender psychic, emotional, cultural, and perceptual anaesthetization. Similarly, Roy Lichten-

stein used comic strips as technical and thematic muses to portray saccharine and unattainably idealized heroic violence or overwrought love, as exclaimed in *Forget It! Forget Me!*, 1962. Lichtenstein also refashioned specific and generic art chestnuts in comic-book style and even his borrowed "true romance" or "war hero" frames can allude to the artworld, from representations of kisses to the machismo of Abstract Expressionism.

Warhol's Death and Disaster series considers how tragedy can arise from celebrity: Think of Jackie, Marilyn, Elvis, and even Warhol himself, who was shot in the late 1960s. Tragedy can also confer "fifteen minutes of fame" on unknowns, and other Pop artists utilized glamour, death, sex, and food as modern-day vanitas symbols. Consumer culture emblems appear in James Rosenquist's work, as in *Two 1959 People*, 1963, which furthermore explores the perceptual idiosyncrasies of the modern environment, whether experienced riding down a highway or leafing through magazine pages. Comparable motifs occur in *Still Life No. 25*, 1963, by Tom Wesselmann, who updates and Americanizes venerable art historical genres. This mixed-media rendition of a somewhat modern kitchen encourages exchanges about materials, textures, and sources, from Cubism through Matisse to images of divine intervention, as floating hands proffer cheese in sparkling aluminum foil.

Food figures prominently in Claes Oldenburg's

work. Less indebted to mass media techniques, Oldenburg amusingly interrogates, transmutes, anthropomorphizes, and eroticizes the power and primacy of everyday objects and forms. Exhibited in the second of his "The Store" events, his *Tray Meal*, 1962, blatantly overlaps art with commodity. Intrigued with visual homologues, Oldenburg creates correspondences between product and art-world consumption. Another piece, a Jello mold cast from the artist's face that stares up from its exhibition plate, challenges the art consumer to dig in. This navigation of the shoals of consumption, victimization, alienation, assimilation, and reputation is a theme in Warhol's *Louis Brandeis*, 1980, part of his Ten Portraits of Jews of the Twentieth Century, and in Marisol's *Ruth*, 1962. Warhol, who grew up shy, bullied, and ostracized, achieved great celebrity, and these Jewish successes signify outsiders acquiring fame through talent, as Brandeis's luminousness lives on in the university named after him. Marisol, combining folk materials and techniques with modern dilemmas that can reveal Pop's sexism, struggled to balance the roles of woman and artist, often incorporating her own features into her art. *Ruth* portrays her friend Ruth Kligman—she and Marisol were part of Warhol's entourage. Kligman, herself an artist, gained notoriety as the girlfriend of several famous artists and lone survivor of the car crash in which Pollock died.

Minimalism, primarily arising on the heels of Pop, shared dissatisfactions with the emotional subjectivism of Abstract Expressionism while indebted to Ab-X's Color Field wing, chiefly to the art of Barnett Newman and Ad Reinhardt. Abstract and geometric and, as its names implies, generally reduced and simplified, Minimalism operates more forcefully in sculpture because of its rationale of approximating a nonreferential object. Painting, no matter how nonallusive or austere, still seemed to imply something pictorial or illusionistic. This is why Frank Stella put canvases on thick stretchers and notched or shaped them in order to assert their "objecthood," a term of the time. Still, Stella's work often has a vernacular energy and optical pulsation. *Konskie*, 1972, a mixed-material sketch for a larger, complex wall piece, is based on the rooflines of eighteenth-century Polish synagogues destroyed by the Nazis, and its interlacing of Constructivist art principles with historical atrocity defies orthodox Minimalism.

More typical is the work of Donald Judd, Carl Andre, and Sol LeWitt. Articulated not just in artworks but in theoretical writings, especially by Judd and Robert Morris, Judd preferred the term "Specific Objects," as spelled out in his essay of the same name, casting a curiously broad net of artists into this tendency. His *Table Object* 1968—from the portfolio multiple *Ten from Castelli* honoring the art dealer who championed Pop and Minimalism—is nonetheless Minimalist. Geometric and

modular, it consists of four three-sided rectangular beams placed side by side, one after the other, rebuffing Cubist asymmetrical relations and urging a holistic, graspable reading. True to its title, *Table Object* has its open sides sitting directly on the floor and no circumscribing pedestal. The piece is not crafted by the artist but industrially fabricated, based on his drawings and instructions.

Andre, best known for floor-hugging metal units on which the visitor can tread, nearly expunges sculptural volume, makes the milieu a crucial part of the piece and defies priapic verticality, challenging the traditional heroic monumentality of sculpture, something Oldenburg also investigated. Invoking while inverting Brancusi's sculpture, Andre's cement sculpture *Concrete Crib,* 1964, comprised of humble, rough-hewn, and less sleek materials than Judd's, interacts porously with its space.

Pop's mundane motifs and commercial techniques made viewers question roles of art, craft, originality, and authorship. Likewise, Minimalism forced spectators to confront how something so apparently simple or unassuming could function as art. Minimalism's stark endemic qualities promoted experiences defined by relationships between the work and other things: the space of the room and its possible institutional location and the observer apprehending and moving around it. As phenomenological as it was formal, Minimalism reflected the attitude of artists whose educational environments were in the liberal as much as in the fine arts, where a philosophy, as well as a studio class, could offer inspiration and provocation.

Focus on conceptualism, philosophy, theory, and industry led some to see Minimalism as cold, corporate, and masculinist. These concerns helped prod Post-Minimalism, which enlisted and subverted Minimalism's rigorous repetition and rectangularity, variously introducing organic, anthropomorphic, primitivist, process-oriented, natural, random, and eccentric elements. Understandably, several Post-Minimalists were women, including Jackie Ferrara, though her art operates in multiple camps. Her *121 Curved Pyramid*, 1973, subjects Minimalist serialism to heterodox handcrafting and curvilinearity. Summoning up the great pyramids and perhaps a contemporary belief in a mysterious "pyramid power," the piece reveals how history could imbue basic forms with idealist and spiritualist meaning, providing an unexpected and unintended way to think about Minimalism. Oscillating between solid and pervious, *121 Curved Pyramid* architectonically inhabits space, implying how Minimalism paved the way for land art, in which Ferrara was engaged. Ambitious earthworks, reverberating with archaic and back-to-nature connotations, commingled with grander surroundings and, if in remote locales, reinforced the institutional rupture and sacred pilgrimage of post-studio art. Recently, Ferrarra has made furniture-art hybrids, recalling Judd's functional reference in *Table*

Object and his own art furniture, as so much of Pop and Minimalism promotes fluidity among art, commodity, object and design.

This chapter contains Optical Art by Richard Anuszkiewicz, Bridget Riley, and Yvaral. Op correlates with aspects of Pop and Minimalism. Its psychedelia and ultimately modish commercialism wed it to pop culture; its abstractness and nonreferentiality to Minimalism; its supposed impersonality and hard-edged style to both movements. Practitioners worldwide exploited optical illusions so that the work seemed to warp, bulge, bend, vibrate, and flicker. In a Constructivist-Bauhaus tradition now energized by the space and science races, much Op was experimental and collective, researching principles for integrating art and design. This came back to haunt William Seitz, Director of the Rose Art Museum in the late 1960s. In 1965, he mounted "The Responsive Eye" at MoMA, where he was then curator. The exhibition was hijacked somewhat as commercial galleries and fashion designers orchestrated an Op-related media blitz prior to its opening, blurring distinctions between MoMA's seriously scholarly international historical survey of Optical and Kinetic art and the publicity circus surrounding this stylistic, but also pop cultural, phenomenon.

Two years earlier, Seitz had perspicaciously published a trenchant analysis of the avant-garde not in an art journal but in the fashion magazine *Vogue*. In an argument with historical precedents and many followers, he wrote about how Western capitalist consumer culture undermines subversive and oppositional art tendencies not through rejection or suppression, but through absorption and acceptance. On the cusp of Modernism and Post or Late Modernism, Pop and Minimalism were protagonists in this seminal vanguard discourse and drama that may have reached its crescendo during the heyday of the 1960s, as Pop opportunistically toyed with commercial exploitation and co-option and Minimalism staunchly resisted it.

DR. GERALD SILK '70, ART HISTORY CHAIR AT the Tyler School of Art, Temple University, writes and curates widely on modern art. He has received a Lindback Distinguished Teaching Award, an American Academy in Rome Prize, a CASVA Senior Fellowship, and several NEH grants.

RICHARD ANUSZKIEWICZ, American,
born 1930
Light Lime, 1971
Acrylic on panel, 26 x 20 inches
Gift of Sidney Rose in memory of his
mother, Mary D. Rose, 1980

Although Richard Anuszkiewicz is primarily associated with the 1960s Op Art movement, much
of his painting, like *Lime Light*, addresses the relationship of figure and ground through the use of
sophisticated color relationships and systematic and gridded constructs. In this composition, concentric
light-green lines of varying widths appear to be methodically placed on pastel fields of blue, lavender,
and orange, creating a general haze effect. However, in the center of the composition, the figure and
ground are energized, emphasizing a glowing orange rectangle punctuated by bright green lines. The
complementary shades of orange and green draw the eye's focus, and the diagonals formed at the
corners of the color bands provide an illusion of three-dimensionality. By using a concrete structure for
color, Anuszkiewicz unified the composition, melding subject and object into one.

NEIL K. RECTOR

GENE DAVIS, American, 1920–1985
Moondog, 1965
Acrylic on canvas, 116 x 161 inches
Anonymous gift, 1966

Gene Davis's monumental stripe painting *Moondog* was created for Gerald Nordlund's *ArtNews* article "Gene Davis Paints a Picture" (April 1966). Davis is associated with the Washington Color School, a group of abstract painters in D.C. who made color the foremost element of their work. Davis's signature stripe style is achieved by the application of highly saturated acrylic paint to unprimed cotton duck in straight lines at equal intervals. Davis's colors are selected and applied intuitively. While they operate with an intrinsic harmony, they maintain their individuality. A former trumpet player, Davis referred to his process as "playing by eye," likening himself to jazz musicians who play by ear. The repetitive and rhythmic nature of Davis's style is echoed in the title of this painting. "Moondog," aka John Thomas Hardin, was a well-known jazz street performer in New York.

NEIL K. RECTOR

JIM DINE, American, born 1935
Double Red Bathroom, 1962
Oil and assemblage elements on canvas,
50 ⅛ x 80 ¼ inches
Gevirtz-Mnuchin Purchase Fund, 1962

Double Red Bathroom, part of Jim Dine's larger Bathroom series of 1962, thematizes the material, object quality of the stuff of our lives. Along with other Neo-Dada artists, Dine recognized the importance of the banal to our everyday existence. As one critic put it, "the tragic and the remarkable, the dramatic and the exceptional can be countered with the comic and the ironic, the obvious and the trivial, because ordinary acts are no less significant than extraordinary events in their effect on us."[1] Thus, an assemblage of items found in a bathroom and painted bright red—a towel rack, toothbrush holder with toothbrush, a toilet paper holder with toilet paper, and mirrored medicine cabinets—can represent the expressiveness of objects; everyday life on display to be considered as thoughtfully and deeply as one would any other artistic presentation.

MEGAN ROOK-KOEPSEL '05

CARL ANDRE, American, born 1935
Concrete Crib, 1964
Cast concrete, arranged in seven tiers
of two bars each, 11 x 11 x 17 ½ inches
overall
Anonymous gift, 1966

In opposition to traditional concepts of unified sculpture, Carl Andre's *Concrete Crib* is made of separate units that can be picked up and interchanged with each other. In this work, the configuration of the blocks are determined by simple, mathematical concepts and connected in a temporary fashion. After working on the Pennsylvania Railway for four years as a freight brakeman and conductor (1960–64), Andre became enamored of ready-made standardized materials. The parts are presumed to be replaceable and nonhierarchical. Precision, consistency, color, and scale are all predetermined. Much of Andre's work has been thought to resemble architecture, as it relates to physical locations. *Concrete Crib*, although retaining placelike qualities, is conceptually and physically different from the location in which it is displayed. By exhibiting the work directly on the floor, free of a base or a case, Andre emphasizes its self-sufficiency and comments upon the confined relationship between sculptures and the interiors in which they are exhibited.

DANIELLA GOLD '07

JACKIE FERRARA, American, born 1929
121 Curved Pyramid, 1973
Fifty-five wolmanized fir-wood blocks,
35 x 60 x 18 inches overall
Rose Purchase Fund, 1993

Ferrara uses modular serial patterns in constructions that convey ambiguity, movement, or serenity. *121 Curved Pyramid* consists of fifty-five wood blocks, each 3 ½ by 5 ½ by 11 ½ inches, placed in ten successive rows, with ten blocks on the lowest row and one at the top. As a curved wall, this sculpture may be considered a shelter, barrier, or divider. The blocks are spaced to touch one another on the inner concave side, and gap on the outer. This creates density on the inside and an airiness on the outside. In contrast, the related *Stacked Pyramid*, a large outdoor sculpture of the same material (1973; Neuberger Museum, Purchase, New York), is solid and immobile. Ferrara works consistently with limitations and systems to create beauty in repetition. Her works range from delicately crafted wood pieces to grand site-specific architectural spaces to mosaics on walls and floors. Her recent seats and tables are functional variations on traditional forms that show refinement and humor.

AMY GOLAHNY '73

DOUGLAS HUEBLER, American,
1924–1997
Bradford Series 2-66, 1966
Formica on wooden armature,
39 x 40 ½ x 25 inches
Gift of Jack O. Cohen, Boston, by
exchange, 1967

Douglas Huebler's performative projects in real time and space, critical to the development of Conceptual Art, grew out of his work as a sculptor in the mid 1960s. While teaching at Bradford College in Haverhill, Massachusetts, less than an hour away from Brandeis, he began making wooden forms covered with Formica. With no predetermined top or bottom, and named for the place where they were conceived, the works derive much of their meaning from interaction with the viewer, and our locating of them in our own space. The use of Formica, a commercial material frequently found in interiors, in neutral shades challenges our perception of tones—the pink of *Bradford Series 2-66* can seem like a shadow, depending on the viewer's position and the surrounding light. Like much of the sculpture associated with Minimalism, Huebler's forces us to question how we define a work of art and our own relationship to an object in space.

ESTHER ADLER '99

144

ROBERT INDIANA, American, born 1928
The Calumet, 1961
Oil on canvas, 90 x 84 inches
Gevirtz-Mnuchin Purchase Fund, 1962

In a world where, according to Robert Indiana, "signs were more profuse than trees," he adopted their shape, colors, lettering, and numerals for his visually arresting art that is symbolic of extended, often political, social, and autobiographical information. His famous image "LOVE" is emblematic of the 1960s "love generation," "free love movement," and slogans like "make love not war." His autograph "Indiana" is a pseudonym inspired by his home state, where his father had a Phillips 66 gas station. *The Calumet*—alluding to "Indians" and Indiana and thus the artist's alias and birthplace—is one of his literary paintings. Comprised of star-encircling phrases from Longfellow's "Song of Hiawatha," it evokes tepees and villages from lost Native American tribes and symbols from the flag of those who displaced them. Red, brown, and yellow may suggest warning road signs, earth and fields, and perhaps skin and hides. Referring to the peace pipe, *The Calumet* was exhibited at the White House in 1966 during the Vietnam War.

GERALD SILK '70

DONALD JUDD, American, 1928–1994
Table Object, from the portfolio
Ten From Castelli, 1968
Stainless steel, 24 x 20 x 2 ⁹/₁₆ inches
Gift of Mr. and Mrs. H.C. Lee, Belmont,
Massachusetts, 1974

The simplification of shape, color, and volume in Judd's *Ten From Castelli* serves to reduce art to its basic form—the cube. Judd challenged the artistic convention of originality by using manufactured elements and by creating simple geometric compositions that were later arranged by his assistants. By using factory materials, Judd obtained perfect finishes on his work without having to lay a hand on the piece itself. The strict geometric arrangement of the sheet metal eliminates any idea or emotion from the composition and achieves a singular focus on the object itself. Instead of referring to his work as sculpture, Judd named them "specific objects," a phrase that purposefully separates his work from traditional artistic expression and craftsmanship. By focusing on the presence of the structure and the space around it, *Ten From Castelli* draws particular attention to the relationship between the object, viewer, and environment.

DANIELLA GOLD '07

BIBLIOTECA CINEMATOGRAFICA

3

Carl Th. Dreyer

Vampyr

L. VERONESI

R. B. KITAJ, American, 1932–2007
*In Our Time: Covers for a Small Library
After the Life for the Most Part*, 1969
Fifty silk screen prints,
30 ¼ x 22 ¾ inches
Gift of Joseph McNasby, Laurel Springs,
New Jersey, 1979

Each print in this suite portrays a book cover. The volumes are wide-ranging in subject, prompting viewers to seek an underlying unity. One unifying feature, suggested by the title, is that these volumes are either from or influenced by Kitaj's time. However, *In Our Time* also refers specifically to Kitaj—an American painter who worked primarily in England—and his wife Elsi, who died the year Kitaj created these prints. Likewise, *After the Life* in the subtitle may mean both "copied from life" and "after Elsi passed away." Collective and personal historical associations are evident in each print. Danish filmmaker Carl Theodor Dreyer's *Vampyr* is in a Spanish edition, indicating the cross-cultural fertilization characteristic of the time, while Dreyer completed *Vampyr* the year of Kitaj's birth. *In Our Time* fascinatingly explores the complex interconnections of history, biography, books, and art.

REVA WOLF '78

YAYOI KUSAMA, Japanese, born 1929
Blue Coat, 1965
Construction of aqua- and black-striped
cotton cloth, stuffed, on wire hanger,
44 ¼ x 44 ½ x 9 inches
Bequest of Louis Schapiro, Boston,
by exchange, 1967

Yayoi Kusama's soft sculpture *Blue Coat* is typical of her manner of obsessive allover abstraction
used in both her individual works and her installation pieces. Here, tightly packed swarms of blue-
striped phallic forms spread over the entire surface of a garment, giving the impression of a body
consumed by sexual compulsion and dominated and obliterated by continuous waves of energy in a
pulsating universe.

JUDY ANN GOLDMAN '64

SOL LEWITT, American, 1928–2007

Pyramid #4, 1986

Painted wood,

78 ½ x 39 ½ x 39 ½ inches

Gift of the artist, 1993

By merging his sculptures with architecture, LeWitt sought to create art that utilized simple, impersonal forms and mathematical guidelines. LeWitt preferred the term "structure" to describe his three-dimensional works, rather than the traditional term "sculpture." *Pyramid #4* draws the viewer's attention away from traditional associations, like the Egyptian pyramids, and toward abstract conceptions of perception and vision. Unlike some Minimalists, LeWitt was more interested in systems and concepts than in materials. To him, it was the ideas that counted. He evolved a method that allowed others to execute his work with simple directions and diagrams. LeWitt even suggested that the Rose refabricate the piece in metal in 1995 because of limited storage and indoor exhibition space. What is fascinating is that LeWitt gave instructions for whom to contact to have it refabricated and that he would not do the work himself.

DANIELLA GOLD '07

ROY LICHTENSTEIN, American,
1923–1997
Forget It! Forget Me!, 1962
Magna and oil on canvas,
80 x 68 ⅛ x 1 ⅝ inches
Gevirtz-Mnuchin Purchase Fund, 1962

Roy Lichtenstein found his raw material in the world of pulp comic books, elevating the low-art genre into high art through a process of selection and exaggeration. By removing panels from their narrative context and enlarging them to epic proportions, he made them at once iconic and fraught with mysterious meaning. *Forget It! Forget Me!* is rendered in his signature style. The ostensible subject matter, the story of a relationship gone sour, is immediately apparent, but without the panels extending on either side, the single moment remains inexplicable. Lichtenstein pays tribute to the graphic power of these mass-market productions while simultaneously deflating the rhetoric and pretensions of high art by replacing them with obviously canned emotions and stilted dialogue. Ironically, though Lichtenstein borrowed his material from the world of cheap, mass-produced images, his signature distillations have now become a shorthand signifier of "high art" that can be used to impart instant glamour to commercial products.

MILES UNGER '81

MARISOL, American, born Venezuelan
in France, 1930
Ruth, 1962
Carved wood and mixed media,
65 x 31 inches
Gevirtz-Mnuchin Purchase Fund, 1962

Marisol's portrait sculpture shows affinities with Pop Art tempered by a folk art sensibility. In this mid 1960s depiction of a friend from the art world, a barrel forms the body; breasts are applied as separate units, as are the multiple legs and heads. The carving of the heads includes finished elements along with others that exhibit chisel marks, as if still in process. As seen here, Marisol often paints parts of the image and leaves others to exhibit the grain and color of the wood which is her chosen medium. The large blocks of color and the inclusion of ready-made elements such as the barrel are characteristic of her technique; the repeated heads and body parts of *Ruth* are seen elsewhere in her work at this time and echo the series of many Pop artists. Often humorous and satirical, sometimes searching, Marisol's portraits capture the essence of the subject in her unusual assemblage technique.

ELLEN C. SCHWARTZ '69

KENNETH NOLAND, American, born 1924
Opt, 1966
Acrylic on canvas, 108 x 60 inches
Gevirtz-Mnuchin Purchase Fund, by exchange, 1967

Kenneth Noland studied at Black Mountain College in North Carolina, an experimental liberal arts college that played a large role in postwar art. There, he experienced the work of Paul Klee, whose use of color became largely influential in Noland's own work. In 1950, art critic Clement Greenberg introduced Noland to Helen Frankenthaler and her Color Field paintings. Noland experimented with the stain technique and other methods of blocked color application. His was among other works termed "Post Painterly Abstraction" by Clement Greenberg. This group of artists worked within contained linear space in a way that Abstract Expressionists traditionally did not.

Opt, painted by Noland in 1966, is classifiable in shape and color. The canvas is a diamond, with four calculated, equal sides. Noland experimented with three shades here: white, which can be classified as the negative space on this canvas; red, the colored space; and black, the positive space. Noland's juxtaposition of these three fields plays with the viewer's perception of color, space, and shape.

TAMAR FRIEDMAN '07

CLAES OLDENBURG, American, born in Sweden, 1929
Tray Meal, 1962
Stainless steel and painted plaster, 11 ⁵⁄₈ x 15 ½ x 4 ⅞ x 4 ⅞ inches
Gevirtz-Mnuchin Purchase Fund, 1962

Claes Oldenburg, a major figure of Pop Art, is best known for humorously interrogating, transmuting, anthropomorphizing, and eroticizing the power and primacy of everyday objects and forms. His procedures most often involve hardening, softening, monumentalizing, miniaturizing, and fragmenting. Oldenburg had two "The Store" exhibitions that investigated the relationship between art and commodity: The first approximated a commercial retail store, the second occurred in a gallery space. *Tray Meal*, exhibited in the second, may allude to a modern standardized, processed convenience and a modern medium: the TV dinner. Still, it reads more like an institutional meal, though its range from "mystery" meat to fresh salad and perhaps avocado indicates conflicting dining levels. Like others of his generation, Oldenburg recognized correspondences between the art world and consumer culture, offering provocative representations of strangely indigestible and sometimes threatening foodstuffs. As Oldenburg challengingly pronounced; "I am for an art . . . that does something other than sit on its ass in a museum."

GERALD SILK '70

MEL RAMOS, American, born 1935
You Get More Salami With Modigliani, 1977
Oil on canvas, 44 x 63 inches
Gift of Louis K. and Susan P. Meisel,
New York, 1999

You Get More Salami With Modigliani exemplifies the artist's insertion of nude, generally female figures related to soft-core, *Playboy*-type pornography into works about food, animals, advertising, and art history. Based on Modigliani's 1917 *Reclining Nude*, the piece acknowledges this motif as favored by both artists. Ramos did twenty versions based on different Modigliani paintings and he sought models or photographed his wife, his favorite source, using odd lenses to approximate Modigliani's strangely shaped figures. The Rose version, with torso facing backward and head turned outward, also harks back to famous paintings of nudes by Velázquez and Ingres. Mixing high and low culture, Ramos emphasizes humor, hoping it will defuse the potential sexism of his art. Ramos likes punning titles; his reworking of De Kooning's *Women I*, titled *I Still Get a Thrill When I See Bill*, received a further twist in Robert Colescott's *I Gets a Thrill Too When I Sees De Koo*, also in the Rose collection.

GERALD SILK '70

AD REINHARDT, American, 1913–1967
*No Title (10 Screenprints by
Ad Reinhardt)*, 1966
Screenprint, 1/250, sheet 22 x 17 inches
Gift of Nathan Cummings, Chicago,
by exchange, 1967

No Title is one of a portfolio of ten screenprints that Ad Reinhardt produced for the Wadsworth Atheneum in 1966. The grid structure, with slight variations of color in a prevailing monochromatic, almost black palette, correlates with Reinhardt's signature "black" paintings, on which he focused exclusively from 1953 until his death in 1967. The artist described this "ultimate" series as "pure, abstract, non-objective, timeless, spaceless, changeless, relationless, disinterested painting."[2] The subtle variations of color in both the "black" paintings and prints challenge the limits of visibility, requiring an intense focus from the viewer to discern the difference in tone and color, thus emphasizing direct observation. Reinhardt saw his compositions as the ultimate essence of art and a repudiation of the extraneous. However, they were also a reaction to the political situation at the time of their making, specifically the Cold War; alongside his search for aesthetic purity, Reinhardt actively participated in political and social issues throughout his life.

ADELINA JEDRZEJCZAK

BRIDGET RILEY, English, born 1931
Untitled, c. 1965
Pencil and gouache on graph paper,
9 ½ x 15 ½ inches
Gift of Mr. And Mrs. Arthur Wiesenberger,
New York, by exchange, 1968

Bridget Riley was one of the main figures in the Op(tical) Art movement in the 1960s, exploring vision through nonobjective works of two-dimensional art, first in black-and-white and later in color. As part of this systematic experimentation, she utilized assistants to translate preparatory studies into paintings, eliminating the personal touch that had been so important in mid twentieth-century art making. This piece is such a study, one of several related to her work *Disturbance*, 1964. It explores the creation of oval forms in different orientations, including notations and diagrams. The set of numbers is Riley's method of controlling what she calls the "optical speed" of change in a sequence of forms. Ovals were part of the geometric vocabulary the artist used in the mid 1960s, as was the exploration of what she speaks of as "repetition, contrast, calculated reversal and counterpoint."

ELLEN C. SCHWARTZ '69

LARRY RIVERS, American, 1923–2002
Webster Superior, 1961
Oil on canvas, 44 x 48 inches
Gevirtz-Mnuchin Purchase Fund, 1962

Larry Rivers, a Jewish artist and musician born in New York, was one of the first to experiment with what would become known as the hallmarks of Pop Art, combining figurative, mass-produced images with nonobjective abstract art. *Webster Superior* showcases these techniques through the use of block lettering, line drawing, and a fluid abstracted figure reminiscent of popular commercial imagery. Rivers drew his inspiration from the portrait of Daniel Webster surrounded by flowers on Webster cigar boxes. *Webster Superior*, purchased less than a year after the Rose officially opened, was acquired through the Gevirtz-Mnuchin Purchase Fund, a gift from Leon Mnuchin and his wife, Helen Gevirtz-Mnuchin, to allow the Rose to start a collection of the best of the new contemporary artists.

NICOLE EATON '01

JAMES ROSENQUIST, American,
born 1933
Two 1959 People, 1963
Oil and assemblage on canvas,
72 x 93 ⅛ inches
Gevirtz-Mnuchin Purchase Fund, 1963

James Rosenquist's use of ads and other images from popular culture came naturally to him after he spent years hand-painting billboards to earn his living. In 1962, he had his first solo exhibition at Richard Bellamy's Green Gallery and participated in Sidney Janis's "The New Realists" exhibition, which launched Pop Art. A classic early Pop painting, in *Two 1959 People* the artist divides his two subjects with a rowboat complete with a bamboo fishing rod attached to a piece of white bread bait. The whole revolves around a license plate with the date 1959. In conversation Rosenquist has said that this represents his impression of 1950s pop culture. It is an updated and expanded interpretation of his *Four 1949 People* (1962, Hara Museum of Art, Tokyo). By the time Sam Hunter and Leon Mnuchin acquired this painting in February 1963, it was difficult to find available work by Rosenquist. This seminal acquisition initiated a long relationship between the artist and Brandeis University, including a commission to publish a print for the Women's Committee in the 1970s.

JOSEPH D. KETNER

ED RUSCHA, American, born 1937
Angel, 1968–1972
Oil on linen, 20 x 24 inches
Anonymous gift, 1977

Ed Ruscha, whose primary mode of expression is language, commonly treats words and phrases as palpable objects, embedding them in an open-ended landscape referencing a metaphorical component or ironic twist on the meaning of those words. Ruscha has stated that "a landscape is just something to put words on." In the painting at the Rose, one of the artist's favorite words, *ANGEL*, hovers in the upper distance engulfed in the lurid, chromatically charged atmosphere of a Los Angeles sunset. Is it Ruscha's intention to suggest that the gaseous sky over his adopted city is the habitation of heavenly creatures?

JUDY ANN GOLDMAN '64

FRANK STELLA, American, born 1936
Konskie (Sketch), 1972
Collage drawing of paint, canvas, felt,
and silk screen grid on paper,
32 ½ x 29 ¾ inches
Anonymous gift, 1983

For more than fifty years, Frank Stella's provocative, challenging artworks have pushed the boundaries of convention and charted new territory for the course of contemporary art. Stella is noted for his prolific output and continual reinvention of his style—moving from minimalist monochromes and pared-down geometries to shaped canvases that explode with electric color, frenetic shapes, and unruly collaged elements—and for a perceived irreverence for tradition. This renegade rebellion infuses his works with a freshness and excitement that withstands the test of time and continues to inspire subsequent generations of artists.

SAMARA MINKIN '94

WAYNE THIEBAUD, American,
born 1920
Pies, 1961
Ink on paper, 19 x 25 inches
Gift of the Friends of the Rose Art
Museum Acquisition Society, 1964

Best known for his richly colored paintings of classic American foodstuffs—hot dogs, ice cream cones, frosted cakes—Wayne Thiebaud in his black-and-white drawing reveals much about the artist's process and attraction to his subject matter. Rows of identical slices of pie are delineated only by the shadows they cast on the plate. As the artist explained, "In spite of the fact that every pie appears to be similar, it was interesting to take all the spaces in between and make each shape dissimilar."[3] Without the lure of candy colors, Thiebaud's baker's counter becomes a study in simplicity of form and an exploration of how much can be depicted with minimal means. The complexity of thought underlying a portrait of pies encourages us to look more critically at all that we see but unconsciously ignore in our day-to-day lives.

ESTHER ADLER '99

163

JEAN-PIERRE VASARELY (YVARAL),
French, 1934–2002
Variation Sur le Carré (*Variation on the Square*), 1962–65
Acrylic on canvas, 72 ⅛ x 72 inches
Gift of the International Artists' Seminar, Fairleigh Dickinson University, Madison, New Jersey, 1965

Jean-Pierre Vasarely used the pseudonym "Yvaral" to distinguish himself from his celebrated artist-father, Victor Vasarely. Yvaral was a member of the French collective GRAV (Groupe de Recherche d'Art Visuel, or The Visual Art Research Group), which sought to produce art without anything extraneous to visual activity. This aim is achieved in *Variation Sur le Carré*, which, like many of Yvaral's compositions from the 1960s, is black and white. When viewing this work, the eye is in constant movement as the interlocking scalloped forms vie to be in the foreground. Focusing on a fixed spot prompts the perception of vibrations and illusions of color. This is owing to the triggering of visual receptors as perceived by the brain. These effects are heightened by the high degree of black/white contrast and the interwoven, complex pattern of the painting.

NEIL K. RECTOR

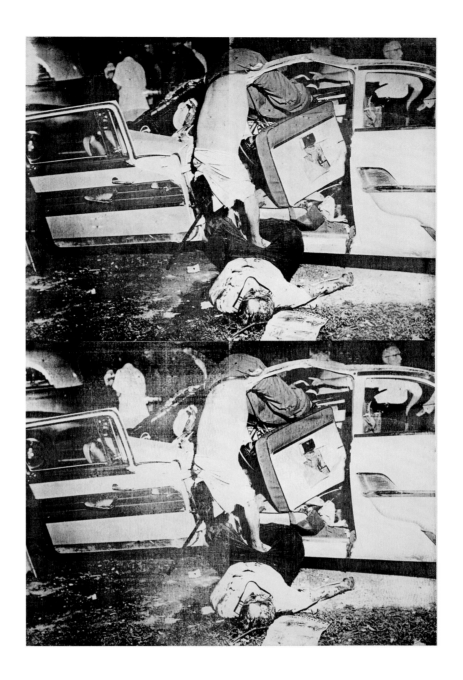

ANDY WARHOL, American, 1928–1987
Saturday Disaster, 1964
Synthetic polymer paint and silk screen
enamel on canvas, 118 ⅞ x 81 ⅞ inches
Gevirtz-Mnuchin Purchase Fund, by
exchange, 1966

The one consistent element in Andy Warhol's work is an attitude that is laconic almost to the point of muteness. But this distant, benumbed stance takes on vastly different meanings depending on the subject at hand. Careless indifference means one thing when applied to celebrity portraits (biting satire? willful co-option into the media glamour machine?) and quite another when applied to products of mass production (capitalist critique? celebration of consumer chic?). In the early 1960s, Warhol turned his sights on subjects that were deliberately disturbing: death by food poisoning or by traffic accident. *Saturday Disaster* is typical of his approach, which combines grisly subject matter with techniques of mass production—including photo silk screening and repetition—that seem to reduce tragedy to banality. The effect of repetition is to increase the horror of the event, in this case a deadly car crash, by treating it less as a dirge than as a monotonous drone. If works like Gericault's *Raft of the Medusa* redeem horror through a heroic grandeur, Warhol's *Saturday Disaster* provides no such solace. Shattered lives and broken bodies are churned out endlessly by our media culture. We are momentarily distracted by the spectacle before we turn away with a yawn.

MILES UNGER '81

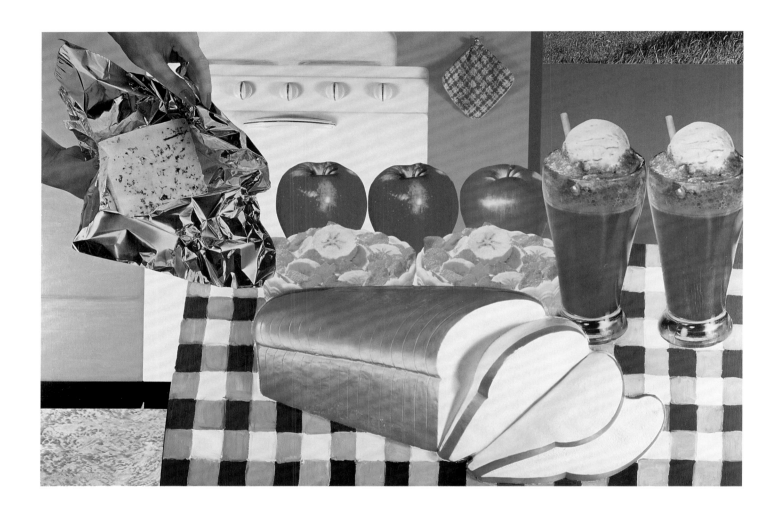

TOM WESSELMANN, American,
1931–2004
Still Life No. 25, 1963
Oil and assemblage on composition
board, 48 x 72 x 4 inches
Gevirtz-Mnuchin Purchase Fund, 1963

Tom Wesselmann's *Still Life No. 25* typifies his large-scale mixed-media pieces that update and
Americanize venerable art historical motifs, such as the nude, landscape or, as here, still life. This
stereotypical American pop culture kitchen establishes particular links to Cubist tabletop collages,
where dialogues between the depicted, reproduced, and real and between textures, volumes, and
mediums flourish. The loaf of white bread is plastic, emphasized in three outward-projecting slices.
Apples, bowls of sliced bananas, ice cream floats, and cheese in aluminum foil are photographic
reproductions; the hand with its painted fingernails sardonically recalls representations of divine
intervention. There is a painted stove with real knobs; a painted blue-checkered tablecloth echoed
by an actual red-checkered pot holder hanging on a peg; and a patterned linoleum floor indicating
the cross-fertilization of design and abstract art. The window with lawn at upper right owes a debt
to Matisse's space-opening depictions, such as windows or art within art, which interrogate the
relationship of artifice to nature.

GERALD SILK '70

HANNAH WILKE, American, 1940–1993
Needed-Erase-Her, 1974
Kneaded erasers on wood,
13 x 13 x 1 ¼ inches
Purchased with funds from the Mortimer
Hays Acquisition Fund, 1993

During the 1970s, Hannah Wilke defied artworld standards and aesthetics by developing a language of aggressive sensuality, repossessing and reconstructing the experience and image of her own body. Wilke's feminist practice took many forms, including performance, video, and photography. But she was unusually cognizant of abstraction's metaphorical power and the psychosexual implications of its ambiguity. From 1973 to 1977, she created a series of sculptures memorably titled *Needed-Erase-Her*, in which multitudes of the little erasers were folded and affixed to either square boards or old postcards. Although clearly Minimalist-inspired in their repetition, literal materiality, and frequent geometric structuring, Wilke's self-described "one-fold gestural objects" were imprinted with a sense of vitality that invited rather than discouraged interpretive readings. By contemporary sculpture standards of the day, Wilke's pieces were insistently insignificant in scale and material. In the Rose collection's example, the erasers are deliberately dispersed with playful chaos, creating a collective of vulvar forms whose cultural erasure Wilke rejected and whose individuality she objectified and exalted.

SUSAN L. STOOPS

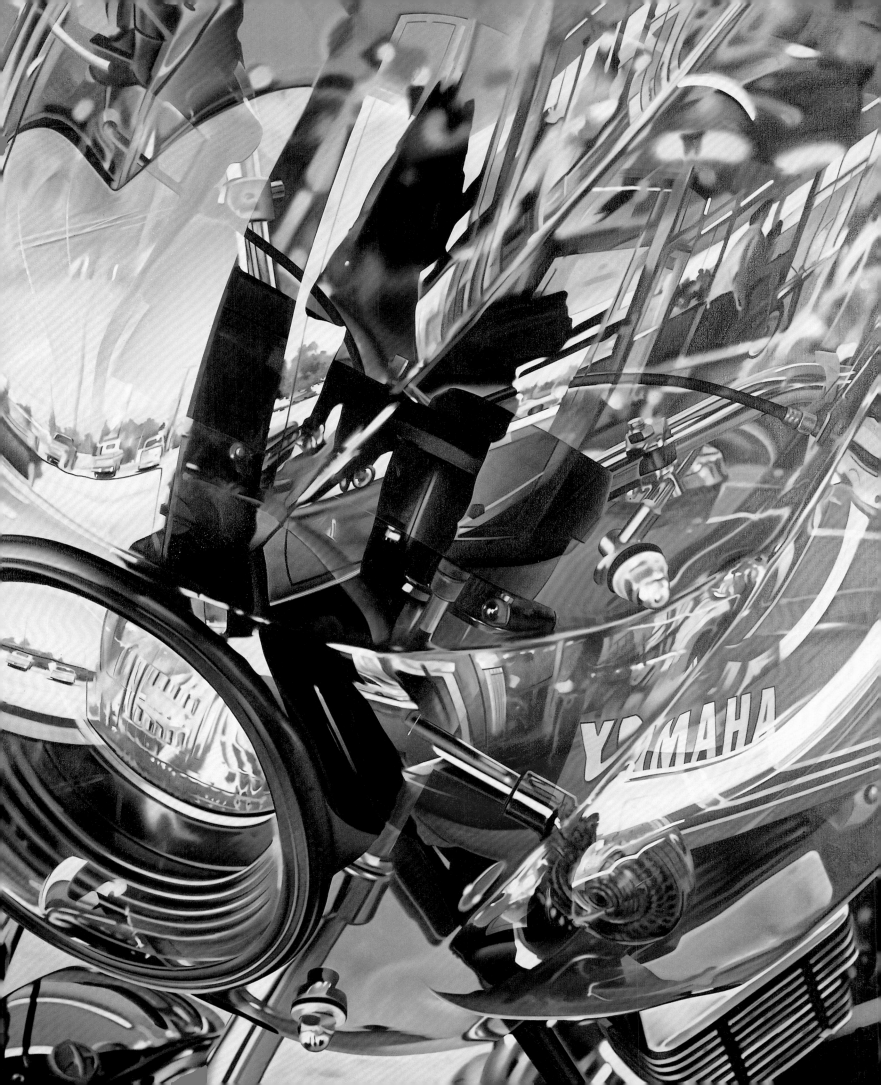

PHOTOGRAPHY AND PHOTOREALISM: THE VANISHING

Lyle Rexer

In the long and strenuous engagement between photography and painting, photography has come to dominate by being itself. Painting thrived—and perhaps may continue to have meaning—by embracing photography. Photography is the jar of the Wallace Stevens poem placed on a hill in Tennessee that takes dominion everywhere. But certainly not the jar of imagination as Stevens conceived it. Too factitious and prosaic, after all. The Rose Art Museum collection provides an exceptionally suggestive snapshot of what happened to bring about this state of affairs.

Simply put, photography belongs to everyone, painting to the happy few. This tension is implicit in images made in both worlds since the inception of photography. I say both worlds as if there is some parity involved, but that's clearly not the case. If photography is a world, painting is a small city block. Baudelaire was certainly the most outspoken commentator to recognize this, and to understand the implications of photography's ability to colonize the representation of experience. He deliberately misunderstood its imaginative component, but he was not alone. The discourse that has expressed and shaped the relation between painting and photography has been confused and confusing from the outset. The Rose collection shows the two "worlds" defining themselves and coming to a new understanding of how they might relate.

The problem, of course, is that photography is a form of image-making that has no real roots in any artistic tradition. It is a technology, not a medium, and its adoption for the multiple purposes that images satisfy in the modern world means that art historical terms taken for granted in the world of the fine arts ("imagination," "expression," "originality," "form," "style," "technique") have had to be either reformulated or jettisoned altogether. Indeed, it was the confusion engendered by the polyglot discipline that ultimately forced the transformation of the vocabulary of fine art in the mid to late twentieth century. At the turn of the nineteenth century, the pages of *Camera Work* magazine were loaded with attempts by the most important early modernist photographers to say what the artistic province of photography was and how it might relate to broader (increasingly abstract) artistic currents. For the most part, these attempts depend on borrowed terms and promote photography's kinship to other media as a matter of good faith. But with Paul Strand's statement in the magazine's final issue of 1917, the tone changed to a militant call for independence: "Photography, which is the first and only important contribution thus far, of science to the arts, finds its raison d'etre, like all media in a complete uniqueness of means. This is an absolute and unqualified objectivity."[1]

For Strand and a significant portion of the vanguard modernist photographers, the salient advantage and

feature of photography was its documentary fidelity, guaranteed by its mechanical nature but shaped and deployed by human subjectivity. Strand's manifesto (that's how it reads) shifts back and forth among political, formal, technical, and expressive rationalizations for photography, but its clear thrust is photography's ontological and cognitive congruence with the world, we might say its consensuality, as opposed to painting's by then avowed singularity. It has often been stated that photography forced painting toward abstraction by usurping its realist roles, but it is clear that painting was already in the process of setting aside the notion of realism in favor of analytical and expressive responsibilities. The camera witnessed, but the painter saw, and testified to that seeing.

No wonder that it was painters (or rather visual artists not trained as photographers) who understood the wider impact of photography best and used it to further the self-consciousness of art. We can date this to the Dada movement and its use of photocollage. In his (much later) portrait of the actress Catherine Deneuve, Man Ray—initially a Dadaist, then a Surrealist—makes a game of references to the affiliations of media, surrounding his subject with Surrealist objects and setting her up as the muse of Luis Buñuel, the film director and one of the originators of cinematic Surrealism. However, the inaugural moment of contemporary, photographically infected fine art is Robert Rauschenberg's Combine paintings from the 1950s and early 1960s (the Rose collection has an especially focused example). These works imported photography and a lot of other demotic material into the relatively confined space of painting. The impact of this importation is well documented. It forms the catechism of Pop Art, from Andy Warhol and David Hockney to Claes Oldenburg. But it is worth revisiting because of the neglected importance of so-called Photorealism in contemporary discussion and appreciation.

What Rauschenberg heralded, what Warhol embodied, and Gerhard Richter later apotheosized, was the notion that painting was one more mode of image making without privileged access to the unconscious, nature, original states of being or feeling—indeed to the a priori in any form. Painting in a world mediated thoroughly by secondhand cultural forms, an image-choked world, in Susan Sontag's phrase, would take those forms and those media as its appropriate subjects. And audiences of whatever sort would increasingly measure all representation against a photographic norm. Audrey Flack makes a wry comment on this development in her painting *Family Portrait*, 1969–70, by putting a Nikon camera in the hands of the youngest family member. He holds it as if he is about to begin focusing it for a shot of the painter at work.

In such a climate, why painting at all, from which originality and privileged access had been expected

(at least in Western art) for the previous 500 years? Photography's documentary impact, its inherent dampening of expressivity, its implicit criticism of the necessity for handwork and its traditions, would seem to make the adoption of any painting approach based on photography a kind of oxymoron, a rearguard action at best, bad faith at worst. Yet what we see in the paintings of Richard Estes or Ralph Goings, two of the leading Photorealists of the 1970s, is something completely different. We could call it the liberation of painting.

With Estes, photography (more specifically late 1950s and 1960s American photography, the images of Garry Winogrand, Robert Frank, and Lee Friedlander, among others) has given the artist permission to exercise a mannerist talent and attitude. The same might be said of David Parrish, whose virtuoso performance in *Yamaha*, 1978, deserves its own discussion. Mannerism as I define it here would be the development of a visual trope at the expense of a naturalist coherence or supervising context. Implicit, also, is the notion of a programmatic art, organized according to a nonvisual scheme of some sort. Estes presents us with the trope of reflection/transparency. He based his paintings on color transparencies, and his images are elaborate explorations of the world seen through and against windows—bank windows, bus windows, store windows—with all the angles, layerings, shadows, and perspectival ambiguities such glasswork can produce.

With the exception of Lee Friedlander, it took photography two decades to catch up to Estes' awareness of the inescapable dominance of the built world (the so-called New Topographics, as practiced by Robert Adams, Louis Baltz, and others, was more a matter of horrified fascination; for Estes, it was a visual phantasmagoria). What Estes seems to have taken from all those slides in his slide tray was a profound intuition emanating from the physical medium itself about the texture of the photographed world, about its oscillation between the apparently natural and the obviously artificial. That's what he would explore as only painting could do, with its rich repertoire of Mannerist, Dutch, and Constructivist lessons.

Goings is a tougher nut because he is deliberately closer to the quotidian revelations, the arbitrary cropping, and visual banality of photography (or, of most photographs). The intense light of California preoccupies his images, and the airbrush flattens or liquefies all the surfaces that might betray an obvious and distracting artistic agency. Like Minimalist art, it's as if the paintings came out of nowhere, not even from photographs, and everything gets the royal treatment regardless of its triviality. If Goings's pictures were photographs, they would simply witness the incongruity of framed insignificance. As paintings, they revel in it. Looking at them now is very much like looking at Ed Ruscha's photographs of thirty-six gas stations or of the buildings on the Sunset

Strip. Ruscha recently remarked that, after all this time, they have come to look like the very art photographs they were meant to repudiate. Their seriality is charming, like a theme and variations, and the format quaint. Likewise Goings's fanatical banality. His work has come to seem not mannered, programmatic, or ironic but loving, meticulous, and celebratory, again, as only painting can be. When a painting forces the question, "Why in the world do that?" and offers no ready answer, we know we are in the realm of pure painting.

So the issue of painting's putative liberation at the hands of photography really has nothing to do with abstraction or choice of subject but rather with an attitude toward painting's own very traditional practice. We can recognize the truth of the painter David Batchelor's statement that painting thrives not by running away from other media but by embracing them and in their contaminations continuously rediscovering its own justifications and pleasures.[2]

The great leveling performed by Rauschenberg and his contemporaries, however, had if anything an even greater impact on photography than on painting. Photography, whose traditional artists had asserted the aesthetic status of the medium and attempted to define it more rigorously, with its own canon, art historical lineage, and critical/visual language, who since Strand and André Kertész in Europe had sought to unite the formal

with the occasional, the expressive with the strictly denotative, found photography once again subsumed by its own utilitarianism. If photography freed the painters to be painters, painting re-bound photography to its documentary ball and chain as well as to its political incorrectness as an instrument of the mass media.

Not that the formalist and broadly humanist agenda had enlisted all photographers. Strictly speaking, the photographic artist's job was to bring a measure of control to a messy situation, that is, that a photograph is always overdetermined in terms of information and underdetermined in terms of meaning. We can see in a photographer such as Sally Mann how that control is asserted, not simply technically, in terms of position, lighting, framing, developing, etc., but also in terms of metaphor. In *The Last Time Emmett Modeled Nude*, Mann's son is positioned half submerged in water, a transparent, liquid blackness linking land and sky. He is an adolescent suspended between extremes, emerging or descending depending on your point of view, and in any case, as the title of the work points out, exiting his relationship as an innocent photographic subject for his mother.

This does not begin to exhaust the traditional artistry of the picture or explain what makes it so difficult to forget (it has to do with the paradoxical texture of the water and the translation of the sense of touch to the photographic surface, so that print and image become one;

the further recognition that black-and-white photographs are born in a liquid medium sets up a chain of metaphoric association that unites the terms "mother" and "artist"). In any case, a glance at Lee Friedlander's work reveals how differently photography can work even when the fundamental techniques are the same. Friedlander's images do precisely the opposite, often offering trivial or elaborately mediated (street signs, television screens, windows, cameras pointing back at us) imagery that deliberately downplays formal coherence in favor of irony and disjunctive juxtaposition. Although Friedlander is a distinctly identifiable presence behind his imagery, his work has the effect of distancing us from a conventional sense of style or individual subjectivity.

Pop Art pointed out the questionable hypostasizing of the artist's subjectivity by downplaying the photograph's origin (Cartier-Bresson's "decisive moment," in which the photographer captures the subject) in favor of its uses and cultural transformations. Indeed, photography in the 1980s became the preferred tool for critiquing the assumptions of modern art and its sustaining social structures. On the one hand, Bernd and Hilla Becher of Düsseldorf, whose careers began in the 1960s, efface themselves in a catalogue of decaying industrial forms all shot in the same format from the same angle and position, while Louise Lawler, in the United States, orchestrates precisely modulated photographs of interiors that point up the physical place of art objects in a culture of consumption, which seeks, nevertheless, to eternalize their value. On the other hand, Cindy Sherman's black-and-white Film Stills present photography as a medium of culturally generated fantasies for which Hollywood provides the imagery. By making herself the subject of each tableau, Sherman indicates that the fantasies (they often feel more like memories: almost but not exactly something we've seen) are scripturally limited but always available. It is not so far to the elaborate stagings of Gregory Crewdson, whose debt to Hollywood is even greater and whose sense of its pervasiveness is total, rather than personal.

To repeat, painting testifies, photography witnesses, and what it witnesses most frequently today is the eclipse of subjectivity. The rise of documentary autobiography is perhaps an index of artists' anxiety about this. There is something confirming about the camera pointed at the self and its surroundings, a kind of redemption in the cataloguing of things taken for granted by everyone else. We can sense this in even the most lurid of Nan Goldin's photographs. But that something can recede into a chain of images, a collection of progressively estranging self-encounters that in the end establish an unbridgeable distance between subject and object when the two are the same. Francesca Woodman's *Rome*, 1977, makes a disturbing commentary on this distance, and does so

in the context of the relationships between painting and photography.

In this stunning picture, the artist, nude, exits the frame smeared with the same liquid (presumably) that has marked the walls of the room behind her. The substance could be blood, and the way it is spread on the wall suggests a razor wound on the body, splashes of blood. Its obvious reference, however, is to painting: the wall looks as if a latter-day Pollock or De Kooning had taken a brush and bucket to it. The photograph frames this aesthetic violence and proposes a different situation for the photographic artist.

If Pollock, Rothko, and others were martyrs to the cause of painting's reach for the numinous (this is Rome, after all, with its catacombs of martyrs and its litany of great painters), if they were overcome in the end by inchoate experiences they explored, Woodman is another kind of martyr—to the distance of a world known at second hand. She is a vanishing subject, the less definite the more she is photographed, whose agonies, registered by a machine that only witnesses, are no longer her own.

LYLE REXER IS AN INDEPENDENT SCHOLAR and critic. He is the author of many books and catalogues and is a contributing editor to *Photograph* and *Art on Paper* magazines. He lives and works in Brooklyn, New York.

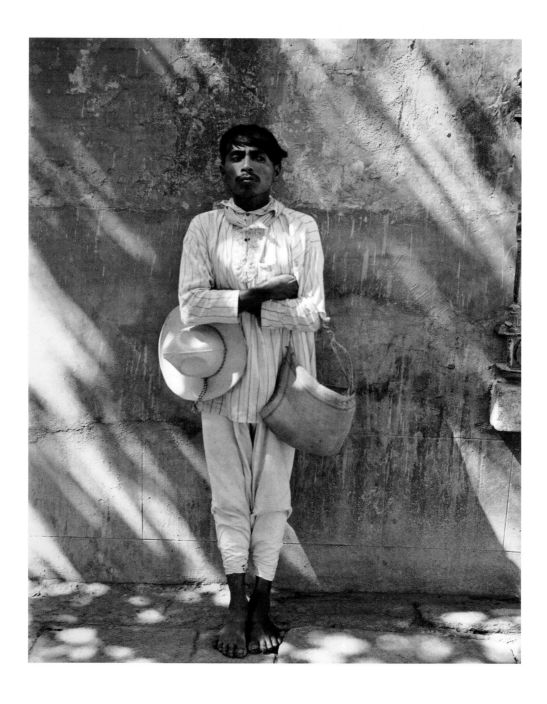

MANUEL ALVAREZ BRAVO, Mexican,
1902–2002
*Señor de Papantla (The Man
from Papantla),* from *Portfolio of
15 Photographs,* n.d. (printed 1977)
Black-and-white photograph,
10 x 8 inches
Gift of Mr. and Mrs. Edward A.
Shapiro, 1982

Manuel Alvarez Bravo has long enjoyed a reputation as the consummate poet-documentarian of his native country. Born in Mexico City, he came of age during the Mexican Revolution and began his career during a period of flourishing creativity in Mexico. While encouraged and influenced by American and European contemporaries like Tina Modotti, Edward Weston, Henri Cartier-Bresson, and André Breton, he drew his subject matter from the indigenous culture and terrain of Mexico. In *Señor de Papantla,* he imbues a straightforward portrait of a local man with mysterious significance, transforming it into a tense and dreamlike vision. While the symmetry of the composition implies a carefully planned tableau, the subject's attitude suggests otherwise. His hardened, impenetrable expression and the defensiveness of his crossed arms declare his total indifference to the photographer's project. At the same time, streaks of light falling on the stones seem to transport him to a more ethereal realm.

CAROLINE WEITZMAN '08

BERND AND HILLA BECHER,

German, Bernd 1931–2007;
Hilla born 1934
Lahnstein, Rheinvally, Germany, 1984, 1989;
Lahnstein, Rheinvally, Germany 2, 1984,
1989; *Waltrop, Ruhrgebiet, 1982*, 2000;
Siegen, 1983, 2000
Four photographs; 36 x 29 ⅝ inches
each, Hays Purchase Fund, 2002

Husband and wife, Bernd and Hilla Becher worked collaboratively from 1957 until Bernd's death in 2007. They met at the Kunstakademie Düsseldorf and although both originally studied painting, they rose to prominence in the contemporary art world on the strength of their stunning photographic works. Their photography focuses on meticulously documented architectural typologies in Europe and North America. Each typology is shot from the same angle and at the same scale, has an evenly distributed light source, and occupies almost the entire frame of the shot. Their photographs are organized by categorical building type in either grid formations or rows. This arrangement, along with the methodical approach to their compositions, stresses the sculptural and portrait elements of the architecture. Each "anonymous sculpture" reinforces form and function while simultaneously revealing the elegant differences that persist in a specific kind of building. Their head-on and unblinking treatment of a theme—in this case prewar brick houses—both strips these edifices of individuality and also highlights the personalities of architecture that often go unnoticed.

SAMARA MINKIN '94

ROBERT ALAN BECHTLE, American,
born 1932
Santa Barbara Motel, 1977
Oil on canvas, 48 x 69 inches
Gift of Herbert W. Plimpton, 1993

Robert Bechtle's portrait of his wife Nancy seated at an outdoor patio table is a dazzling example of the Photorealist snapshot style. A commentary on the look and feel of the vernacular environment of Southern California, this seemingly instantaneous presentation of a casual moment belies the artist's shrewd perception of his physical and emotional surroundings. It exhibits the same fascination with the imagery of middle-class lifestyles and suburban sprawl as seen in works by photographers of the 1970s like Bill Owens and Lewis Baltz, while Bechtle's masterful handling of compositional elements and formal organization anticipate the content and scale of photo works of the 1990s.

JUDY ANN GOLDMAN '64

WILLIAM BECKMAN, American, born
1942
Double Nude, 1978
Oil on birch panel, 59 ½ x 55 ½ inches
Herbert W. Plimpton Collection, 1993

This painting of the artist and his then-wife, Diana, typifies the polished, Superrealist style of William
Beckman's subtly confrontational portraiture. Beckman delineates every hair and every vein with a
precision that evokes the Northern Renaissance. Though Beckman's illusionism and smooth finish have
linked him to Photorealism, he works almost exclusively from life, using photographs only as a last
resort. He is equally uncompromising in his portrayal of what he sees. Though he is clearly fascinated
with the human body, Beckman resists idealizing it and includes every bump, flaw, and irregularity. The
artist's almost clinical indifference complements the tension in the figures. Posed in front of a plain, flat
background, their joined hands contrast with the sense of emotional estrangement. Beckman seems
more engaged with the viewer than with his wife; Diana's diverted eyes suggest that only her thoughts
keep her company. Together, they evoke a postlapsarian Adam and Eve: aware of their nakedness and
their flaws, but imbued with the nobility of the human form.

CAROLINE WEITZMAN '08

ROBERT CAPA, American, born in
Hungary, 1913–1954
*Loyalist Soldier at Moment of Death,
Spain*, 1936
Photograph, 21 x 30 inches
Riverside Museum Collection, Rose
Art Museum, 1971

As a founding artist of the photographic collaborative Magnum Photos, Robert Capa was able
to pursue his photojournalistic vision around the world, unfettered by editorial concerns. Today,
Capa's intimate confrontation with the disasters of war continues to inform our understanding of
Photojournalism despite the more than seventy years since this image was made. Although the
authenticity of the moment captured has long been cause for debate, Capa's genuine plea for reason
on behalf of the loyalist cause still resonates. Standing shoulder to shoulder with the photojournalist
in the field we recoil from the sudden, brutal effect of the nearby bullet. This gritty image from Spain's
civil war surpasses even Picasso's *Guernica* (completed the following year), painted primarily in the
blacks and whites of a photograph, as perhaps the most-known war image of all time.

SYDNEY RESENDEZ '88

JAMES CASEBERE, American,
born 1953
Nevisian Underground #3, 2001
Digital chromogenic print (two panels),
96 x 77 inches overall
Rose Purchase Fund, 2001

Since the late 1990s, James Casebere has been photographing the flooded interiors of elaborate miniature models based on real architectural spaces. Influenced by the visual language of film and television, Casebere's images use rich tonal visual qualities to draw the viewer into his seductive spaces. *Nevisian Underground* is no exception. A bright beam of sunlight streams into this underground space and reflects off the calmly lapping water and onto the warmly painted walls. Yet there is also an uneasiness to the scene, which is played out in the contrasts of fiction and reality, artificial and natural, dark shadow and bright sunlight. Through these visual tensions, Casebere explores the darker political implications within this otherwise aesthetically engaging architectural space. The island of Nevis was once a location of central importance to the slave trade. Casebere's choice to portray this architectural space using a fictive but well-concealed model subtly emphasizes the unconscious presence of political realities within our built environment.

MEGAN ROOK-KOEPSEL '05

SARAH CHARLESWORTH, American,
born 1947
Unidentified Man, Unidentified Location,
1980
Photomural print, 77 x 40 inches
Rose Purchase Fund, 1997

Sarah Charlesworth was part of a movement of photographers in the 1970s and 1980s who
appropriated existing images rather than creating their own "original" photographs. Aptly, she took
this picture, which presents a figure in midair, presumably jumping out of a building, from an Andy
Warhol painting in which the image presented was also appropriated. These levels of removal from its
original context are essential to the work's ability to question the assumed intrinsic truth and reality
of photographs. Though the image seems strongly to suggest a before and after, it also refuses them;
and thus as viewers we are unable to make judgments about the narrative. Supported by the ambiguity
of its title, *Unidentified Man, Unidentified Location* shows us that photographs can do nothing more
than communicate the visual data of the moment at which the picture was taken. Released from any
contextual information, this photograph becomes simply a hauntingly exuberant visual expression of
freedom upon which gravity and time cannot act.

MEGAN ROOK-KOEPSEL '05

ROBERT COTTINGHAM, American,
born 1935
Discount Store, 1970
Oil on canvas, 78 x 78 inches
Herbert W. Plimpton Collection, 1993

Robert Cottingham became known in the early 1970s as part of the first generation of Photorealist artists. Inspired by the Pop Art procedure of working from media intermediaries and the supposed sense of coolness and detachment it promotes, several artists, such as Richard Estes and Ralph Goings, began using photographs as their visual sources to make paintings meant to simulate the appearance of the photo itself. Cottingham, who briefly worked in advertising and graphic design, was fascinated by building facades and the signs that grace them. He mines imagery, frequently from older stores in urban downtowns, rife with complicated typography and often sharply colored fronts and signage. Like much of his work, *Discount Store* comes from a photo of a storefront and sign taken from a dramatic angle that crops words and letters. The artist seems especially intrigued by the geometric or sinuous interplay of the shapes and shadows of letters from different and abutting store signs and related architectural forms.

GERALD SILK '70

GREGORY CREWDSON, American,
born 1963
Untitled, from the Twilight
series, 2001
Laser C-Print, 47 ½ x 59 ½ inches
Rose Purchase Fund, 2001

Since the late 1990s Gregory Crewdson has been constructing elaborate sets in which to play out the repressed drama of contemporary suburban life. His piercingly odd, often otherworldly images explore the psychological disturbances hidden within otherwise emphatically normal situations. Perhaps Crewdson's most engaging series of works is Twilight (1998–2002), in which photographs inspired by the visual language of film capture moments suspended between realities. Undoubtedly the most captivating work in the series, *Untitled (Ophelia)* presents a woman in a sheer nightgown floating in her apparently flooded suburban living room. Stillness pervades the paranormal scene, contrasting with the ordinariness of the accumulated clutter of everyday life; the house is oblivious to the strangeness of the event within it. The subtitle *Ophelia* suggests the constant tension of twilight, a decidedly interjacent time of day, and leaves the viewer wondering: Did she commit suicide or not? Is she even dead? Or is this a psychological fantasy? Like her Elizabethan counterpart, this modern-day Ophelia rests continually in limbo.

MEGAN ROOK-KOEPSEL '05

THOMAS DEMAND, German, born 1964
Rechner (Super Computer), 2001
C-Print on diasec, 68 ⅞ x 172 inches
Rose Purchase Fund, 2002

Like American photographer James Casebere, German artist Thomas Demand constructs architectural models that subsequently serve as subjects for photographs. The similarities end there. Casebere is a formalist who creates generalized constructions that allow him to explore space and light. Despite their lack of fine detail, Demand's images are realist and address history and politics. Although his large color images seem to be bland functional spaces, they are often the sites of charged events. His subjects include the office where the failed 1944 assassination attempt against Adolf Hitler occurred and the kitchen of Saddam Hussein's hideout in Tikrit. The Rose image is of a different order. It shows IBM's supercomputer, Bluegene. In it, Demand has continued his practice of confounding initial impressions. The image seems to be of an empty room; however, the computer has been embedded beneath the floor, the blue tiles indicating the sites of different computer parts.

DAVID BONETTI '69

RICHARD ESTES, American, born 1936
Return of the . . . , Bus Interior, from
Urban Landscapes III portfolio, 1981
Two silk screens, 15 x 21 inches each
Gift of Stuart A. Paris, President, Paris
International Corp., 1983

Richard Estes's canvases portray the sleekness and grit of the urban landscape with uncanny verisimilitude, showcasing his expert artistry as well as a profound fascination with the built environment. A key figure in the Photorealist movement of the 1960s, Estes trains his eye on the often overlooked details of everyday settings, laboriously translating unremarkable city sights into irresistibly polished and seductive compositions. New York, his longtime home, frequently plays the part of muse, providing an endless array of buildings, streets, and cars to populate his paintings and prints.

SAMARA MINKIN '94

WALKER EVANS, American, 1903–1975
Cabin Interior, n.d.
Black-and-white photograph,
6 x 9 ½ inches
Gift of Dr. and Mrs. Jack Solomon, 1985

Photographer Walker Evans has served as an inspiration to generations of artists. In the 1930s, he was employed as a photographer for the Farm Security Administration (FSA), an organization that attempted to ameliorate rural poverty. The FSA engaged selected photographers and writers in the documentation of the effects of the Great Depression, providing images and prose to inform the public. *Let Us Now Praise Famous Men,* Evans's collaboration with writer James Agee, stands as a work of art beyond categorization, documenting the lives and conditions of sharecroppers in the rural South. Photographs such as *Cabin Interior* demonstrate Evans's ability to distance himself from the scene in an almost ethnographic manner, bearing witness to the dignity and grace of the humble abode and its unseen inhabitants. His aesthetic honesty and contextualization of each image within the photograph's frame allow the viewer to be moved, yet not overwhelmed by sentimentalism.

MINDY NIERENBERG '77

JANET FISH, American, born 1938
Spring Evening, 1977
Oil on canvas, 44 x 66 inches
Herbert W. Plimpton Collection, 1993

Janet Fish works with recognizable subject matter, primarily still life, although figures and landscape appear in her recent paintings and prints. Process is always evident; in her words, she is interested in "a mark that explains a form and is a mark at the same time." Light, color, and reflectivity animate the surface: here, the glasses set before a window dissolve in a glittering array linked by a limited palette of yellow and bluish tones as well as by the echoing horizontals of bases and rims. This painting represents a turning point in her work. Until 1976, each subject filled the canvas; *Spring Evening* is one of the first to include a background—in this case, a distant view of the New York skyline. Fish's move to a new studio in Manhattan inspired this change, one of many instances in which the artist's experience—a new venue or experimentation in a printmaking medium—occasioned a shift in subject matter or style.

ELLEN C. SCHWARTZ '69

AUDREY FLACK, American, born 1931
Family Portrait, 1969–70
Oil on canvas, 40 x 60 ¼ inches
Riverside Museum Collection, 1971

Audrey Flack often uses photography to obtain heightened detail. This painting is her first using slides projected onto the canvas and, uniquely, a commissioned family portrait. Peter Farb (1929–1980), Oriole Horch Farb Feshbach, and their two sons stand in their dining room in the Masters Apartments, New York; this building housed The Riverside Museum, directed by Oriole from 1953 to 1970 and the site of several important exhibitions of West Side artists, including Flack. In posing for the photographer, a willing *Newsweek* friend, Peter selected a beaded tie signifying his publications on Native Americans, Oriole wore a Tibetan necklace, one son wore an African tie, and the other held a camera to take a photograph of the photographer. The tanka painting portrays a Tibetan Buddhist, Tsong Ka Pa. These attributes locate the family within its own sphere of interests, contemporary fashion, and cultivated tastes. Illusion extends to the painted gold frame with brass plate, as a museum label. Flack has since turned to sculpture, incorporating Classical references into images of powerful female characters.

AMY GOLAHNY '73

193

LEE FRIEDLANDER, American,
born 1934
Egypt, 1983
Photograph, 15 x 22 ½ inches
Rose Purchase Fund, 1991

Lee Friedlander is one of the most respected and prolific photographers in contemporary art. His work was first shown at the Rose Art Museum in 1967 in the show "Twelve Photographers Toward a Social Landscape." Friedlander began his career in the late 1950s in commercial photography, moving in the 1960s into shooting what he refers to as the "American social landscape." His work has continued to focus on the ordinary, with everyday scenes transformed through the lens of his camera into images of beauty, wonder, wit, and fascination. He is drawn to scenes in the landscape that pair the monumental with the ordinary, as in this photograph taken in Egypt. In the background, ancient pyramids and the Great Sphinx contrast with the foreground composed of rubbish and debris. Dogs are scattered across the scene in silent repose, creating a scene that combines awe with a comic note of grace, strangeness captured for us to ponder.

MINDY NIERENBERG '77

RALPH GOINGS, American, born 1928
Bank of America, 1971
Oil on canvas, 40 x 40 inches
Gift of Mr. and Mrs. Norman Zachary,
2003

As a Photorealist artist, Ralph Goings made paintings intended to replicate the look of the photographs he took. *Bank of America* typifies his late 1960s and 1970s work done while living in Sacramento, based on snapshots of the urban and suburban storefront, mall, strip, roadside, housing complex, and parking lot. "Visual aura," as Goings said, not social commentary, encouraged emphasis on formal rather than expressive matters. Unsparing California light drenches this mundane scene, as geometry and repetition abound in signage, bricks, vents, metal-partitioned glass doors and windows, and the interplay of light and shadow. Part of a larger sensibility of coolness, neutrality, and putative objectivity, *Bank of America* is hard-edged, tightly brushed, and psychologically and emotionally deadpan. This is an environment, as one critic put it, where a "hubcap would be as interesting, or uninteresting, as a face." But might this painting also offer commentary on the atmosphere of standardization and homogenization of the environment it depicts?

GERALD SILK '70

NAN GOLDIN, American, born 1953
Self-Portrait in the blue bathroom,
London, 1980; *Tabboo! on the phone,*
NYC, 1991
Two Cibachromes, each 20 x 24 inches
Hays Purchase Fund, 1994

Portraying her life or the life of her closest friends in settings such as bedrooms, bathrooms, hotel rooms, night clubs, Nan Goldin provides an intimate panorama of the human condition. Through her richly colored snapshot images, she raises awareness of gender roles in society, of the horror of the AIDS epidemic, and of drug abuse. In *Tabboo! on the phone, NYC,* her frequently photographed drag queen friend is pictured seated on his bed, unposed. Capturing the sensuality and vulnerability of his being, he is depicted in profile, in an atmosphere of stillness. Without being voyeuristic, Goldin is interested in the personal and the intimate, which she observes with detachment. In *Self-Portrait in the blue bathroom, London*, the artist continues her exploration of self. Depicted standing in the back of an empty bathroom, outside the picture but with her face reflected in a corner of the mirror, this self-portrait captures her feeling of displacement. The shadows and colors of the picture reinforce the detached atmosphere, while the only light falling directly on her face communicates Goldin's in-between state. This photograph is a fine example of the way in which the artist uses composition to create the feeling she is trying to convey.

ELISABETH IOANNIDES '00

MONA HATOUM, Palestinian, born in
Lebanon 1952
Untitled, 2000
Photograph, 24 x 20 inches
Gift of Jeffrey Keough, 2004

Mona Hatoum often deals with themes of exile and authority in her installations, videos, sculptures, and photographs. Her work frequently centers on the human body, which she has used as a tool to illustrate issues of invasion, of the familiarly grotesque, and of pure corporeality. In *Hair Necklace*, 1995, she created a necklace out of human hair, wood, and leather that from a distance appears to be a string of large brown beads, but upon closer observation is eerie and disturbing. *Corps Étranger*, 1994, one of her most famous works, is a video capturing endoscopic images of Hatoum's inner organs and demonstrates both invasiveness and inspection. In *Untitled*, an image of the eye symbolizes both a permeable orifice—it is rotated to resemble an almost vaginal opening—as well as a tool to penetrate the visual world. The eye is at once pierced and piercing.

KAREN CHERNICK '06

mona holmin 2000

ANDRÉ KERTÉSZ, American, born in Hungary, 1894–1985
Chez Mondrian, Paris, 1926
Photograph, 11 x 14 inches
Riverside Museum Collection, Rose Art Museum, 1971

André Kertész began teaching himself photography when he was twelve, taking photos in small peasant towns when he visited relatives. He served during World War I and took photos of soldiers and war-ravaged villages. After moving to Paris in 1925, he became acquainted with other artists in the city, including Piet Mondrian. In this photograph of Mondrian's studio, Kertész reflects Mondrian's use of geometric forms in the doorway and table, but contrasts them to the curves in the banister and hat. Kertész places the focus on the single flower in the vase on the table; Mondrian had recently stopped painting images of single flowers and Kertész made an homage to this time in his friend's life.[3] This photograph was part of the Rose Art Museum exhibitions "Permanent Collection" (1982) and "Early Moderns, Contemporary Art and 20th Century Photography" (1984).

SARA TESS NEUMANN '07

LOUISE LAWLER, American, born 1947
A Good Room to Sleep In, 1994
Cibachrome, 18 ⁷/₈ x 23 ¹/₂ inches
Rose Purchase Fund, 1997

A wrought-iron-framed bed connects the viewer to the title of the work, but as both the severe cropping of this object and the presence of a well-known work by Cindy Sherman suggest, *A Good Room to Sleep In* is not really about a particular room in a house, but instead is about the contexts in which art resides. Yet, Lawler's goal is not to open the viewer's eyes to the storage practices of art collectors; rather, her aim is to highlight the deeply imbedded connection of the meaning of artworks to both their surrounding sociopolitical context as well as to the complex network of museums, galleries, auction houses, and private collectors that assign them value. In naming her work *A Good Room to Sleep In*, Lawler highlights the intrinsic importance not of the artwork but of the space in which it rests, reminding us that no artistic act is completely autonomous, no artwork without context.

MEGAN ROOK-KOEPSEL '05

SALLY MANN, American, born 1951

The Last Time Emmett Modeled Nude, 1987

Silver gelatin print,

19 ³/₄ x 23 ¹/₂ inches

Rose Purchase Fund, 1990

Sally Mann's studies in photography included a brief stint working as an assistant to Ansel Adams before graduating from Hollins College with a BA in 1974 and an MA in writing in 1975. This image is from *Immediate Family* (1984–1991), a series that shows her three children growing up in rural Virginia. It includes photographs of the children playing, often in the nude. She received praise for her honest depictions of childhood, and some outrage calling the works immoral. This image of her young son, standing nude waist-deep in a river and looking at the camera, took seven weeks to get perfect; Mann stated, "I had to buy Emmett so many things to get him to go back into the water."[4] This photograph was part of the Rose Art Museum exhibitions "The Hand That Rocks the Cradle" (1990); "Body Language! The Figure in the Art of our Time" (1990); and "Subject(s): A Collective Portrait" (1997).

SARA TESS NEUMANN '07

YASUMASA MORIMURA, Japanese,
born 1951
Futago, 1989–90
Photograph, 135 x 94 ½ inches
Rose Purchase Fund, 2000

When Morimura was studying in his native Japan, his art curriculum consisted primarily of European art history, the result perhaps of the post–World War II American occupation. This early experience of cultural disjuncture led him to examine the "gray areas" in gender, national, and ethnic identities while visualizing the established masterpieces of Western painting from an Asian point of view. Part of his *Daughter of Art History* series, *Futago* is a complex, ambiguous meditation on cultural translation via a restaging of Eugène Manet's *Olympia*. In 1863, *Olympia* was shocking not only because the idealized Venus had become a prostitute, but because the flat space of the painting reflected the influence of Japanese prints and its harsh value contrasts resembled early photography. Morimura regains some of the original's impact by creating a contradictory self-portrait. The work is a photograph, but is lathered in acrylic to mimic brushwork. Although his torso is clearly male, Morimura's build strongly resembles, is twinned with, Olympia's. Finally, props such as the wedding kimono and the ceramic cat reveal that this is a work of both Postmodern and cross-cultural appropriation.

PAMELA ALLARA

DAVID PARRISH, American, born 1939

Yamaha, 1978

Oil on linen, 78 x 77 inches

Herbert W. Plimpton Collection, 1993

Yamaha by David Parrish is one of several major works by Photorealist and other modern realist artists, including Robert Bechtle, William Beckman, Richard Cottingham, Janet Fish, Alex Katz, Fairfield Porter, James Weeks, and Neil Welliver, that came to the Rose as part of the Herbert W. Plimpton Collection. Parrish is best known for paintings of motorcycles, an iconic fixture of his home culture, the American South. He worked from slides projected onto large canvases, minimizing certain pictorial decisions over which he had obsessed before adopting this more mechanical process. The motorcycle offered a fascinating and challenging array of shapes, textures, surfaces, colors, and reflections. In *Yamaha,* Parrish takes the Photorealist sensibility to Baroque or Mannerist extremes, producing a modern tour de force. The artist amplifies and revels in the interplay between the clarity and fuzziness of in- and out-of-focus portions of the shot, the brilliance of the photographic reproduction of lustrous hues, and the intricacy and complexity of light and reflections, all cropped for maximum effect.

GERALD SILK '70

RICHARD PRINCE, American, born 1949
Untitled (Cowboy), 2000
Ectacolor, 42 x 96 ¾ inches
Gift of the artist, Tibet House, New York;
N. and L. Horch to the Riverside Museum
Collection, by exchange, 2003

From an early age, Richard Prince has been enamored of pop culture created for the masses—
advertising, comic books, television, billboards, and magazines. As an artist, he appropriates iconic
images from these and re-creates them, injecting them with irony. In his *Cowboy* series, Prince actually
rephotographs cigarette advertisements featuring cowboys—those Madison Avenue models of
masculine identity. These images are firmly planted in mass culture as an ideal stereotype, exemplifying
the perceived all-American male characteristics of independent spirit, strength, and hardiness. The
irony of this icon as the advertisement for the cigarette—an addictive, cancer-producing substance—is
not lost on Prince. Seduction plays a role in both the original advertisements and in Prince's work. His
cropped, edited, and newly invented contextualizations of consumerism and commercialism provide
more questions than answers.

MINDY NIERENBERG '77

MAN RAY, American, 1890–1976
Catherine Deneuve, c. 1966
Photograph, 16 x 11 ¾ inches
Purchased by Rose Art Museum, 1984

Man Ray, born Emmanuel Rudnitzky in 1890, is one of the few American artists to be classified as a forerunner of the Dada and Surrealist movements. He worked as a painter, and also became known as a groundbreaking photographer. He was a portrait and fashion photographer. He approached photography as an art form, but used his skills in the medium as a means of earning a living.

As a Surrealist, Man Ray used photography to evoke unfathomable atmospheres, overstepping the boundaries of predictability. In the photograph *Catherine Deneuve*, a portrait of its namesake, Man Ray captured the subject's delicate beauty. She is the focal point of the photograph, yet her surroundings are distracting. She is suspended in an unfamiliar milieu. Her setting is nonsensical—Dada in matter and space. Man Ray captures the human fragility of an actress who is the manifestation of unwavering strength. She is introverted, engrossed in her own experience.

TAMAR FRIEDMAN '07

ANDRES SERRANO, American,
born 1950
The Church (St. Clotilde II, Paris), 1991
Cibachrome, 40 x 32 ½ inches
Gift of Donald and Jeanne Stanton, 1997

On May 18, 1989, when Senator Alphonse D'Amato (R-NY) tore up a copy of the photograph *Piss Christ* on the floor of the United States Senate, Andres Serrano, the author of the image, momentarily became the most famous artist in America. Despite its presumed blasphemy—abetted in no small part by its title—the image is ravishingly beautiful, one of the most serious works of religious art created during the late twentieth century. Serrano has made many other works that address religion. In 1991, he created a series titled *The Church*. Many of the images are portraits of Catholic priests, brothers and sisters. Others are of spaces in churches in Paris and Venice. This image of St. Clotilde shows a door chained shut with a padlock. Although it might refer to the Roman Catholic Church's closed nature, other images in the series suggest its openness. Besides, the lock is clearly so flimsy that anyone who wants to could easily break it open.

DAVID BONETTI '69

CINDY SHERMAN, American, born 1954
Untitled, 1981
C-Print, 24 x 48 inches
Rose Purchase Fund, 1982

One of the most celebrated artists of her generation, Cindy Sherman is a conceptualist who uses photography as her medium. Although she appears as the subject of nearly every one of her works, they are not self-portraits. She uses her face and body as props in carefully directed performances. Viewers are invited to project their own feelings and ideas about what she has chosen to show upon her images. Sherman captured the art world's attention in the late 1970s with a series of black-and-white photographs called *Untitled Film Stills*. In 1981, she was commissioned by *Artforum* to produce a project for the magazine. Sherman chose to explore the familiar format of the *Playboy* centerfold, replacing the highly eroticized nudes with innocent and vulnerable young women. The magazine did not publish them on the grounds that the project was too obscure, but the series went on to garner international acclaim. *Untitled* is one of the lesser-known images from the series.

DAVID BONETTI '69

SAM TAYLOR-WOOD, American, born 1967
Third Party—Ray and Pauline, 1999
C-Print, 53 ⅛ x 42 ⅛ inches
Rose Purchase Fund, 2001

Ray and Pauline, a still from Sam Taylor-Wood's 1999 film project *Third Party*, expresses the tension and drama of everyday life. This tension is brought about in part by the sense of isolation that pervades the scene: Pauline aggressively twists away, the movement eloquently captured in the blurring of her still-moving arms and hair. Meanwhile, Ray looks vacantly off to the side; each seems to exist entirely separate from the other. The fragmented narrative suggested through the disconnect between the characters in the image calls attention to the artist's intended meaning. As Taylor-Wood notes, "In my work, I look at what people view as desirable—a desirable lifestyle, a desirable moment in time, desirable people—and then I unravel it and make it more real."[5] As Taylor-Wood's anxious image suggests, the reality of contemporary life is not always desirable.

MEGAN ROOK-KOEPSEL '05

WEEGEE (ARTHUR FELLIG),

American, born in Poland, 1899–1968
*Fire Scene—The Old Lady Has a Child
Caught in the Burning Building*, 1942
Silver print, 10 ⅝ x 13 ¼ inches
Rose Purchase Fund, 1984

Photographer and photojournalist Arthur Fellig adopted Weegee as his professional name, which stood for the phonetic spelling of the popular fortune telling game Ouiji. Weegee was notorious for being the first to arrive at a scene of crime or tragedy—he was one of America's first photographic ambulance chasers. His iconic images are characterized by a dark film noir aura and he is best known for using a photographic "flash" to illuminate the scene. The dramatic closeness and bright-lit scene in *Fire Scene* creates a directness that blurs the line between participant and viewer. Acutely aware of the social problems in New York during the time between the Great Depression and the end of World War II, Weegee made photographs that are representative of the problems of everyday people just trying to get by. The in-your-face intensity of his photographs exemplifies the changing social fabric of America.

DANIELLA GOLD '07

JAMES WEEKS, American, 1922–1998
Santa Monica Easter Sunday, 1967–73
Acrylic on canvas, 69 ¾ x 90 inches
Gift of the Herbert W. Plimpton
Foundation, 1993

James Weeks was a central member of the Bay Area Figurative School, a group of painters identified in a 1957 exhibition at the Oakland Museum. The group, which also included David Park, Richard Diebenkorn, and Elmer Bischoff, was among the first to show their discontent with the Abstract Expressionist hegemony that then dominated American painting. Although both Diebenkorn and Bischoff embraced abstraction in their late work, Weeks remained true to the figure. In 1970, he moved to the Boston area to teach at Boston University. In 1976, the Rose Art Museum mounted an exhibition of his work, from which Herbert W. Plimpton purchased *Santa Monica Easter Sunday*. The picture, which shows five women on a terrace above the Pacific enjoying the California good life, was started before Weeks moved to Boston and finished afterward. Art critic Thomas Albright described Weeks's late style as "serene, elegiac, classical, and soft-spoken. . . ."

DAVID BONETTI '69

NEIL WELLIVER, American, 1929–2005
Late Light, 1978
Oil on canvas, 96 x 96 inches
The Herbert W. Plimpton Collection, 1993

Neil Welliver's large-scale paintings of the Maine landscape where he lived and worked are painstakingly detailed in their treatment of every tree limb and rock formation. And yet Welliver's subject matter is as much the act of painting and the physicality of his media as it is the forest. The fittingly titled *Late Light* captures the sun as it seeps its way through tree cover to reach the ground, but the painting is also a study of the possibilities of the limited palette Welliver worked with throughout his career. Moss-covered stones are also carefully considered flat planes of color. The artist's masterful handling of two seemingly contradictory styles of painting, exacting realism and the abstraction of light and tone, is at the heart of his work, as is a love and respect for the natural landscape familiar to many who have spent time in New England.

ESTHER ADLER '99

EDWARD WESTON, American,
1886–1958
Orozco, 1930
Silver print, 9 ¾ x 7 ⅝ inches
Rose Purchase Fund, 1987

Edward Weston ranks among the most important American photographers of the twentieth century. Working with an eight-by-ten-inch view camera, he created crisp, richly detailed photographs of a wide range of subject matter, from nudes and portraits to landscapes, shells, and vegetables. His still-life images endure as some of his most significant work, elevating common objects into sculptural forms in dazzling close-ups. With Ansel Adams and Imogen Cunningham, Weston founded Group f/64, whose members dedicated themselves to the idea of photographic purity. It was a goal Weston never abandoned.

SAMARA MINKIN '94

FRANCESCA WOODMAN, American,
1958–1981
Rome, 1977–78
Gelatin silver print, 4 ½ x 4 ½ inches
Hays Acquisition Fund, 1997

In the theater of this image, a paint-splattered figure flees halfway outside the frame and away from the expressive, perhaps even menacing, gestures of dripping paint and fingerprints on the wall behind her. Francesca Woodman's self-portraits, which make up the majority of her work, often depict the artist interacting with the architecture of old and neglected buildings—first as a student at Rhode Island School of Design in Providence, and then during a year in Rome (1977–78) as part of a RISD honors program. The blurred movement, sublime decay of interior architecture, and her subjects' faces, often obscured or altogether eliminated from the frame, show photography's ability and its limitations in capturing complex relationships among self, time, and space. The haunting imagery of Woodman's self-portraits conflated with the circumstances of her suicide at age twenty-two calls into question whether or not such biographical information can or should be repressed from critical readings of her work. Though most historians were not introduced to her photographs until after the artist's short lifetime, the surreal, feminist, formal, and phenomenological aspects of Woodman's art endure as a rich ground for critical and artistic engagement.

EMILY MELLO

ZHANG HUAN, Chinese, born 1965
¹/₂ (MEAT #1) (TEXT); ¹/₂ (MEAT #2) (MEAT); ¹/₂ (MEAT #3) (MEAT AND TEXT), 1998
Three C-Prints, each 37 x 31 inches
Hays Purchase Fund, 2000

Zhang Huan is one of the most important Chinese artists of his generation. He began his career as a performance artist, but has more recently turned to painting and sculpture. *¹/₂* was produced at a pivotal point in his career, just before he moved from Beijing to New York. The work includes three separate photographic images of performative actions: one of the artist, nude to the waist, his body inscribed with calligraphy; one showing him encased in an animal's carcass stripped of meat; and one combining a carcass and calligraphy. It prefigures two important later works—*Family Tree* (2000), in which the artist had his face and head inscribed with calligraphy that progressively darkened his face until it was covered in black ink, and *My New York*, in which he encased himself in a "suit" made of raw meat, performed for the 2002 Whitney Biennial. All these works demonstrate Zhang Huan's central preoccupations with grueling performances, sometimes bordering on the masochistic, that embody questions of identity and self-identity.

KIMERLY RORSCHACH '78

REGARDING THE CONTEMPORARY | *Peter R. Kalb*

COLLECTING THE CONTEMPORARY

Since its beginnings in 1961, the Rose Museum has collected contemporary art. A 2005 document outlining museum priorities for the new millennium begins by stating that the Rose "should focus on the art of our time and reflect the issues of contemporary life." Collecting art has changed dramatically since Leon Mnuchin and Sam Hunter took $50,000 to New York City to jump-start the collection in 1962. The hyperbolic art market and the global art world of the present have made such trips impossible today: the best art is no longer in one place or quite so affordable. To remain active, the museum has established the Rose and Hays purchase funds to increase its control over the collection while strengthening connections to its community and reaching out to artists, collectors, friends of the museum, and the university. As the contemporary art of Sam Hunter's day has become classic, the contemporary collection of today represents new priorities and judgments. The art discussed in this chapter is both worldly and self-reflexive, directing the attention of museum visitors to issues ranging from history to gender to globalism while continually recontextualizing the original core collection of United States painting.

Just as the economics of the art world have changed since the early 1960s, so have its intellectual foundations. Between the late 1960s and the late 1980s, artists, theorists, and historians challenged the process of evaluating quality and presenting culture. Following French historian and theorist Michel Foucault, artists and critics of the 1980s including, from the collection, Cindy Sherman, Ross Bleckner, Richard Prince, Haim Steinbach, Robert Colescott, Tim Rollins, and David Salle, examined how terms of value aligned with sources of power. Quality, they determined, rested on politics as much as on connoisseurship. By the 1990s, the principle of collecting globally was being scrutinized by other artists represented in the collection—including Mona Hatoum, Alfredo Jaar, and Isaac Julien, all attuned to postcolonial theory and history. The Rose responded to changing currents by focusing on three kinds of acquisitions: work that marked turning points in an artist's career or the history of a movement, characteristic works within select areas, such as postwar painting, feminist art, or Photorealism; and art that itself addresses questions of collecting. This essay will point to important moments in the history of the museum and to significant works that have joined its collection in the last decades of the twentieth and first years of the twenty-first centuries.

REGARDING THE COLLECTION

The inaugural purchases from the Rose and Hays funds mark an important moment in the museum's

history and express the philosophy and character of the collection. Cindy Sherman's *Untitled*, 1981, Rose Purchase Fund 1981—from only the artist's second body of work—was an investment in a young artist. Selecting Sherman, an artist concerned with gender politics, masquerade, and mass media, was also a head-on confrontation with the politics of culture in the 1980s. The Sherman was not the only political work to enter the collection at this point. The year 1981 also saw the donation of Robert Colescott's *I Gets a Thrill Too When I Sees De Koo*, 1978, one of a series of works begun in the mid 1970s in which Colescott inverted the race of the protagonists in masterpieces from the canon of Western art history—including Emanuel Leutze's *Washington Crossing the Delaware* (1851), Vincent van Gogh's *The Potato Eaters,* 1882, Pablo Picasso's *Demoiselles D'Avignon,* 1907, and, in our case, Willem de Kooning's *Woman I,* 1950–52. These works question the inclusions and exclusions of art history. They ask what the history of art would look like with black subjects instead of white ones or what individuals of African descent must do to be admitted into the canon of art history. De Kooning saw his women as fantastic Michelangesque figures, commanding great pleasure and power. The face resembling Aunt Jemima that Colescott abruptly painted onto the white body in his version of De Kooning's woman suggests that African American women can only enter the canon of Western painting by reflecting racist stereotypes. But Colescott's painting does not end there. *I Gets a Thrill* is as full of ebullient brushwork and bawdy humor as it is of social critique. The pleasure Colescott clearly takes in the act of painting is contagious, and his explosions of thick, bright oil paint speak to a sense of empowerment echoed in the curious glance of his main character. This Aunt Jemima casts a quizzical smile down at several bold brushstrokes that appear to be trying to jump off the canvas, as if Western painting was breaking free under her watch. Colescott, who has continued addressing art history and racial politics, represented the United States at the Venice Biennale in 1997.

One of Colescott's legacies has been the interest among young African American artists in appropriating pop culture representations of African Americans. Artists including Michael Ray Charles, Kara Walker, and Ellen Gallagher—whose *Doll's Eyes*, 1992 was a 1993 Rose Purchase Fund acquisition—have rooted their practice in manipulating representations of African Americans. *Dolls Eyes* is an early example of what would become Gallagher's expansive cosmology of abstractions that refer directly to the image world of mass media. The white ovals specked with a single dot are the eyes of Gallagher's title, and they relate to the flat, impenetrable eyes painted onto caricatures such as Sambos and lawn jockeys. Gallagher's abstractions communicate well with earlier serial imagery such as that of Yayoi Kusama or Lawrence Poons in the

Rose and with Op Art such as Gene Davis's, also in the museum, while their sources link her work to the daily world of advertising and pop culture.

The Hays Acquisition Fund was initiated with the purchase of Kiki Smith's *Lucy's Daughters*, a work featured in the exhibition of works on paper "Kiki Smith: Unfolding the Body," organized at the musem by Rose curator Susan Stoops. The show presented Smith as an artist deeply concerned with the intersection of the body, the self, and society, and also attentive to issues of myth, religion, and evolution. These latter interests distinguished her art from the media concerns of many of her peers. In 1992, the turn to macroscopic concerns of spirit and history were new for Smith. For approximately the first decade of her career, ending in the early 1990s, her work was rooted, she has said, in her childhood. The objects with which she chose to express herself were bodies, but from the inside out. Throughout the 1980s, she created work based on the fluids, organs, and systems that keep us alive. Many of these pieces were prints, a mediium she had used in her earliest work as a member of the New York City artists group Colab, for which she produced low-budget prints, often on T-shirts. She would slowly move from the interior of the body to its surface, and in the early 1990s produced her first identifiable portraits, also prints. By mid decade, she had come through her past and was speaking about social systems, power, and identity.

Lucy's Daughters is a work about history and women. Its title refers to the name given to the hominid *Australopithecus afarensis* that lived 3.2 to 3.8 million years ago and whose remains were discovered in Ethiopia in 1974. With its inverted pyramid composition and binding threads, *Lucy's Daughters* charts a lineage for the oldest-known ancestor of humanity, the mother of us all. Smith's mid 1990s work, much of which is, like the Rose piece, devoted to women—including Lilith, the Virgin Mary, Mary Magdalene, and Daphne—surveyed the grand scale of human history and spirit with a poetry equal to her earlier explorations of the microscopic details of human life.

If Smith's interest in prehistory and spirituality had little to do with the media interests of many 1980s feminists, it had precedent in art of the 1970s. Ana Mendieta's *Body Tracks*, 1982, a 1991 purchase, demonstrates the inflection of avant-garde form with personal and spiritual content. Like many artists of the 1970s, Mendieta used her body and the elements—water, earth, air, and fire. She also drew upon her native Cuban culture and incorporated aspects of Santeria, an Afro-Cuban religion. *Body Tracks* records a ritualistic act performed first in 1974 and then again in 1982, in which Mendieta pressed her blood- and paint-covered arms against a wall and slowly collapsed onto the floor, letting her body leave its mark on the paper. The body and blood refer to San-

teria, while the form and performative aspect of the event were rooted in process and performance art of her New York milieu as well as Afro-Cuban culture. The confident mix of personal, cultural, and art historical sources is a model for the allusive combinations of form and content in today's contemporary art.

HISTORY AND EXPERIENCE AT THE ROSE

In 1996, the Rose received a gift of Christian Boltanski's *Tiroire (Drawer)*, 1988, from a friend of the museum who thought its Jewish content would contribute to the Brandeis commitment to Jewish concerns. *Tiroire (Drawer)* is, in fact, from among the first works in which Boltanski makes reference to the Holocaust. In 1987, he found a photograph of the 1931 graduating class of a Jewish high school in Vienna. Though the fate of the students is not known, they were probably murdered by the Nazis. Boltanski cropped and enlarged this photo and another of a Purim celebration from the same era, creating numerous obscured portraits he then combined with simple lights and tins or drawers—as in *Tiroire (Drawer)*—to create altars and installations. The face in the Rose piece appears to be selected from the Purim photo. Several works nearly identical to *Tiroire (Drawer)* have the title *Reserves: The Festival of Purim*.

Boltanski's blurred and cropped photos and his handmade relics evoke the crime of the Holocaust in oblique and obscured fashion, and have thus resonated with viewers struggling with the elusiveness of memory. Whether or not the source of the photographs is clear, the juxtaposition of the insistent materiality of Boltanski's sculpture and the forever-vanishing individuality of its subjects make works such as *Tiroire (Drawer)* central to discussions of the fate of art and culture after the Holocaust. Boltanski has explained that the inclusion of the Jewish portraits, even enlarged past the point of recognition, brought the Holocaust from its place at the periphery of his oeuvre into the center. All his work has since been understood as an extended mediation on memory, history, and the Holocaust, and even his biography as a child of Jewish descent on his father's side, born in Paris in 1944—just weeks after the city's liberation—has acquired new significance. *Tiroire (Drawer)* is an invitation to reflect on history, biography, and art.

Boltanski's explicit interest in the past came in a decade that included Maya Lin's *Vietnam Veterans Memorial* (1984), Anselm Kiefer's monumental paintings addressing the legacy of Fascism, and heated debates about the relationship between art and history. William Kentridge's animated film *Tide Table*, 2003, a return to characters and issues he explored in the late 1980s, is a similarly history-minded work. In it, we witness the

transformation of South Africa as experienced by an aging white businessman whose observations of social change are infused with melancholy, hope, and dreams. Kentridge animates in a novel fashion—by drawing with charcoal on a single page, erasing the drawing or parts of it, and filming each manifestation. Watching *Tide Table*, a 2004 purchase, we witness not only a story and the contemplation of the past, but also the creation and obliteration, recording and obscuring, remembering and forgetting of an image. Anri Sala's video *Dammi i colori*, 2003, a 2005 purchase, also chronicles one man's reaction to national change. Shot in Sala's hometown of Tirana, Albania, the video presents a striking response to the economic crisis following the fall of Communism: The mayor repainted the city. As he tells us in the film, the mayor created colorful abstract geometric compositions to cover the collapsing city as a first step, he hoped, in a creation of civic concern, public interest, and modest revitalization.

Sala's *Dammi i colori*, through its integration of aesthetics and civics, reminds us that contemporary artists and their audiences continue to care as deeply about color and composition as about history and politics. Throughout the 1990s, many artists and critics celebrated a return to beauty. Such appeals were received with ambivalence however, as though such a traditional concern must be cover for escapist desires. Ross Bleckner's *Slide*, 2000, conveys the coloristic beauty celebrated in the 1990s. The stains of deep red, like spilled wine on silver, evoke Color Field paintings by Morris Louis and Sam Francis, both represented in the collection. Bleckner began his career as part of the 1980s movement Neo-Geo, so named because its use of pattern and geometry looked like Minimalist and Op Art, but its meanings were decidedly new. Bleckner's earliest abstractions were elegiac stripes, and now his stains refer to blood cells on a microscopic slide. *Slide* is a reminder that we still live with the threat of AIDS. But not every appeal to beauty and the senses is laden with melancholy. In some cases, escape is exactly the point, not as subterfuge, but in the name of experiencing our senses and taking pleasure in life. Fred Tomaselli's *Web for Eyes*, 2002, presents the viewer with details so small and numerous that we are brought close to the painting, only to discover that this is not even a painting, but a collage buried in resin. Our eyes move over eyes cut from magazines and carefully arranged hemp leaves as we survey this fantastic object that was designed, it seems, to test our perception.

The final work to be discussed in this chapter returns us to questions of collecting as well as those of history, art, and society. Isaac Julien's *Vagabondia*, 2000, a 2001 purchase, is one of several films in which Julien examines how African, Black British, and African-American culture appear and are produced in Western museums. In the film, a museum conservator tends to the eclectic Sir

John Soane's Museum in London. As she surveys the collection, the voice of Julien's mother speaks in Creole, her words never translated, while the rooms conjure ghosts of the imperial past. Greek and Egyptian sculptures are briefly illuminated, and a pair of shackles hangs ominously on a wall. Vignettes of characters of African descent, including the artist himself, dressed in Victorian and contemporary dress and contemplating their surroundings, balance Julien's gothic visions of the museum. Julien places the collection at the center of narratives that contrast imperial conquest with contemporary identity. *Vagabondia* was commissioned for and first exhibited at Sir John Soane's Museum, and was thus always both a critique of collecting and a collected object. Its function was not to stand outside the museum, but to transform it from within. The contemporary collection at the Rose, like Julien's film, invites viewers to evaluate the important questions of museum collecting: What is great art, what is the power and responsibility of the museum, and how might individuals of all sorts be active players in the creation of culture?

PETER R. KALB, ASSISTANT PROFESSOR OF Art History, is the Cynthia L. and Theodore S. Berenson Chair of Contemporary Art at Brandeis University. He is currently writing *Art at the Turn of the Millennium* (Laurence King Publishers, UK, and Pearson/Prentice Hall), is the revising author of H.H. Arnason's *History of Modern Art, Fifth Edition* (Prentice Hall, 2005), is author of *High Drama: The New York Cityscapes of Georgia O'Keeffe and Margaret Bourke-White* (Midmarch Arts Press, 2003), and has contributed to *Art in America*. He earned his PhD from the Institute of Fine Arts, New York University.

ROSS BLECKNER, American, 1949
Slide, 2000
Oil on linen, 96 x 120 inches
Hays Purchase Fund, 2000

Two unrelated events from the 1980s have influenced the course of Ross Bleckner's career: post-modernism in the visual arts and the HIV/AIDS pandemic. Although his early *Stripe* paintings referenced the "failed" movement of Op Art and by extension modernist painting, they were an anomaly within the Neo-Geo movement. As a gay man in the era of AIDS, Bleckner was faced with the challenge of reinvesting painting with the subjective content of mourning and loss that postmodernist theory had deconstructed. Beginning in the 1990s, a new iconography of urns, doves, and domes, symbolizing the macrocosm and the infinite world of the spirit, was accompanied by his investigation of the microcosm: life at the cellular level, equally mysterious but more sinister. *Slide*, 2000, is a memento mori, a meditative counterpart to his activism in the Community Research Initiative on AIDS (CRIA). The overlapping, airbrushed cells make visible the microscopic appearance of this blood-borne Invisible Disaster, while simultaneously suggesting departed "souls." While the beauty of the painting seduces, the scale of the canvas suggests the awesome scope of the disease and its attendant suffering.

PAMELA ALLARA

MATTHEW BARNEY, American,
born 1967
The Cremaster Suite, Ed. 10, 1994–2002
Five C-Prints in self-lubricating plastic
frames, each 44 ¼ x 35 ¼ inches
Gift of Mr. and Mrs. Edward Rose by
exchange, Rose Purchase Fund, 2003

American artist Matthew Barney spent from 1994 to 2002 making his epic Cremaster Cycle, a pentalogy of films accompanied by related sculptures, photographs, drawings, and installations. Named after the muscle that regulates testicular reaction in response to external stimuli, Barney created a symbolic and multilayered story referring to the idea of gender undifferentiation in embryonic development.

The Rose Collection owns color photographs of a character from each of the five films: Goodyear, a 1930s glamour girl played by Marti Domination (*Cremaster 1*, 1995); Garry Gilmore, a convicted murderer played by Matthew Barney (*Cremaster 2*, 1999); the Entered Apprentice (*Cremaster 3*, 2002) and the Loughton Candidate, a dancing satyr (*Cremaster 4*, 1994), both played by Barney himself; and the Queen of Chain, played by Ursula Andress (*Cremaster 5*, 1997). Framed in self-lubricating plastic, a material widely used by Barney, the five portraits reference Christian altarpieces: two women serve as muses flanking the three images of the artist in a classically balanced composition.

ELISABETH IOANNIDES '00

CHRISTIAN BOLTANSKI, French,
born 1944
Tiroire (Drawer), 1988
Photograph, clip lamp, and clothing in
tin drawer with mesh, 37 x 24 x 16 inches
Gift to the Rose Art Museum in Memory
of Edna Sloan Beron, 1996

Memory and loss are the predominant themes on display in this hauntingly beautiful work by French artist Christian Boltanski. A fading, blurry photograph of a girl brightly illuminated by the direct light of a clip lamp hangs above a tin drawer with clothing in it and is covered over with a mesh screen. Here the intimate and personalized contrasts deeply with the general and nonspecific. The photograph elicits thoughts of a unique moment now lost, while the blurring of the image visually recalls the process of memory fading over time. The work incorporates only one person's possessions, yet their anonymity recognizes the massive loss of individualized and specific memory caused by the Holocaust, a pervading theme in the artist's oeuvre. Boltanski's moving recognition of death on a personal level within a greater tragedy provides an appropriate reminder of the importance of each life lost, and the danger of it all fading away.

MEGAN ROOK-KOEPSEL '05

ANTHONY CARO, British, born 1924
Octave, 1971
Steel, 58 x 58 x 51 inches
Gift of Arthur A. Goldberg, New York,
1980

Though classically trained at the Royal Academy Schools in London, Anthony Caro has displayed a feverish experimentalism resulting in marked alterations in style and content. Having apprenticed with Henry Moore in the early 1950s, Caro was abruptly changed by a visit to the United States in the early 1960s, where he encountered the writings of Clement Greenberg and saw the work of Kenneth Noland and Jules Olitski. His work shifted from Picasso-inspired Cubist sculptures toward abstraction, best exemplified in *Prairie*, 1967, which contains four cantilevered rods painted in a matte yellow. Similarly, *Octave*, assembled like the partial encasement of a sturdy crib, is painted a standard deep olive. Solid steel geometric forms, resembling a set of random but sturdy wings, are affixed to the central bars. The entire piece is placed on the floor, which was Caro's singular contribution to the history of sculpture: removing the object from its exalted place on the plinth. He was awarded an honorary doctorate from Brandeis in 1980.

MICHAEL RUSH

I GETS A THRILL TOO WHEN I SEES DE KOO

ROBERT COLESCOTT, American, born 1925
I Gets a Thrill Too When I Sees De Koo, 1978
Acrylic on canvas, 84 x 66 inches
Gift of Senator and Mrs. William Bradley, 1981

Robert Colescott, the first African American to represent the United States in a solo exhibition at the Venice Biennale in 1997, often recasts well-known art historical motifs in personal and social terms. His style is raucous and acid, and he mines sources ranging from great chestnuts of art history to generic art historical iconography. In *I Gets a Thrill Too When I Sees De Koo,* Colescott inserts an Aunt Jemima face into his appropriation of Willem de Kooning's iconic *Woman I.* The title derives from risqué black lingo and Mel Ramos's *I Still Get a Thrill When I See Bill,* a Pop *Playboy*-centerfold reinterpretation of the De Kooning. In an age of multiculturalism and feminism, Colescott addresses inclusion and noninclusion in art and history, posing playfully provocative questions about synergistic intermixing—including high and low; artist and model; original and copy; fine and vernacular; good and "bad."

GERALD SILK '70

JUDY CHICAGO, American, born 1939
Birth Trinity, 1982–84
Filet crochet, cotton thread and six text panels, 41 x 113 ³/₄ inches
Gift of Lois L. Lindauer '53, in honor of the 35th anniversary of her graduation, 1989

A founder of the feminist art movement, Judy Chicago creates multimedia installations, often in collaboration. Her *Birth Trinity* is a monumental piece worked by Martha Waterman in a crochet technique that creates solid and void with a single stitch. Three abstract figures intertwine to depict a historical birth posture: one figure supports the mother, while the lower figure is midwife and birthling in one. Part of *The Birth Project*, this composition was rendered in various sizes in silk screen, batik, needlework, and reverse quilting. The project comprised eighty artworks in various fiber techniques, each exhibited with text panels providing context and naming the fiber artist(s) who realized the image Chicago created. Pieces were exhibited in different combinations in nontraditional venues such as hospitals, schools, and banks, along with galleries. Chicago's later Holocaust Project was shown at the Rose in 1995.

ELLEN C. SCHWARTZ '69

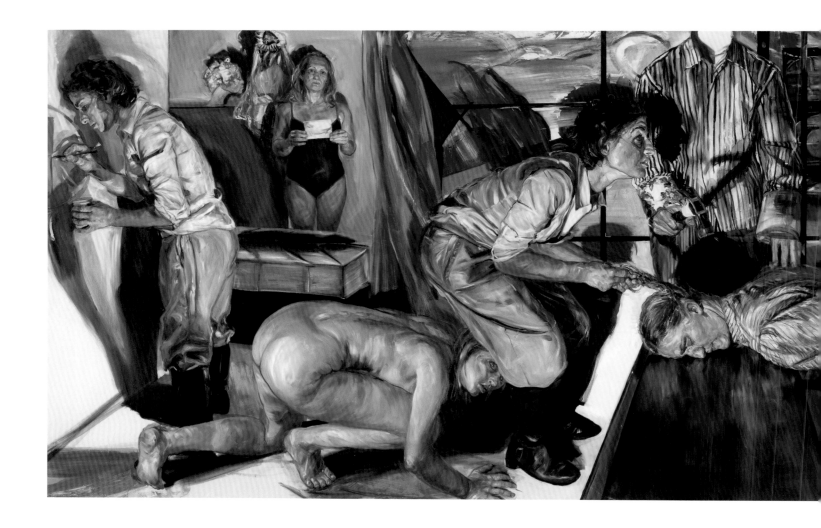

NATALIE FRANK, American born 1980

The Czech Bride, 2008

Oil on canvas

74 x 192 inches

Gift of Eric and Debbie Green,
Dallas, Texas, 2008

Natalie Frank constructs universal narratives that evoke deeply personal reactions. Executed in formally classical and intellectually feminist traditions, Frank's paintings contain dense meaning expressed with theatrical flair. *The Czech Bride,* a large-scale triptych, is based on the writings of German-Jewish political theorist Hannah Arendt—specifically on her coverage of Adolf Eichmann's trial in Jerusalem in 1961, in which she coined the phrase "the banality of evil" to describe Eichmann, who was also known as "the architect of the Holocaust." In his defense, Eichmann cited a concession he made to the Jews that allowed for non-German women marrying German men to be photographed for official documents partially clothed, as opposed to the earlier mandate of nudity. This is the narrative point of departure for Frank's triptych, which depicts a series of the Czech bride's private moments: being photographed and attempting to hide; being threatened; and experiencing a moment of intimacy with her German partner. *The Czech Bride* captures and commemorates a historical event while raising awareness that anyone can become a victim of the banality of evil.

ADELINA JEDRZEJCZAK

ELLEN GALLAGHER, American, born
1965
Doll's Eyes, 1992
Pencil, oil, and paper on canvas mounted
on wood, 59 ¾ x 37 ¾ inches
Rose Purchase Fund, 1993

Doll's Eyes was made while Ellen Gallagher was a student attending the School of the Museum of Fine Arts, Boston; it appeared that year in her first ever solo exhibition at the Akin Gallery, from which it was purchased for the Rose collection. Nowadays, Gallagher is one of the most acclaimed contemporary artists working internationally, known for the subtlety and strategy of her uncommonly beautiful cultural critiques. Yet it is all apparent in this early work: the modulated palette of pale tones with black and white, the exquisite touch, the layering of drawing and painting, paper on canvas, figure within field. While at first glance or from a distance Gallagher's early works seem to be tender exercises in modernist abstraction, closer inspection reveals alternate histories told obliquely through small, subliminal details. Deftly, her abstracted narratives subvert assumptions about identity and power and offer fluid sites for reinvention and negotiation.

ANNETTE DIMEO CARLOZZI '75

MARY HEILMANN, American,
born 1940
Diamonds, 1989
Acrylic on canvas, 60 x 42 inches
Gift of Donald and Jeanne Stanton,
1998

Mary Heilmann's paintings contradict what we have come to expect from abstraction. Her joyous colors and unexpected compositions add an element of playfulness that is a surprise in works without easily identifiable subject matter. Here, a checkerboard pattern is hidden by a field of white paint, reflecting the artist's interest in ceramics and translucent glazes. Only small areas of red peek through in the shape of diamonds, a classic square tipped on end. Heilmann's work plays with ideas of femininity—here she selects seemingly gendered colors (pink, red, and white) and a suggestive title—geometric abstraction becomes "a girl's best friend." A brave subversion of the modernist grid, the work also reflects the artist's working method, with visible brushstrokes, drips, and imperfections functioning as a crucial part of the painting. Ultimately, Heilmann frees the viewer's relationship to abstraction, revealing the inherent physicality of making a painting and insisting on an intense enjoyment of color, shape, and surface.

ESTHER ADLER '99

JENNY HOLZER, American, born 1950
Stave, 2008
Seven curved, double-sided LED signs:
red and blue diodes on front, blue and
white diodes on back,
5 ¼ x 57 ¾ inches per sign
Unique Rose Acquisition Fund, 2008

Jenny Holzer began her career-long preoccupation with language in the late 1970s, when she pasted what she called "Truisms" in public places around Manhattan (in phone booths, on walls, and on billboards). Phrases such as "A man can't know what it is to be a mother" or "A lot of professionals are crackpots" appeared like geeky graffiti for the Conceptual Art set. As her work matured into elaborate displays—such as covering the outside of the Guggenheim Museum with a vast text-based light projection—her interactions with technology became increasingly complex, as did the content of her language games. *Stave* (a word that can mean stick or strip of wood as well as the alliterative sound in a line of poetry) is a wall sculpture that echoes the sleek steel stacks of a Donald Judd sculpture. Rapidly flashing on the seven silvery signs are declassified outtakes from prisoner interrogations at a United States prison camp in Guantánamo Bay during the Iraq War.

MICHAEL RUSH

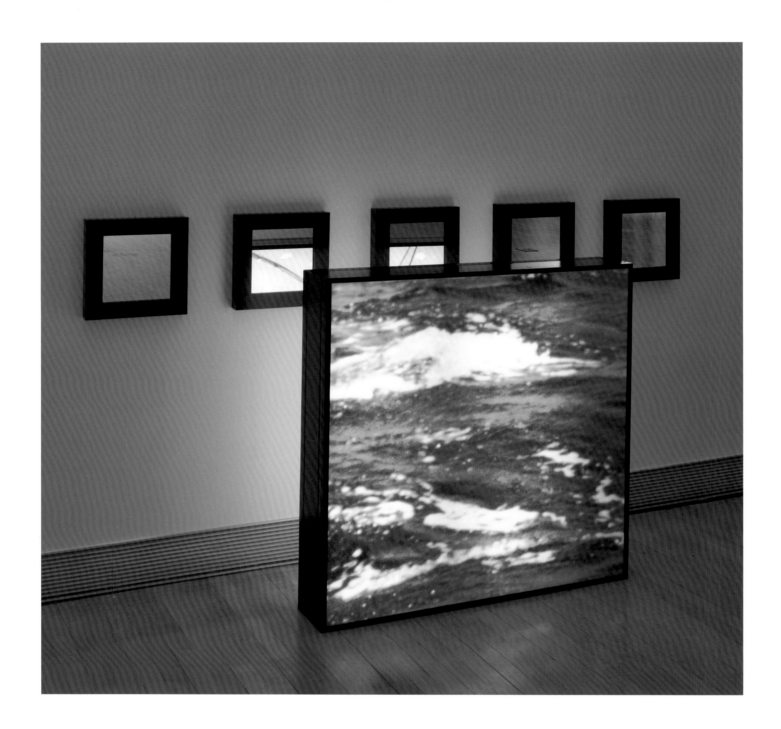

ALFREDO JAAR, Chilean, born 1956
Untitled (Water and Child), 1990
Double-sided light box with color
transparencies and five wood-framed
mirrors, 40 ½ x 40 ½ x 7 inches
Purchased with funds from the Mortimer
Hays Acquisition Fund, 1997

Alfredo Jaar creates an emotional arena by removing objects from their familiar context. He obscures and relocates images to create an intensely personal encounter with them. *Untitled (Water and Child)* is comprised of two photographs—one he took of a little girl in 1990 in a refugee camp in Hong Kong and another of the sea he made from a patrol boat rescuing refugees in the South China Sea. On one side of a light box, the viewer is faced by the image of the rolling surf; behind the box, so close to the wall that it can only be seen via mirrors, is the photograph of the child. As viewers look at the mirrors, the child appears to return their gaze—directly confronting them with the atrocities of the camps.

RAPHAELA PLATOW

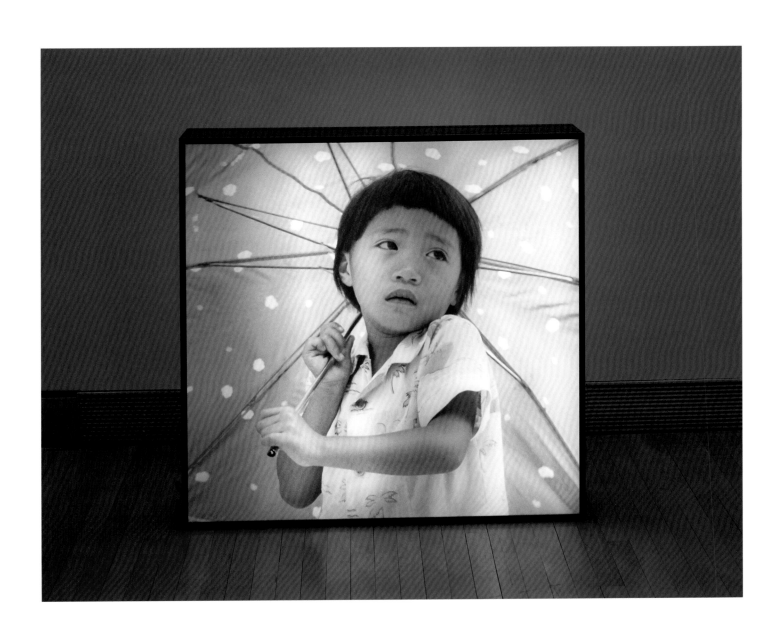

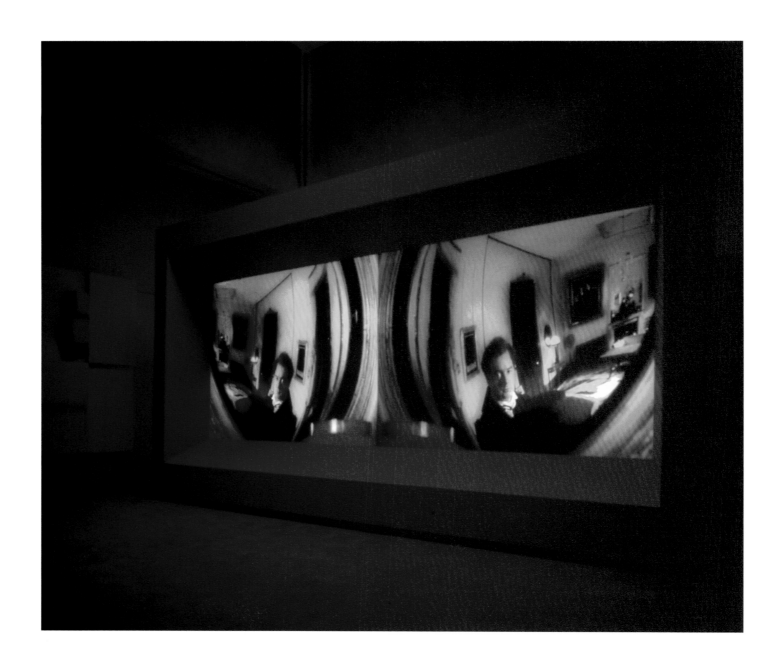

ISAAC JULIEN, British, born 1960
Vagabondia, 2000
Double-screen projection: Beta
submaster for copying to any format
plus 2 DVDs in presentation box
Rose Purchase Fund

Combining aesthetics and politics, British artist Isaac Julien continues his postcolonial exploration of the institutionalization of fine art in his video projection *Vagabondia*. Shot in Sir John Soane's (1753–1837) Museum in London, Julien's film subtly examines and critiques the architect's house and art collection, paid for with a fortune partly amassed through the slave trade. A black conservator, Cleo Sylvestre, acts as mediator between past and present. During her nightly round, she encounters various ghostly figures, including the museum's curator, Soane, two young black women in eighteenth-century dress, and a dancing vagabond (choreographed by Javier de Frutos) who does not abide by the orderly rules of the museum. Through the use of fluid camera movements, mirror images, contradictory viewpoints, and shadows, the artist represents the house as a space that turns in on itself while at the same time allowing the visitor to inhabit several spaces at once. The film's looped presentation makes it difficult to tell beginning from end. With *Vagabondia*, Julien presents a narrative that comments on high art, political history, race, and nationalities by bringing to life past and present.

ELISABETH IOANNIDES '00

WILLIAM KENTRIDGE, South African, born 1955
Tide Table, 2003
Video projection: 16mm, 35mm, and video with sound, transferred to Betacam and DVD, duration 8 minutes, 138 x 156 inches
Mortimer Hays Acquisition Fund, 2004

South African artist William Kentridge achieved world renown for his works that address life in his native land and investigate the human condition as a symptom of their political situation. Through his flickering animated films, for the creation of which he progressively alters, erases, and redraws charcoal drawings, he comments on the contemporary sociopolitical and cultural issues in South Africa, on the fraught legacy of apartheid and colonialism. In *Tide Table*, Kentridge revives his alter ego, Soho Eckstein, the pinstriped industrialist tycoon who first appeared in *Johannesburg, 2nd Greatest City After Paris*, 1989. Eckstein symbolizes the white ruling elite that established and benefited from the apartheid system. In *Tide Table*, he appears sitting on a deck chair at the beach, reading the paper. As he sits, impassive and unmoving, several events unfold around him that metaphorically reveal the history of postapartheid South Africa. Although there is play and comedy within the animation, there is a great sense of disturbance as well. For the first time, the artist contemplates or meditates on the devastating impact HIV and AIDS have had on the South African people.

ELISABETH IOANNIDES '00

ROBERT MANGOLD, American,
born 1937
Gold & Painting, 1980
Acrylic and pencil on canvas,
104 x 78 inches
Purchased from John Weber Gallery,
New York, 1982

The architectural nature of Robert Mangold's *Gold & Painting,* 1980, is perhaps the factor which most pointedly classifies this work as part of Mangold's oeuvre. Mangold's paintings are mostly constructed of matte paint on irregularly cut pieces of canvas or plywood. Despite their architectural quality, the paintings remain adaptable in nature. They are homogenous in their ability to merge with the environment that surrounds them, and simultaneously outstanding in their tendency to capture major focus in any setting.

 Gold & Painting is a three-panel work. The immensity of this canvas, along with its deep hue, follows the trend of Mangold's other paintings. This gold, a familiar color in Mangold's work, is captivating in its ability to flood the space that surrounds the canvas. The lines in the painting are abstract in appearance and simplistic in form. They add some dimension to the canvas and also remove the painting from the realm of surrounding architecture, asserting its value as an individual form.

TAMAR FRIEDMAN '07

AGNES MARTIN, American, born in
Canada, 1912–2004
Untitled #10, 1997
Acrylic and graphite on canvas,
60 x 60 inches
Rose Purchase Fund and Riverside
Museum Collection by exchange, 1997

Untitled #10 shows Agnes Martin's mature style, in which washes of pale color predominate in paintings and works on paper. Here, delicate contrasts of unsaturated warm and cool tones hint at three-dimensionality while almost uniform values create a floating, glowing impression. Paintings in the 1990s display a predilection for horizontal forms within her trademark square canvas, as opposed to the earlier grid-oriented works. While her nonobjective content and geometric forms show affinities with Minimalism, Martin considered herself an Abstract Expressionist because of her emphasis on the personal touch visible in the irregularity of lines and forms and the buildup of the surface through multiple layers of paint. She is further linked to Expressionism by her sense of art as emotionally potent; her speeches and writings emphasize that the aim of her art is to explore beauty and convey joy. Works by Martin were included in exhibitions at the Rose in 1974 and 1990.

ELLEN C. SCHWARTZ '69

BARRY MCGEE, American, born 1966
Untitled, 2003–4
Mixed media installation, dimensions variable
Purchased with funds from the Mortimer Hays Acquisition Fund, 2004

Fusing found and invented imagery, graffiti "tags," and objects, Barry McGee draws on a range of influences to create a unique visual language. He employs both the bold style and process of graffiti art and the techniques and imagery of the commercial culture that permeates urban spaces. *Untitled* includes a wall covered with old metallic galley trays bearing the words "things are getting better" and an array of scraps of paper that the artist has drawn on and mounted in cheap frames. McGee brings his own world into the gallery through his community of friends—their presence acknowledged with photographs, drawings, and the memory of their active participation in the installation process—and a haunting group of hobos and outcasts whose sagging faces line the wall. McGee's installation exposes the ills of contemporary urban life while offering a personal response to the mass-produced advertising that bombards consumer society.

The Rose presented the first solo exhibition of Barry McGee's work on the East Coast. *Untitled* was created for the Rose and purchased directly from the exhibition.

RAPHAELA PLATOW

250

ANA MENDIETA, American, born
in Cuba, 1948–1985
Body Tracks (Rastros Corporales), 1982
Blood and tempera paint on paper;
each 38 x 50 inches
Rose Purchase Fund, 1991

Ana Mendieta's *Body Tracks* on paper allowed her to capture an ephemeral moment of action
in a lasting medium. Dipping her hands and arms in a mixture of red paint and blood during a
performance at the Franklin Furnace art space in 1982, the artist used her body to record gestures
that simultaneously implicate a primal celebration of life and a slow descent into death. The drawings,
with their use of blood and raised, goddesslike hand gestures, reflect Mendieta's interest in the spiritual
culture of her native Cuba as well as of Mexico, which she visited frequently as a student. The use of her
body as both subject and tool also relates to the feminist movement she encountered in the New York
art world. On a more practical level, *Body Tracks* left Mendieta with unique (and salable) documentation
of her time-based practice, which was more often captured with slides, photographs, or video.

ESTHER ADLER '99

MARY MISS, American, born 1944
Stake Fence, 1970
Whitewashed wood,
48 x 48 x 252 inches
Rose Purchase Fund, 1995

The work of pioneering public artist Mary Miss was shown at the Rose Art Museum in the 1996 group show "More Than Minimal: Feminism and Abstraction in the 70's." Miss redefines the relationship between built and natural environments, working at the juncture of sculpture, installation art, landscape design, eco-art, and architecture. She builds bridges between public and private, inviting both individual contemplation and shared communal experience. Her work over the last forty years has spanned the intimate, interior realm and large-scale outdoor spaces. *Stake Fence* is an example of her earlier work created within the context of feminism, post Minimalism, and environmentalism. The piece evokes skeletal formations common to both nature and architecture, using simple building materials. Mary Miss has continued to work in a wide variety of spaces—interior and exterior, urban and rural, museums and waterfronts—engaging audiences in explorations of public concerns, physical environments, and the individual imagination.

MINDY NIERENBERG '77

ELIZABETH MURRAY, American,
1940–2007
Duck Foot, 1981
Oil on canvas, 129 x 132 inches
On extended loan from Mr. Gerald
Lennard, 2007

Elizabeth Murray created colorful, dynamic artworks that literally erupt out of tradition. She is recognized as one of the New York painters who helped reshape modernist abstraction in the 1970s, reinvigorating the painting medium with artists like Frank Stella and Brice Marden, who proposed an alternative in their works to the reductivist tendencies of Minimalism. Her paintings—often eccentrically shaped and multipaneled—burst into the third dimension with brilliant colors and often humorous figuration. Drawing inspiration from Abstract Expressionism, Surrealism, and Cubism, among others, Murray brought her own sense of humor to her canvases, often populating her compositions with abstracted domestic objects. With her embrace of both the high and low and her ability to combine abstraction with figuration in new and exciting ways, Murray produced an influential body of work that broke boundaries and helped to steer the medium of painting in a completely new direction, reintroducing narrative, process, and self to the painting medium. In 2006, the Museum of Modern Art in New York mounted a retrospective of Murray's work, an honor only a handful of women artists have so far received.

SAMARA MINKIN '94

NAM JUNE PAIK, American, born in
Korea, 1932–2006
Charlotte Moorman II, 1995
Nine antique TV cabinets, two cellos,
one thirteen-inch color TV, two five-inch
color TVs, 92 x 68 x 24 inches overall
Purchased with funds from the Mortimer
Hays Acquisition Fund, 2005

Pioneering video artist Nam June Paik had a significant relationship with the Rose Museum. Both
he and his longtime collaborator, Charlotte Moorman (1933–1991), were featured in the Rose's
groundbreaking 1970 exhibition "Vision and Television," the first exhibition of video art in a United States
museum. Moorman's performance, *TV Bra for Living Sculpture*, opened the exhibition and formed the
basis for *Charlotte Moorman II*, Paik's homage to Moorman. The sculpture, built like a giant human/TV
hybrid, is comprised of twelve monitors displaying fast-paced images of Moorman performing *TV Bra*.
Accompanying this sculpture is a suite of photographs taken by Peter Moore of the same performance.
In 1984, the Rose gave Paik a solo exhibition titled "The Color of Time: Video Sculpture by Nam June
Paik." In 1988, Paik created an homage to his many experiences at the Rose with his sculpture *Rose Art
Memory*, a twenty-monitor grid piece encased in a large lacquered frame.

MICHAEL RUSH

ROXY PAINE, American, born 1966
Poison Ivy Field (Toxicodendron radicans), 1997
PETG and vinyl with lacquer, oil paint, earth, sticks, and stones in Plexiglas case, thermoset polymer, 48 x 66 x 48 inches
Rose Purchase Fund, 1997

Multimedia artist Roxy Paine's work was featured in the Rose Art Museum's 2002 traveling solo show *Second Nature*, organized by the Rose in collaboration with the Contemporary Arts Museum in Houston. *Poison Ivy Field (Toxicodendron radicans)* is one of a number of his works that focus on the juxtaposition between what is natural and man-made. Paine painstakingly creates synthetic versions of plants such as poison ivy, mushrooms, and dandelions, placing them in the closed environment of a glass-covered case along with detritus such as trash and syringes. This tableau of specimens is encased as if it belongs in a natural history museum rather than an art museum, creating objectification and distance from the viewer. With the threat removed from these objects, space is created for wonder, awe, and questions about the natural world and its potential for outright harm or destruction.

MINDY NIERENBERG '77

JUDY PFAFF, American, born in England
1946
Untitled, 1992
Watercolor, collage, and burn marks on
paper, 21 x 31 inches
Rose Purchase Fund, 1993

Judy Pfaff, a practicing artist and teacher, utilizes a variety of media in her artwork to create stunning installations, sculpture, paintings, and prints. Since the 1970s, her work has blurred the lines between painting and sculpture and her innovative uses and combinations of different materials have consistently amazed and inspired. Probably best known for her lively, large-scale installation pieces, Pfaff combines traditional two-dimensional materials with found objects, sculptural elements, painting, and architecture to realize site-specific installations rich with intricate detail. Her two-dimensional works push the boundaries of the medium as well, with Pfaff combining painting, photography, collage, and burn marks, among other things, to create arrestingly beautiful and moody images.

SAMARA MINKIN '94

258

LARI PITTMAN, American, born 1952
Like You Ebullient But Despairing, 1995
Alkyd on mahogany panel, 36 x 48 inches
Gift of Sandra and Gerald Fineberg in
honor of Lelia Amalfitano, 1999

West Coast artist Lari Pittman's paintings reveal the intersection of basic daily activity with our overloaded sociocultural landscape. His paintings, hybrid hyperactive relatives to the flat Decorative/ Pattern painting of the 1970s, draw on various visual languages and the practice of Pop to exploit the functions of sign. This combination produces works that are quotidian *and* enigmatic. *Like You Ebullient But Despairing* provides the viewer a dazzling overload of image, color, and symbol simultaneously proposing multiple realities. The play of all the parts—social codes and surrogates— in Pittman's work confounds logical narrative(s). Meticulously painted Victorian silhouettes juxtaposed with the simplicity of folk art, images of sexual fantasy, and capitalism combine to reveal the bittersweet duality of pleasure, the inevitability of pain, and the finality of decisions. From the social to the sexual, the sinister threats to the needs of the self all coexist with that which brings pleasure—life is commingled with death.

LELIA AMALFITANO

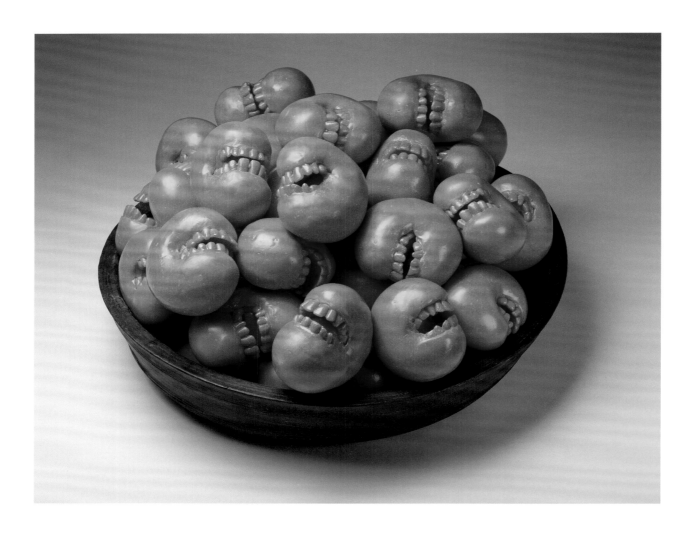

RONA PONDICK, American, born 1952
Red Bowl, 1993
Wood and plastic, 11 x 18 x 18 inches
Mortimer Hays Acquisition Fund, 1994

Incorporating a symbolic figurative presence and the formal strategies of fragmentation and repetition, Rona Pondick's *Red Bowl* is typical of the work that brought her to international prominence during the 1990s. Her ongoing fascination with the idea of metamorphosis has resulted in sculptures that provoke powerful physical and psychological responses. She acknowledges parallels in her work to the poignant contradictions of Franz Kafka, especially in the ways the grotesque coexists with the comic and the creative and destructive seamlessly merge. In this paradoxical still life, a wooden bowl holds a mound of forty-eight red, fist-sized balls—a signature image of Pondick's from that time—which read alternately as ripe apples ("forbidden fruits") or disembodied heads, inducing attraction and repulsion simultaneously. Featureless except for their rows of grinning teeth, Pondick's radically mutated forms reduce human experience to genderless and ageless impulses of desire and need.

SUSAN L. STOOPS

KATHERINE PORTER, American,
born 1941
Grey Square, 1975
Oil on canvas, 84 ½ x 64 inches
Gift of David and Renee McKee,
New York 1987

The Rose organized Katherine Porter's first retrospective in 1985, and the exhibition of thirty paintings spanning fifteen years revealed an extraordinary development in her personal style. Work from the late 1960s into the early 1970s both delineated and disrupted the artist's diagonal, herringbone grid. By the end of the decade, and from that point forward, Porter turned to boldly colored expressive abstraction, with grid lines replaced by swirls, spirals, and fields of loose brushwork. *Grey Square*, dating to a transitional period of Porter's career, maintains the rectilinear underpinnings and muted colors of early abstractions, but it is far from pristine, with its areas of scribbled line and drips of paint disrupting the orderly grid apparent just below the surface. This visible struggle between geometry and the free mark is a fitting parallel to Porter's efforts to express her political consciousness and anger at world events in an abstract yet relevant language.

ESTHER ADLER '99

ROBIN RHODE, South African, born 1976
Untitled/Hondjies, 2001
DVD
Hays Acquisition Fund, 2004

Robin Rhode's video *Untitled/Hondjies* begins with a black screen, like a blank chalkboard. The title letters appear one by one, with the final "S" resembling a dollar sign. The action opens on a shallow space closed off by a blank white wall. A man enters and draws a circle on the wall with a piece of charcoal. He lifts his leg to juggle the "ball" and is soon joined by three more players. As they maneuver the "balls" with their bodies, charcoal circles proliferate on the wall. Rhode has said that his performance drawings were initially inspired by school hazing rituals in which older boys stole chalk and drew objects on walls and forced younger boys to interact with them. Though Rhode's work is playful, he also comments seriously on power structures. Perhaps here he is contrasting the minimal means available to most players of the world's most popular sport with the huge sums invested by the South African government in its bids to host the soccer World Cup.

KATE EZRA '72

ROBERT RYMAN, American, born 1930
Four Aquatints and One Etching,
Plate V, 1990
Aquatint, 32 ³/₄ x 32 ³/₄ inches
Gift of Jonathan Novak, Los Angeles,
California, 1997

Internationally regarded for his intensely Minimalist "white paintings," Ryman has had a lifelong interest in the process of painting itself and the "idea" of painting as an activity. These notions extend to his works on white paper, as is evident in his series *Four Aquatints and One Etching,* of which *Plate Five* is included here. The gentlest pencil marking of a square border about three-quarters of an inch from the edge of the paper is barely discernible. On the upper left corner the border is broken for two inches, making what looks like a vertical strip down the left side. Intense looking is both required and rewarded in this lesson in reductivity. Ryman is often linked with Ad Reinhardt and Agnes Martin, other masters of the "monochrome." For Ryman, the neutrality of white allows for absolute noninterference with the direct experience of the work. His almost sculptural-looking "cutting" on the edge of this piece, however, suggests that Ryman was not afraid of "interfering" and thus allowing his viewers to wander into mysterious territory unexplained by the artist.

MICHAEL RUSH

ANRI SALA, Albanian, born 1974
Dammi i colori, 2003
Video projection, 15 minutes 24 seconds
Purchased with funds from the Rose
Purchase Fund, 2005

During the last twenty years, political instability, neglect, and economic crisis transformed Tirana into one of the bleakest capitals of Europe. Without the economic means to carry out the extensive renovation of the infrastructure that was required, mayor Edi Rama made an unorthodox decision to paint the depressing and degraded gray facades of the city's main streets with brightly colored geometric patterns—a fast, financially feasible improvement for the city. His idea was not so much to cover up reality as to create a hiatus from it that would serve to signal strongly that change was coming and hope was viable.

Anri Sala does not take a position on Rama's project. He simply reports the unlikely story. Like Rama, his means are minimal but striking—he uses only a camera during the day, and at night adds strobes to illuminate the eerie facades as he tours the city. As is often the case in the artist's work, *Dammi i colori* blurs the boundaries between video art and documentary, creating what critic Roberta Smith has called a "docu-poetry"—a poetic meditation on reality that holds a belief in the healing power of color.

RAPHAELA PLATOW

DANA SCHUTZ, American, born 1976
How We Would Drive, 2007
Oil on canvas, 76 x 78 inches
Rose Purchase Fund, 2007

Dana Schutz's paintings begin with invented stories or situations that she inserts into imaginary worlds. With a remarkably sophisticated mastery of the painting medium, she lays out the imagery on canvas in a vibrant palette. *How We Would Drive* depicts a sinister, melting couple—empty holes where their eyes should be, limp hands holding cigarettes that are mostly ash—driving while the sun beats down on their rusty vehicle. On a depicted surface that can be seen as either side mirror or windshield is an additional barefoot being. The title speaks of Schutz's imaginary "how to" scenarios and reflects the premises of her fictitious world. To create the work, the artist projects blobs of saturated paint onto the canvas in colors that reflect the nature, rather than the reality, of her subject. She applies thick strokes as if the imagery were being sculpted from paint and fluidly references various aspects of the Western painting tradition.

 "Dana Schutz: Paintings 2001–2005" at the Rose was the artist's first solo museum exhibition in the United States.

RAPHAELA PLATOW

RICHARD SERRA, American, born 1948
St. Louis VI, 1982
Oilstick on paper, 80 x 80 inches
Rose Purchase Fund, 1982

Richard Serra is a celebrated sculptor of monumental works in the heroic mode. Throughout his career, he has also made drawings and prints that derive from and reference his three-dimensional work. In 1982, Serra completed *Twain*, a sculpture composed of eight heavy, weathering steel panels that occupies an entire city block in downtown St. Louis. Commissioned by the city, it proved to be a controversial work. Despite many calls for its removal, it has remained in place, unlike other examples of his public work. Serra made a series of six large oilstick drawings after the sculpture was completed. In a 1988 catalogue on the collection of Emily and Joseph Pulitzer, Jr., published by the Harvard University Art Museums, Angelica Zander Rudenstine writes that these drawings are "stimulated by [the sculpture], arise from it, but do not represent it." Instead, the drawings "serve in various ways as intermediate phases toward the evolution of new concepts."

DAVID BONETTI '69

JOEL SHAPIRO, American, born 1941
Untitled, 1992
Bronze, 19 ½ x 20 ½ x 11 inches
Gift of Jonathan Novak, 2007

The Rose Art Museum's newly acquired piece *Untitled*, made in 1992, is unique in the overwhelmingly rectilinear character of Joel Shapiro's oeuvre. Like much of Shapiro's sculpture, it explores the object's relationship to the space around it. In this work, two spheres pierced with cylindrical tubes that jut out of their surfaces rest against each other on a pedestal, while another sphere hangs from above. The individual components relate to one another and the surrounding space. These dynamic compositional elements give the work an expressive force. Speaking in 1990, Shapiro said: "Twentieth-century art is or should be about something real. I think the struggle of the century is the struggle for work to be real, not to be mimetic, not to be pictorial, but to be about the real world, to be its own real issue."[1] In this striking work, Shapiro has demonstrated his keen ability to accomplish such a feat.

MEGAN ROOK-KOEPSEL '05

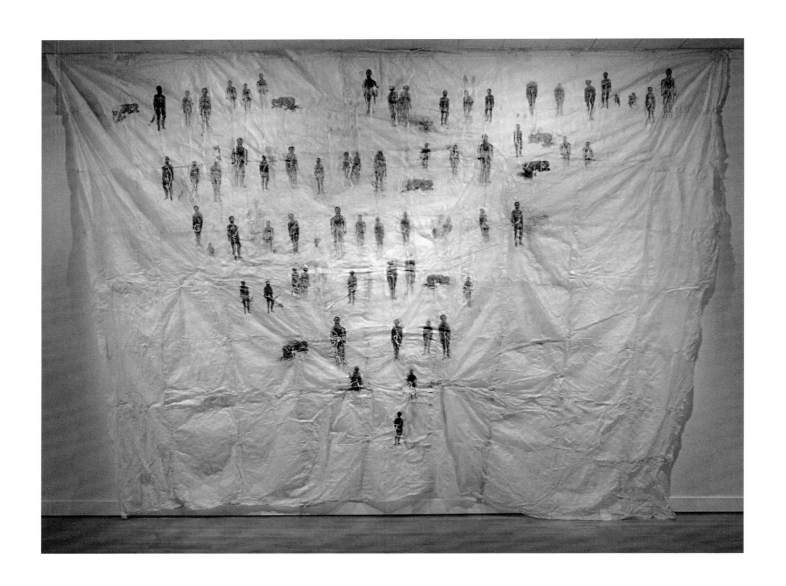

KIKI SMITH, American, born in Germany, 1954
Lucy's Daughters, 1992
Ink on paper with string, 96 x 178 inches
Hays Acquisition Fund, 1992

Throughout her thirty-year career, Kiki Smith has worked in a variety of media, including glass, papier-mâché, wax, bronze, and fabric. The daughter of pioneering Minimalist sculptor Tony Smith, she is particularly renowned for her own sculptural work. An intense fascination with the human body fuels much of her creative process, and some of her most striking pieces have emerged from her practice of rendering it. Starkly mapping forms in all of their functions and deformities, her frank, sure lines create both portraits and fables. The presence of the individual body within a social and political whole provides a point of access for Smith through which she confronts notions of gender, sexuality, and oppression.

SAMARA MINKIN '94

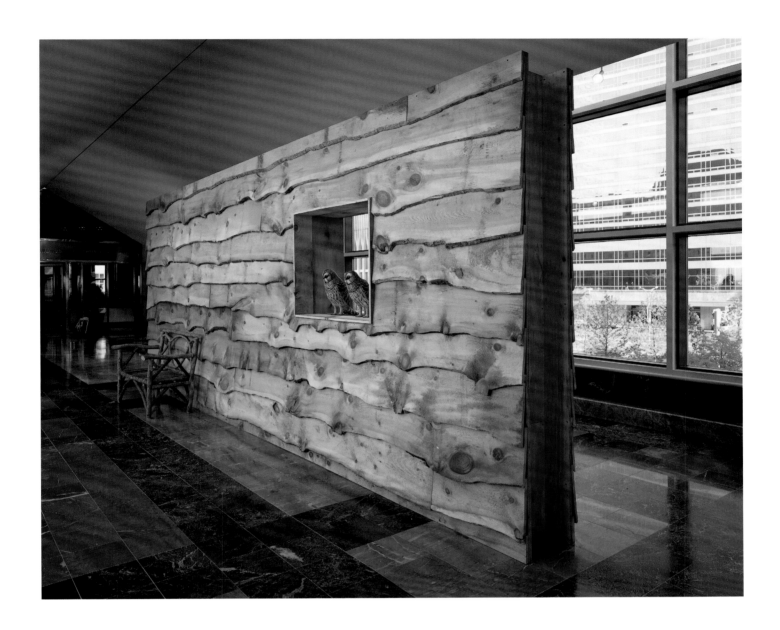

HAIM STEINBACH, American, born in Israel, 1944
Adirondack Tableau, 1988
Mixed media installation,
108 x 265 x 66 ½ inches
Gift of Sandra and Gerald Fineberg, Boston, 1997

Israeli-born sculptor and installation artist Haim Steinbach often uses everyday and ready-made objects in his installations to comment on themes of mass production and commoditization. *Adirondack Tableau*, a grouping of objects inside a large log cabin constructed out of industrially processed wood, is an illustration of the tension between modern man's desire to be closer to nature and materialism. The objects inside the cabin include a factory-produced bench intended to appear handmade, as well as two owls perched on a windowsill (which acts as a sort of shelf, a recurring motif in Steinbach's work that signifies a contemporary domestic tool for display). The modern inhabitants of this Adirondack cabin yearn for a rustic habitat but, in their current commercialized condition, are only capable of living in a mass-produced, fetishized version of the natural.

KAREN CHERNICK '06

JOAN SNYDER, American, born 1940
Morning Requiem (For the Children),
1987–88
Oil paint, acrylic, wire, chain, nails, wood,
papier-mâché, velvet, and wood block
print on linen mounted on birch board,
66 x 291 inches
Rose Purchase Fund, 1989

Deeply moved by a series of news stories on the plight of children around the world, Joan Snyder painted a memorial that stretches more than twenty-four feet in length. Drawing from her personal lexicon of symbols and experiences, Snyder painted vineyards, which move from the barren and petrified on the left to the sun-drenched on the right. Outlined figures are both suffering and transcendent as they move across the composition, and evocative materials like chain, nails, and velvet heighten the emotion inherent in the work. Snyder's use of abstract language and the physicality of her mediums allow her to share a dedication to social and political justice with her viewers in a highly individual and deeply effective way—the seeming narrative of *Morning Requiem* pauses in the center of the canvas, an area of color and gesture that encourages reflection.

ESTHER ADLER '99

JESSICA STOCKHOLDER, American,
born 1959
Untitled, 1992
Leather skirt, velvet skirt, yarn, aluminum
tubing, mixed media, 56 x 56 x 67 inches
Gift of Michael Black and Melody Douros,
2007

Jessica Stockholder is a sculptor and installation artist who received her MFA in sculpture from Yale in 1985. Her sculptures are assemblages of seemingly unrelated objects, creating a narrative or metaphor through the found articles; in this case the objects include an umbrella, a leather skirt, and yarn. Each item carries an association or purpose that is challenged by its placement and use among the other items. She enjoys the random process of putting together her found objects, stating, "My work often arrives in the world like an idea arrives in your mind. You don't quite know where it came from or when it got put together, nevertheless, it's possible to take it apart and see that it has an internal logic. . . . The various parts of my work are multivalent, as are the various parts of dreams. At best, there are many ways to put the pieces together."[2]

SARA TESS NEUMANN '07

PHILIP TAAFFE, American, born 1955
Glyphic Field, 1998–99
Mixed media on canvas,
113 ¼ x 178 inches
Rose Purchase Fund, 1999

A glyph is a pictograph or other symbolic character, which in ancient art was usually carved into a stone surface. In Taaffe's painting, glyphs take the form of printed collage elements attached to a canvas surface. At that material level, the artist seems to be suggesting that contemporary culture lacks depth, that it is a parade of superficial signs signifying nothing. Taaffe, who along with Peter Halley and Ross Bleckner emerged in the early 1980s as a member of the Neo-Geo movement, is a scholar of decorative pattern and a master of surface effect. In a *New York Times* review of the exhibition at the Gagosian Gallery in which *Glyphic Field* first appeared, Michael Kimmelman wrote that the surfaces of Taaffe's dense collages "remain shallow, fluid and smooth, like water flowing over pebbles." During the time Taaffe painted *Glyphic Field*, he was using organic images of flora and fauna rather than abstract decorative patterning. The results are reminiscent of Henri Matisse's large 1946 silk screen *Ocean*.

DAVID BONETTI '69

FRED TOMASELLI, American, born 1956
Web for Eyes, 2002
Hemp leaves, photo collage, acrylic, resin on wood, 48 x 48 x 1 ½ inches
Purchased with funds provided by Lynn P. Warner, 2002

Fred Tomaselli, born in California, is best known for his meticulously detailed paintings on wood panels. Tomaselli often combines hand-painted elements with a variety of unorthodox collage objects and materials suspended in a clear resin applied to the surface. These collage elements are applied seamlessly to the wood, and merge with the painted image to create dazzling organic patterns that spread throughout the entire composition. Sometimes unsettling, his use of dismembered body parts (eyes are a common motif) creates hallucinogenic abstract patterns that breathe with life. The swirling geometries that form the base of his compositions continue out from the canvas, furthering the impression of his compositions as living, breathing organisms.

SAMARA MINKIN '94

TERRY WINTERS, American,
born 1949
Station, 1988
Oil on canvas, 24 ¼ x 19 ½ inches
Gift of Mildred and Aaron Keller, 2003

An innate energy imbues Brooklyn-born artist Terry Winters's work with vigor, calling to mind the style of the Abstract Expressionist era. Unlike the artists of that time, Winters incorporates the vague representation of matter and space into his paintings, drawings, and prints, using art as a means to arrest chaos. He takes a scientific approach to building inherently organic artistic planes.

Station typifies Winters's work. As an artist interested in science, Winters takes care in choosing his materials, sometimes mixing his own pigments from scratch. He builds paintings from the ground, applying oil to canvas in a sculptural manner. *Station* presents an ambiguous image in a world of quietude. The pigment he used in this painting is dark, yet gentle. The shape emerges from the abyss, revealing itself to us in its strong, silently peaceful nature. Brushstrokes are evident, and we are able to imagine the sequence of the picture plane's original development.

TAMAR FRIEDMAN '07

ENDNOTES

INTRODUCTION

1 For a detailed history of both the founding of Brandeis and President Sachar's devotion to the arts, cf Abram Sachar: *Brandeis University: A Host at Last*. New Hampshire: Brandeis University, 1976.

2 The Castle is a fortresslike building dating back to the earliest days of Middlesex University, which used to occupy the land now owned by Brandeis.

3 Conversation with Sam Hunter, Princeton, New Jersey, August 18, 2008. According to Hunter, some anti-Semitic sentiments among Board members of the Institute led a Hunter supporter to suggest to President Sachar that he hire Hunter for the Brandeis post.

4 The exhibition, *American Art Since 1950*, was a collaboration with Boston's Institute of Contemporary Art, whose Director, Sue Thurman, arranged for the work to be shared by the two institutions. Cf *American Art Since 1950*, catalogue of the exhibition, 1962, Brandeis University, sponsored by the Poses Institute of Fine Arts.

5 Sam Hunter, "A Personal Memoir of the Founding of the Rose Art Museum," in *A Defining Generation: Then and Now, 1961–2001*, Joseph D. Ketner, ed. Waltham: Rose Art Museum, 1962, p. 16.

6 The Gevirtz-Mnuchin fund was supplemented by grants from Mrs. Harry E. Doniger and Mr. and Mrs. A.I. Sherr.

7 Sam Hunter: The Gevirtz-Mnuchin Collection, pamphlet accompanying the exhibition at the Samuel Kootz Gallery, New York, March 26–30, 1963. Interestingly, the collection premiered as a collection at a commercial gallery, not at the Rose. It opened at the Rose later that year, May 3–20, 1963.

8 Ibid.

9 Designed by the firm of Harrison and Abramovitz, New York, architects of Lincoln Center as well as of the master plan for the Brandeis campus.

10 Hunter was lured away to become director of the Jewish Museum in New York. Having left the Minneapolis Institute of Arts in part because of lurking anti-Semitism in the Board in 1960, he was to leave the Jewish Museum in 1967, after only two years, because he was deemed "not Jewish enough." His concentration on avant-garde art neglected too much the Judaica exhibitions desired at the time by some influential board members. Cited in conversation with the artist, op cit. See also *New York Times*, "Director of Jewish Museum Quits in Policy Rift," October 25, 1967, p. 42. Hunter went to Princeton in 1969, where he remains as Professor Emeritus.

11 IX São Paulo Bienal, catalogue of the exhibition, São Paulo, Brazil, 1967, p. x. Seitz left Brandeis in 1970 for the University of Virginia.

CHAPTER 2: SOCIAL REALISM AND SURREALISM

1 Diego Rivera, "The Revolutionary Spirit in Modern Art," in *Modern Quarterly* 6, no. 3, autumn 1932, p.51; reprinted in David Shapiro, ed., *Social Realism: Art as a Weapon.* Critical Studies in American Art. New York: Fredrick Ungar, 1973, p.54.

2 Meyer Schapiro, "The Social Bases of Art," in *First American Artists' Congress* (1936); repr. Matthew Baigell and Julia Williams, eds., *Artists Against War and Fascism: Papers of the*

First American Artists' Congress. Rutgers: The State University of New Jersey, 1986, p. 106.

3 André Breton, *Second Manifesto of Surrealism*, 1930; repr. Breton, *Manifestoes of Surrealism*, translated by Richard Seaver and Helen R. Lane. Ann Arbor: University of Michigan Press, Ann Arbor Paperback, 1972, p. 124.

4 Rivera, "The Revolutionary Spirit in Modern Art," 1932, p. 55; and André Breton, *Second Manifesto of Surrealism*, 1930, p. 125.

5 For example, Thomas Craven, "Art and Propaganda," *Scribner's* 95, no. 3 (March 1934): 189–194; repr. in David Shapiro, ed., *Social Realism: Art as a Weapon*, pp. 81–94.

6 Alejandro Anreus, Diana L. Linden, and Jonathan Weinberg, eds. *The Social and The Real: Political Art of the 1930s in the Western Hemisphere*, University Park: Pennsylvania State University Press, 2006, pp. xv-xvi. Social Realism is actually a fairly recent term established in the literature in 1973 by historian David Shapiro. "Social content" and "Social protest" art were the more typical descriptors used during the 1930s.

7 André Breton, *Manifesto of Surrealism*, 1924, p. 14.

8 Harold Rosenberg, "The American Action Painters," *Art News* 51, no. 8, December 1952: 22–23, 48–50.

9 Ibid., p. 23.

CHAPTER 3: POSTWAR AMERICAN ART AND ABSTRACT EXPRESSIONISM

1 The epigraph to Ernest Hemingway's novel *The Sun Also Rises*, 1926.

2 Quoted in Richard Ruland and Malcolm Bradbury, *From Puritanism to Postmodernism: A History of American Literature*, New York: Penguin, 1991, p. 273.

3 Adolph Gottlieb, "Ides of Art," *The Tiger's Eye*, no. 2, December 1947, p. 43.

4 The tendency to spatialize and map the mind—Gottlieb likened the grids of his Pictographs to "a house in which each occupant has a room of his own." ("Adolph Gottlieb," *Arts and Architecture*, vol. 68, no. 9, 1951, n.p.)—has a venerable history. For one aspect of this tradition, see Frances A. Yates, *The Art of Memory*. London: Pimlico, 1966.

5 Robert Motherwell (1963), quoted in E.A. Carmean, Jr., Eliza Rathbone, and Thomas B. Hess, *American Art at Mid-Century: The Subjects of the Artist*. Washington, D.C.: National Gallery of Art, 1978, p. 101.

6 This painting, with its titular reference to Al Dubin and Harry Warren's 1933 song, "Remember My Forgotten Man," is stark testimony to the continuation of the disasters of the interwar years into the period of Abstract Expressionism.

7 See Frank Kermode, *The Sense of an Ending: Studies in the Theory of Fiction*. Oxford: Oxford University Press, 1966.

8 Several Abstract Expressionists—including Arshile Gorky, Jackson Pollock, and Ad Reinhardt—held decidedly left-wing views ultimately indebted to Marx; Nietzsche was central to Mark Rothko's thought and arguably also Clyfford Still's. Freud's influence permeated the entire movement.

9 Dore Ashton and Joan Banach, eds., *The Writings of Robert Motherwell*. Berkeley: University of California Press, 2007, p. 36.

10 Sanford Hirsch, *Adolph Gottlieb*—1956. Glen Falls, New

York: The Hyde Collection, 2005, p. 13.

11 Here I am indebted to Mary Davis MacNaughton's unpublished paper, "Alchemy and the Inner Drama of Transformation in the Art of Adolph Gottlieb."

12 As MacNaughton, op. cit., p. 6, noted, in 1945 alone Gottlieb made six paintings with alchemical titles.

13 See David Anfam, *Franz Kline: Black & White*, 1950–1961. The Menil Collection: Houston, 1994.

14 Ibid., p. 9.

15 William C. Agee, *Sam Francis: Paintings 1947–1990*. Los Angeles: Museum of Contemporary Art, 1999, p. 18.

16 Rothko, "Letter to the Editor, July 8, 1945," in Miguel López-Remiro, ed., *Mark Rothko: Writings on Art*. New Haven: Yale University Press, 2006, p. 46.

17 See Claudia Benthien, *Skin: On the Cultural Border Between Self and the World*. New York: Columbia University Press, 2002.

18 James E.B. Breslin, *Mark Rothko: A Biography*. Chicago: University of Chicago Press, 1993, p. 306.

19 See B.H. Friedman, *Alfonso Ossorio*. New York: Harry N. Abrams, 1972, p. 19.

20 Hyman Bloom, quoted in Dorothy Thompson, *Hyman Bloom*. Brockton: The Fuller Museum of Art, 1996, p. 35.

21 See Francis V. O'Connor, "Review No. 81" on http://members.aol.com/FVOC/reviews.html.

22 Willem de Kooning, quoted in Thomas B. Hess, *Willem de Kooning*. New York: The Museum of Modern Art, 1968, p. 100.

23 Ibid., p. 26.

24 In the 1950s, the American writer J.B. Jackson coined the term "odology" to describe the new world unveiling itself to the driver's eye.

25 Harold Rosenberg, "Interview with Willem de Kooning," *Artnews*, no. 71, September 1972, p. 55.

26 On De Kooning and the carnal, see David Anfam, "De Kooning, Bosch and Bruegel: Some Fundamental Themes," *The Burlington Magazine*, 145, October 2003, pp. 705–15.

27 George Scrivani, ed., *The Collected Writings of Willem de Kooning*. Madras and New York: Hanuman Books, 1988, p. 167.

28 John O'Brian, ed., *Clement Greenberg: The Collected Essays and Criticisms*, vol. 4. Chicago: University of Chicago Press, 1993, p. 130.

29 As does, from a quite different perspective, Jasper Johns's *Drawer*, 1957. With its flatness that can open into the recess of the eponymous drawer, this painting is, inter alia, a parody of Abstract Expressionism's claims to emotional depth.

30 On the changing modes of "surface," see David Joselit, "Notes on Surface: Toward a Genealogy of Flatness," *Art History*, vol. 23, no.1, March 2000, pp. 19–34.

CHAPTER 5: PHOTOGRAPHY AND PHOTOREALISM: THE VANISHING

1 Paul Strand, "Photography," in *Camera Work* 4‰, 1917.

2 David Batchelor, *Chromophobia*. London: Reaktion Books, 2000, pp. 101–2.

BIBLIOGRAPHY

Ades, Dawn. *Dada and Surrealism Reviewed*. London: Arts Council of Great Britain, 1978.

Alloway, Lawrence. *American Pop Art*. New York: Whitney Museum of American Art, 1974.

Anfam, David. *Abstract Expressionism*. London and New York: Thames and Hudson, 1990.

Anreus, Alejandro, Diana L. Linden, and Jonathan Weinberg, eds. *The Social and the Real: Political Art of the 1930s in the Western Hemisphere*. University Park: Pennsylvania State University Press, 2006.

Baigell, Matthew, and Julia Williams, eds. *Artists Against War and Fascism: Papers of the First American Artists' Congress*. Rutgers: The State University of New Jersey, 1986.

Barron, Stephanie. *Exiles and Emigrés: The Flight of European Artists from Hitler*. Los Angeles: Los Angeles County Museum of Art, 1997.

Battcock, Gregory, ed. *Minimal Art: A Critical Anthology*. New York: E. P. Dutton, 1968.

Benthien, Claudia. *Skin: On the Cultural Border Between Self and the World*. New York: Columbia University Press, 2002.

Boltanski, Christian. *Christian Boltanski*. Milan: Charta, 1997.

Boyajian, A., and M. Rutkoski. *Stuart Davis: A Catalogue Raisonné*, 3 vols. Yale University Press, 2006.

Breton, André. *Manifestoes of Surrealism*. Trans. by Richard Seaver and Helen R. Lane. Ann Arbor: University of Michigan Press, Ann Arbor Paperback, 1972.

Chave, Anna. "Minimalism and the Rhetoric of Power." *Arts Magazine* (January 1990): 44–63.

Colpitt, Francis. *Minimal Art: The Critical Perspective*. Seattle: University of Washington Press, 1990.

Cooper, Douglas, and Gary Tinterow. *The Essential Cubism: Braque, Picasso, and Their Friends*. G. Braziller in association with the Tate Gallery, 1983.

Crow, Thomas. *The Rise of the Sixties*. New Haven: Yale University Press, 1996

Dijkstra, Bram. *American Expressionism: Art and Social Change, 1920–1950*. New York: Harry N. Abrams, 2003.

Fer, Briony, David Batchelor, and Paul Wood. *Realism, Rationalism, Surrealism: Art Between the Wars*. Modern Art Practices and Debates series. New Haven: Yale University Press in association with the Open University, 1993.

Francis, Mark, and Hal Foster, eds. *Pop*. London and New York: Phaidon, 2005.

Frizot, Michel, ed. *A New History of Photography*. Cologne: Konemann Verlagsgesellschaft, 1998.

Greenough, Sarah, ed. *Modern Art and America: Alfred Stieglitz and His New York Galleries*. National Gallery of Art, Washington, D. C., in association with Boston: Little, Brown, 2000.

Hemingway, Andrew. *Artists on the Left: American Artists and the Communist Movement, 1926–1956*. New Haven: Yale University Press, 2002.

Janus, Elizabeth, ed. *Veronica' Revenge, Contemporary Perspectives on Photography*. Berlin: Scalo/LAC Switzerland, 1998.

Julien, Isaac. "Creolizing Vision," in Okwui Enwezor, et al., eds. *Creolite and Creolization: Documenta 11 Platform 3*. Ostfildern-Ruit, Germany: Hatje Cantz, 2002, 149–155.

Kermode, Frank. *The Sense of an Ending: Studies in the Theory of Fiction*. Oxford: Oxford University Press, 1966.

Kornhauser, Elizabeth Mankin, ed. *Marsden Hartley: American Modernist*. Hartford : Wadsworth Atheneum Museum of Art in association with Yale University Press, New Haven, c. 2002.

Krumrine, Mary Louise Elliot. *Paul Cézanne: The Bathers*. Harry N. Abrams, New York. Basel: Oeffentliche Kunstsammlung Kunstmuseum,1984.

Lippard, Lucy. *Pop Art*. London: Thames and Hudson, 1970.

Livingstone, Marco. *Pop Art: A Continuing History*. London: Thames and Hudson, 1990.

López-Remiro, Miguel, ed. *Mark Rothko: Writings on Art*. New Haven: Yale University Press, 2006.

Lucie-Smith, Edward. "Superrealism," in *Art Today*. New York: William Morrow, 1977, pp. 455–83.

Madoff, Steven Henry, ed. *Pop Art: A Critical History*. Berkeley: University of California Press, 1997.

Meisel, Louis K. *Photorealism*. New York: Harry N. Abrams, 1980.

Meyer, James. *Minimalism: Art and Polemics in the Sixties*. London: Phaidon, 2000.

Natter, Tobias. *Oskar Kokoschka: Early Portraits from Vienna and Berlin, 1909–1914*. New York: Neue Galerie, 2002.

Posner, Helaine. *Kiki Smith*. Boston: Little, Brown, 1998.

Richardson, John. *Picasso: A Life, Volume III: The Triumphant Years: 1917–32*. New York: Alfred A. Knopf, 2007.

Rose Art Museum. *Kiki Smith: Unfolding the Body*. Waltham, Massachusetts: Rose Art Museum, 1992.

Ruland, Richard, and Malcolm Bradbury. *From Puritanism to Postmodern: A History of American Literature.* New York: Penguin, 1991.

Russell, John, and Suzi Gablik. *Pop Art Redefined.* New York: Frederick A. Praeger, 1969.

Sawin, Martica. *Surrealism in Exile and the Beginning of the New York School.* Cambridge: MIT Press, 1995.

Seitz, William C. *The Responsive Eye.* New York: Museum of Modern Art, 1965.
———."The Rise and Dissolution of the Avant-Garde," *Vogue* (September 1963): 182–83, 230–33.

Shapiro, David, ed. *Social Realism: Art as a Weapon.* Critical Studies in American Art series. New York: Frederick Ungar, 1973.

Staatliche Kunstsammlungen, Dresden. *Von Monet bis Mondrian.* Modern Masterpieces from Dresden's Private Collections of the First Half of the 20th Century. Dresden: 2007.

Stieglitz, Alfred. *Camera Work: The Complete Illustrations 1903–1917.* Cologne: Benedikt Taschen, 1997.

Stich, Sidra. *Anxious Visions: Surrealist Art.* New York: Abbeville Press, 1990.

Tashjian, Dickran. *A Boatload of Madmen: Surrealism and the American Avant-Garde, 1920–1950.* New York: Thames and Hudson, 1995.

Viso, Olga. *Ana Mendieta: Earth Body: Sculpture and Performance, 1972–1985.* Ostfildern-Ruit, Germany: Hatje Cantz, 2004.

INDEX

Moore, Peter, 254

Morimura, Yasumasa, *Futago*, 204, *204*

Motherwell, Robert, 9, 13, 277
 Elegy to the Spanish Republic No. 58, 12, 85, 86, 117, *117*

Murray, Elizabeth, *Duck Foot*, 253, *253*

Murrow, Edward R., 81

Museum of Modern Art, 9

N

Neo-Dada, 131, 141

Neo-Geo, 225, 227, 273

Neue Sachlichkeit, 29

Nevelson, Louise, 13
 Landscape, 118, *118*

Newman, Barnett, 134

New Objectivity, 29

New Topographics, 171

Nietzsche, Friedrich, 86

Nijinsky, Vaslav, 53

Noland, Kenneth, 115, 234
 Opt, *130*, 153, *153*

Nordlund, Gerald, 139

Novak, Jonathan, 15

O

Odita, Odili Donald, 15

Oldenburg, Claes, 10, 170
 Tray Meal, 133–34, 154, *154*

Olitski, Jules, 234

Oppenheim, Meret, 107, 137

Optical (Op) Art, 136, 137, 158, 227

Ossorio, Alfonso, 278
 Flayed Skin, Symbol of St. Bartholomew, 87
 Making of Eve, 85, 87, 119, *119*

Owens, Bill, 178

P

Paik, Nam June, 14
 Charlotte Moorman II, 254, *254*

Paine, Roxy, *Poison Ivy Field (Toxicodendron radicans)*, 255, *255*
 Paper Trail, 15

Park, David, 214

Parrish, David, *Yamaha*, *168*, 171, 205, *205*

Perlmutter, Nathan, 13

Perlmutter, Ruth Ann, 13

Persky, Marlene, 15

Peto, John, 107

Pfaff, Judy, *Untitled*, 1992, 256–57, 257
 Philip Guston Select Retrospective, 1966, 13, *13*

photocollage, 170

photography, 168–219

Photorealism, 168–219, 221

Picasso, Pablo, 19, 31, 41, 114
 Les Demoiselles D'Avignon, 22, 222
 Girl Before a Mirror, 49
 Head of a Woman (Fernanda), 54
 Reclining Nude, 23, 49, *49*

Pittman, Lari, *Like You Ebullient But Despairing*, 258–59, 259

Platow, Raphaela, 14–15

Plimpton, Herbert, 14, 214

Pointillism, 123

Pollock, Jackson
 Abstract Expressionism and, 11, 61, 129
 Hunter and, 9
 Kligman and, 134
 Krasner and, 112
 Louis and, 115
 Male and Female, 126
 Marxism and, 277
 Matta and, 79
 photography and, 174

Pondick, Rona, *Red Bowl*, 260, *260*

Poons, Lawrence, 14, 222
 #30A, 88, 120, *121*

Pop Art
 Abstract Expressionism and, 131–33
 Cottingham and, 184
 Davis, S., and, 24
 Guston and, 12
 Hunter and, 10
 overview of, 130–67
 photography and, 173
 Rauschenberg and, 170

Porter, Fairfield, 205
 View of Barred Islands, 122, *122*

Porter, Katherine, 14
 Grey Square, 261, *261*

Poses, Jack I., 9

Poses, Lillian, 9

Poses Institute of Fine Arts, 9

Post-Minimalism, 135

Post-Modernism, 136

Post-Painterly Abstraction, 88, 104, 110, 131, 153

postwar American art, 84–129, 221

Pousette-Dart, Richard, *Untitled*, 1961, 123

Prendergast, Charles, 50

Prendergast, Maurice Brazil, *Bathers on the Beach*, 50, *50*

Prince, Richard, 221
 Untitled (Cowboy), 206–7, 207

R

Rama, Edi, 264

Ramos, Mel
 I Still Get a Thrill When I See Bill, 235
 You Get More Salami With Modigliani, 132, 155, *155*

Rauschenberg, Robert, 9–11, 13, 107, 131, 170
 Second Time Painting, 124, *124*

Ray, Man, *Catherine Deneuve*, 170, 208, *208*

Realism, Modern, 109

Reed, David, *#1*, 125, *125*

Reff, Theodore, 34

Regionalism, 58

Reinhardt, Ad, 134, 277
 No Title (10 Screenprints by Ad Reinhardt), 156, *157*

Reinharz, Jehuda, 7

Renoir, Auguste, 122

Rexer, Lyle, 169–74

Rhode, Robin, *Untitled/Hondjies*, 262, *262*

Richter, Gerhard, 170

Riley, Bridget, 136
 Disturbance, 158
 Untitled 1965, 158, *158*

Rivera, Diego, 57
 "The Revolutionary Spirit in Modern Art," 276–77

Rivers, Larry, *10*, 10–11, 131–32
 Webster Superior, 132, 159, *159*

Rockefeller, Nelson, 114

Rockman, Alexis, 13

Rojas, Clare, 13

Rollins, Tim, 221

Rose, Bertha, 8, *8*, 11, 14

Rose, Edward, 8, *8*, 14

Rose Art Museum
 development of, 10–15, 19
 history of, 8–9
 photo of, 6, *6*

Rose Geometries, 15

Rosenberg, Harold, 61, 117

Rosenberg, Paul, 93

Rosenblum, Robert, 124

Rosenquist, James, 10
 Two 1959 People, 133, 160, *160*

Rothko, Mark
 Abstract Expressionism and, 87, 174
 Avery and, 28
 Hunter and, 9
 Stamos and, 128

Rubin, Reuven, *Near Jerusalem*, 22, 51, *51*

Rubinstein, Helena, 22

Ruscha, Ed, 171–72

PHOTOGRAPHY CREDITS

Every reasonable effort has been made to trace and contact copyright holders for individual images. In the event a copyright holder has been missed, the Rose Art Museum at Brandeis would be glad to rectify the situation in a future printing.

Courtesy of ACA Galleries, New York, 70

With permission of Archivio Marca-Relli, Parma, 116

© The Adolph and Esther Gottlieb Foundation / Licensed by VAGA, New York, 101

Agnes Martin / Artists Rights Society (ARS), New York © 2008, 249

© Al Held Foundation, Inc. / Licensed by VAGA, New York, 104

© Alex Katz / Licensed by VAGA, New York, 109

© The Alexander Liberman Trust, Courtesy of Mitchell-Innes & Nash, New York, 113

© Alfredo Jaar, 244, 245

© The Estate of Ana Mendieta Collection, Courtesy of Galerie Lelong, New York, 251

Courtesy of Andres Serrano and Yvon Lambert Gallery, 209

The Andy Warhol Foundation for the Visual Arts / Artists Rights Society (ARS), New York © 2008, 16, 165

Courtesy of the Artist, 195

Courtesy of the Artist and James Cohan Gallery, New York, 255

Courtesy of the Artist and Luhring Augustine, New York, 185, 204

Courtesy of the Artist and Mitchell-Innes & Nash, 234

Courtesy of the Artist and Perry Rubenstein Gallery, New York © Robin Rhode, 262

Courtesy of the Artist at Metro Pictures, 246

Artists Rights Society (ARS), New York / ADAGP, Paris © 2008, 30, 35, 38, 43, 45, 52, 77, 78, 93, 164, 233

Artists Rights Society (ARS), New York / VG Bilt-Kunst © 2008, Bonn, 27, 29, 37, 55, 69, 186

Courtesy of Barry McGee and Gallery Paule Anglim, 250

Courtesy of the Bellows Family Trust, 64, 65

© Bernd & Hilla Becher, Courtesy of Schirmer / Mosel, 176, 177

Bridget Riley © 2008, All Rights Reserved, Courtesy of Karsten Schubert, 158

Bruce Conner / Artists Rights Society (ARS), New York © 2009, 92

C. Herscovici, London / Artists Rights Society (ARS), New York © 2008, 74

Calder Foundation, New York / Artists Rights Society (ARS), New York © 2008, 91

Carl Andre / VAGA, New York, and DACS, London © 2007, 142

Courtesy of Cindy Sherman at Metro Pictures, 211

Claes Oldenburg © 2008, 154

© Colette Urbajtel, 175

Collection Center for Creative Photography, Arizona Board of Regents © 1981, 216

© David Reed, 125

© Dedalus Foundation, Inc. / Licensed by VAGA, New York, 117

Douglas Huebler, Courtesy of Darcy Huebler / Artists Rights Society (ARS), New York © 2008, 144

© Ed Ruscha. Courtesy of Gagosian Gallery, 161

© Elizabeth Murray, Courtesy of PaceWildenstein, New York, 253

© Ellen Gallagher, 240

© Ellsworth Kelly, 110

Estate of Ad Reinhardt / Artists Rights Society (ARS), New York © 2008, 157

Estate of Alfred Jensen / Artists Rights Society (ARS), New York © 2008, 106

© Estate of André Kertész / Higher Pictures, 200

© Estate of Ben Shahn / Licensed by VAGA, New York, 81

Estate of David Burliuk © 1968, 33

© Estate of David Smith / Licensed by VAGA, New York, 126

© The Estate of Gene Davis / Smithsonian American Art Museum, 138

© Estate of George Grosz / Licensed by VAGA, New York, 73

© Estate of Jacques Lipchitz, Courtesy of Marlborough Gallery, New York, 114

© Estate of James Brooks / Licensed by VAGA, New York, 90

Estate of John Marin / Artists Rights Society (ARS), New York © 2008, 46

© Estate of Larry Rivers / Licensed by VAGA, New York, 159

Estate of Louise Nevelson / Artists Rights Society (ARS), New York © 2008, 118

Estate of Pablo Picasso / Artists Rights Society (ARS), New York © 2008, 49

© The Estate of Philip Guston, 102

Estate of Reginald Marsh / Arts Students League, New York / Artists Rights Society (ARS), New York © 2008, 75

Estate of Richard Pousette-Dart / Artists Rights Society (ARS), New York © 2008, 123

© Estate of Robert Rauschenberg / Licensed by VAGA, New York, 124

© Estate of Roy Lichtenstein, 151

© Estate of Stuart Davis / Licensed by VAGA, New York, 36

© Estate of Tom Wesselmann / Licensed by VAGA, New York, 166

Estate of Yves Tanguy / Artists Rights Society (ARS), New York © 2008, 82

fam. Jorn / Artists Rights Society (ARS), New York / COPY-DAN, Copenhagen © 2008, 84, 108

Fondation Oskar Kokoschka / Artists Rights Society (ARS), New York / ProLitteris, Zürich © 2008, 44

Courtesy of Forum Gallery, New York, and Los Angeles © 1978, 179

Frank Stella / Artists Rights Society (ARS), New York © 2008, 162

The Franz Kline Estate / Artists Rights Society (ARS), New York © 2008, 111

Fundació Antoni Tàpies / Artists Rights Society (ARS), New York / VEGAP, Madrid © 2008, 83

© Gene Gropper, 71

Courtesy of George and Betty Woodman, 217

Succession H. Matisse / Artists Rights Society (ARS), New York © 2008, 47

Courtesy of Haim Steinbach, 269

Helen Frankenthaler © 2009, 99

Reproduced by permission of the Henry Moore Foundation, 48

Courtesy of Hirschl & Adler Galleries, New York, 122

© Hyman and Stella Bloom, 67

© Jackie Ferrara, 143

© James Casebere, Courtesy of Sean Kelly Gallery, New York, 181

Courtesy of James Cohan Gallery, New York, 274

© James Rosenquist / Licensed by VAGA, New York, 160

© The James Weeks Trust, 214

© Janet Fish / Licensed by VAGA, New York, 192

© Jasper Johns / Licensed by VAGA, New York, 107

Jenny Holzer, member Artists Rights Society (ARS), New York © 2009, 243

© Jessica Stockholder, Courtesy of Mitchell-Innes & Nash, 272

Jim Dine / Artists Rights Society (ARS), New York © 2008, 140

© Joan Snyder, Courtesy of Betty Cuningham Gallery, New York, 271

Joel Shapiro / Artists Rights Society (ARS), New York © 2008, 220, 267

The Josef and Anni Albers Foundation / Artists Rights Society (ARS), New York © 2008, 25

© The Joseph and Robert Cornell Memorial Foundation / Licensed by VAGA, New York, 94, 95